THE
REJECTION
COLLECTION VOL. 2

MORE Cartoons You've Never Seen, and Never Will See, in *The New Yorker*

THE
REJECTION
COLLECTION VOL. 2

EDITED BY MATTHEW DIFFEE

SSE
SIMON SPOTLIGHT ENTERTAINMENT
New York London Toronto Sydney

This book is neither authorized nor sponsored by *The New Yorker*.

SIMON SPOTLIGHT ENTERTAINMENT

An imprint of Simon & Schuster

1230 Avenue of the Americas, New York, New York, 10020

Copyright © 2007 by Matthew Diffee

SIMON SPOTLIGHT ENTERTAINMENT

and related logo are trademarks of Simon & Schuster, Inc.

Designed by Michael Nagin and Jane Archer

Manufactured in the United States of America

First Edition 10 9 8 7 6 5 4 3 2 1

Library of Congress Cataloging-in-Publication Data

The rejection collection vol. 2 : the cream of the crap / edited by Matthew Diffee.

p. cm.—1st ed.

ISBN-13: 978-1-4169-3401-1

ISBN-10: 1-4169-3401-4

[1. New Yorker (New York, N.Y. : 1925). 2. American wit and humor, Pictorial.]

I. Diffee, Matthew. II. New Yorker (New York, N.Y. : 1925).

NC1428.N47 R452 2007

2007024872

Pages 297 and 298 constitute an extension of this copyright page.

CONTENTS

INTRODUCTION

So this is volume two of *The Rejection Collection*. Welcome to it.

To appreciate the concept of this collection, I think it helps to know a little something about the submission process for cartoons at *The New Yorker*. It goes like this: Every week the forty or fifty regular cartoonists at the magazine come up with ten cartoons. On Tuesday we each bring our batch of ten ideas into the office or fax them in from afar, depending on where we live and how social we're feeling. Bob Mankoff, our cartoon editor, looks them over and selects a stack to present to David Remnick, the editor of *The New Yorker*. This happens on Wednesdays in the art meeting where an undisclosed process, which may or may not involve the use of darts, results in the selection of the fifteen to twenty gags the magazine will purchase that week. On Thursday a lucky few cartoonists get phone calls telling them that they've sold one of their ten. The rest get rejected. This happens every week and has been going on for years. By now, there are quite a lot of rejected cartoons out there, and some of them are pretty good. This book is a collection of our favorites. Every cartoon in this book was submitted to and then rejected by Mankoff or Remnick, some several times, and I guess you can't really argue with their decision. These gags are, for the most part, very wrong for *The New Yorker*, which makes them perfectly right for *The Rejection Collection*.

That's all you really need to know to enjoy the book, but if you don't mind too much, I'd like to take a minute here to try to clarify a few other things. I'm often asked questions that imply some basic misunderstandings about

the way the cartooning gig works. It seems to me that people make their first wrong step when they assume that being a cartoonist for *The New Yorker* is a real job. It isn't. Not really (see appendix 1, page 273).

First of all, there are no meetings. Mankoff and Remnick have meetings, but not your run-of-the-mill, foot-soldier cartoonists like myself. We don't sit around a big table as a team and discuss cartoon ideas. There's no team. We're just a bunch of individuals in our own homes, shuffling around the coffeepot in our pajamas, wondering where we set down our "world's greatest cartoonist" mug. Sometimes I think it would be nice to sit around a writer's room, bandying jokes around until we come up with something brilliant for one of us to go off and draw. It would be particularly nice on those all-too-frequent days when you've got nothing—just a big, blank nothing going on in your head. You could hide for days in a room like that. Instead you're all alone and forced to stare daily down the barrel of your own creative incompetence. It always amazes me how impossible the task of coming up with an idea seems until the exact moment when you somehow get an idea. Most cartoonists I know are like this—they're very good at what they do but have very little idea what they're doing. It's like being a jet fighter pilot, but every time you strap into the cockpit you find that someone's gone and rearranged all the buttons. To be honest, it's probably less like a jet fighter and more like a blimp.

Also, unlike real jobs, we have no health insurance, retirement plan, or office space. These are the drawbacks of being a freelancer. On the plus side, we have no dress code, no performance reviews, no time clock, no inter-office memos, and no guy in the cubical next door whistling Limp Bizkit while eating fish curry.

Contrary to what some people have assumed, there are no cartoon assignments at *The New Yorker*. This conversation, for example, never happens:

Mankoff (on the phone): Diffee, it's Mother's Day next Sunday. Get me something on it by three.

Diffee (on phone, in pajamas): Yes, sir.

Mankoff: I'm seeing something in a kitchen. . . . Try getting the word "spatula" in the caption. Spatula's a funny word. Or maybe "whisk."

Diffee: (writing in a notebook) Kitchen . . . spatula . . . whisk. Got it.

Mankoff: Good. And how's it coming with the baseball gags?

Diffee: Nothing to report yet, but I've got my staff working double shifts. We'll crack it soon enough.

Mankoff: Well, get on it. I've got Old Man Remnick breathing down my neck. If I don't have something funny for him by five o'clock, it'll be your ass.

Diffee: Yes, sir.

Mankoff: One more thing, I just noticed there's a new spray cheese on the market.

Diffee: Yes, sir.

Mankoff: I want you, Roz, and Shanahan to cover it.

Diffee: Right. I'll set up a meeting.

Nope, there's none of that. We're all on our own—rudderless and drifting. We also don't get a lot of feedback, which can be a bad thing or a good thing. Bob wants cartoonists who have their own unique voices. So, the best thing

for me to do is what I think is funny, not what I think he and Remnick think is funny. The hope, of course, is that there will be some overlap between the two and something I think is funny will also seem funny to them. If that happens, I might sell one. It's like this:

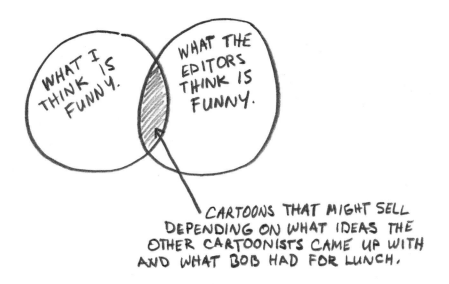

CARTOONS THAT MIGHT SELL DEPENDING ON WHAT IDEAS THE OTHER CARTOONISTS CAME UP WITH AND WHAT BOB HAD FOR LUNCH.

Actually, that might be a bit too simplistic and optimistic. It's probably more like this:

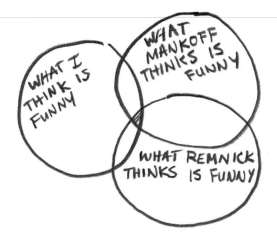

The tricky thing is that my circle shifts, depending on what sort of things I might be thinking about that week or even how good I am at coming up with stuff, so that on another week it might look like this:

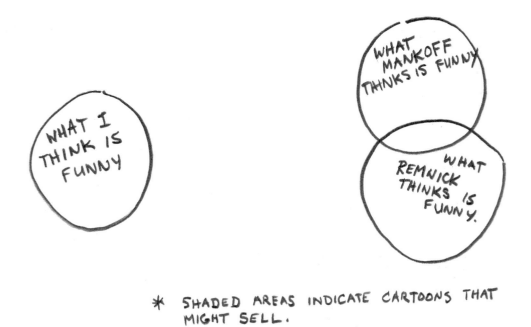

* SHADED AREAS INDICATE CARTOONS THAT MIGHT SELL.

This is why it's a bad strategy to tailor your submissions to what the editors want because their circles are moving around too. The situation becomes hopelessly complicated when you start figuring in what *The New Yorker* readers themselves think is funny, so we usually don't think about that at all.

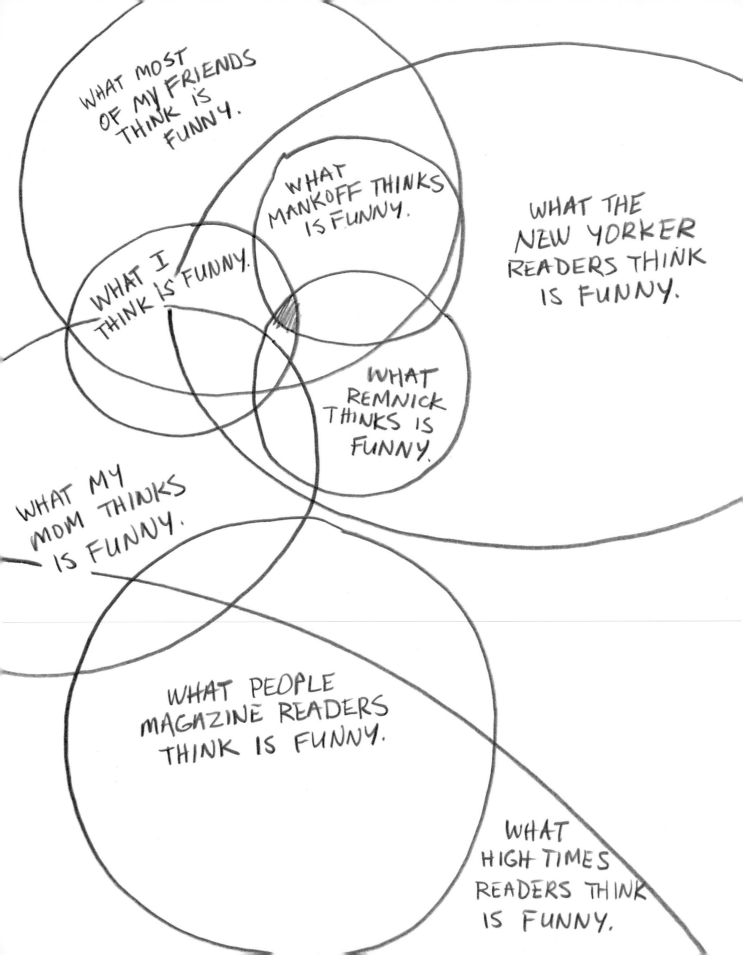

WHAT ANI DIFRANCO
FANS THINK IS FUNNY.

WHAT GERMANS
THINK IS FUNNY

So at the end of the day, cartoonists at *The New Yorker* are free and encouraged to do whatever it is they personally find amusing, which I think is pretty good advice for anyone, unless they're a criminal or a cartoonist who isn't funny.

Finally, after volume 1 of *The Rejection Collection* came out, a lot of people kept asking me why these cartoons were rejected. I'll try to give you my best guesses, along with some of my own rejected cartoons as examples in appendix 2 (see page 275). To get the official answer though, you'd have to ask Mankoff and Remnick that question, and please do by the way, if you ever see them out lounging on one of their yachts or at a caviar tasting. Just go right up to them and say, "Dude, what gives?" You'll find then both to be extremely intelligent, creative guys who love talking to aggressive strangers.

That's it. I hope you like our book.

Fill-in-the-Blank Bio

I was born the third of nine children — yes, we are Catholic and so must reproduce as abundantly and asexually as jellyfish. I grew bored with Mad Libs long before I enrolled in high school, where being a cartoon-nerd won me loads of popularity & sex. Not long after that, I realized I was different from other people — and, luckily, not different in the "worse-than" sort of way but rather the opposite, "better-than" way of being different. Eventually, however, despite my best efforts, others reacted skeptically when I told them this. "How can I prove it?" I wondered, and then it hit me: roller boogie!! It's fun, healthy and a great way to meet inferior people. Perhaps not surprisingly, I was critically beaten by a woman I mistook for Ashley Judd. Yes, things were finally looking up. The next day Bob Mankoff, of The New Yorker called: "is this the Paul Noth who drew the flaming bunny on his tax return? Son, your country needs you. We're at war." "Count me in!" I said. And so, I suppose without any fear of contradiction, we can say my career in cartooning began... "Career?!" you may scoff, "Shouldn't 'careers' provide health care?" my friend, you are preaching to the choir. In closing, I'd just like to say: our world would be a kinder, better place if everyone just watched my web cartoon at nbc.com/paleforce

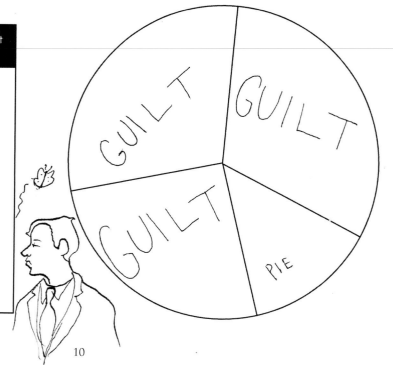

prrrr

Frequently Asked Questions

Where do you get your ideas?

From a magical place called "Boredom."

Which comes first, the picture or the caption?
1. mental image/idea
 2. written caption (if necessary)
 3. drawing

How'd you get started?

Sketchin' for nickles on the old Bert Levy Circuit

I've got a great idea for a cartoon—wanna hear it?

How did you get into my basement?

Infrequently Asked Questions

Have you mooned or *been* mooned more often in your life?
I guess "been mooned." ...No, wait...
Hold on a sec... Okay, make that "mooned."

What would make a terrible pizza topping?
Mike Wallace

What might one expect to find at a really low-budget amusement park?
The "Tilt-o-Merle"

What did the shepherd say to the three-legged sheepdog?
Something hilarious in Pashto.

Complete the pie chart below in a way that tells us something about your life or how you think.

In the box below, draw something you couldn't live without.

and

What do you hate drawing?

WORDS and LETTERING

Being as accurate as possible, how many desert island cartoons do you think you've come up with and submitted to *The New Yorker*?

5

What's the funniest thing that you witnessed, overheard, or came up with that you couldn't figure out how to use in a cartoon?

That time I was stranded on a desert island.

If you could ask Bob Mankoff, *The New Yorker* cartoon editor, one question, what would it be?

I can and I don't.

Draw some sort of doodle using the random lines below as a starting point.

Answer the following questions with a number from 1 to 10 (1 being not very much at all and 10 being quite a bit):

How much do you enjoy bowling? 6

How close have you ever come to getting a tattoo? 2

How often do you whistle or hum? 6

How much do you resemble Bea Arthur? 10

How likely is it that you will water-ski in the coming year? 1

How often do you curse? 10

With what frequency do you imbibe smoothies? 4

How much do you dislike licorice? 3

What's your favorite number between one and ten? 3

How confident are you in your dancing ability? 5

How Jewish are you? ה

Please do not draw anything in the space below. Seriously, I mean it this time.

I'm a violation of copyright law!

Naming Names

What name might you give to a mild-mannered, slightly overweight dental assistant in one of your cartoons?

Jenkins

Other than Lance, what name would you give to a twenty-eight-year-old metrosexual entertainment lawyer who cycles on weekends?

Pierce

What would be a good name for a new, commercially unviable breakfast cereal?

Swollen Bub-O's

Come up with a name for an unpleasant medical procedure.

Swollen-Bubo-Lance-Pierce

If you used a pen name, what would it be?

Jenkins

Circle your preference.

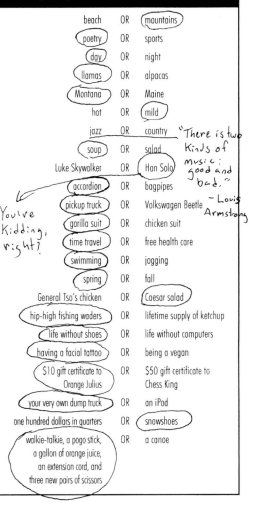

beach	OR	(mountains)
(poetry)	OR	sports
(day)	OR	night
(llamas)	OR	alpacas
(Montana)	OR	Maine
hot	OR	(mild)
jazz	OR	country
(soup)	OR	salad
Luke Skywalker	OR	(Han Solo)
(accordion)	OR	bagpipes
(pickup truck)	OR	Volkswagen Beetle
(gorilla suit)	OR	chicken suit
(time travel)	OR	free health care
(swimming)	OR	jogging
(spring)	OR	fall
General Tso's chicken	OR	(Caesar salad)
(hip-high fishing waders)	OR	lifetime supply of ketchup
(life without shoes)	OR	life without computers
(having a facial tattoo)	OR	being a vegan
($10 gift certificate to Orange Julius)	OR	$50 gift certificate to Chess King
(your very own dump truck)	OR	an iPod
one hundred dollars in quarters	OR	(snowshoes)
(walkie-talkie, a pogo stick, a gallon of orange juice, an extension cord, and three new pairs of scissors)	OR	a canoe

"There is two kinds of music: good and bad."
— Louis Armstrong

You've kidding, right?

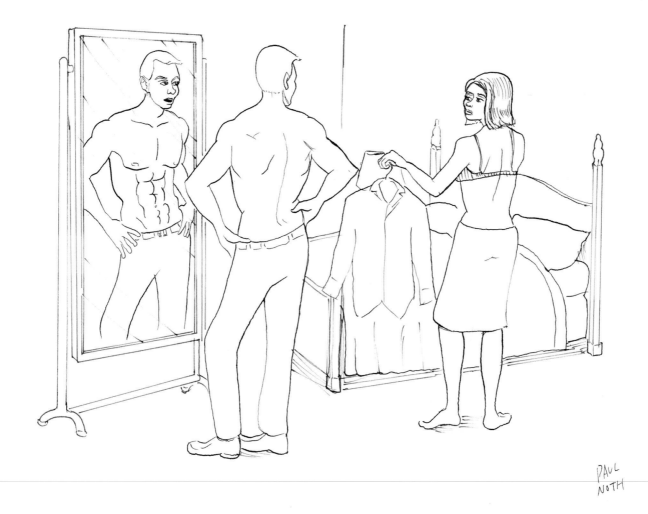

"Do these abs make me look gay?"

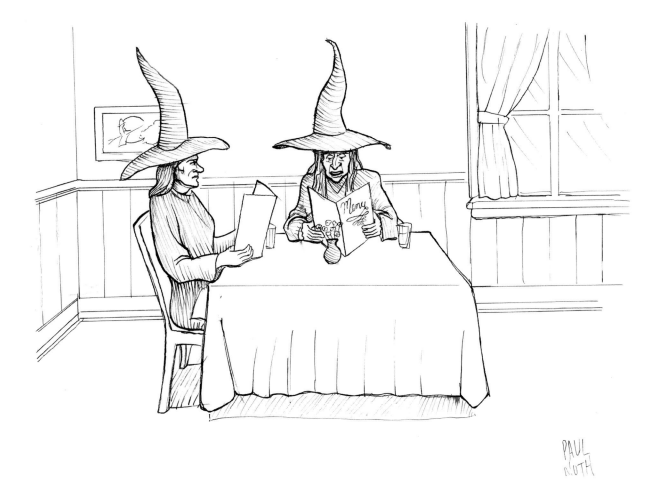

"I'm thinking about having a child."

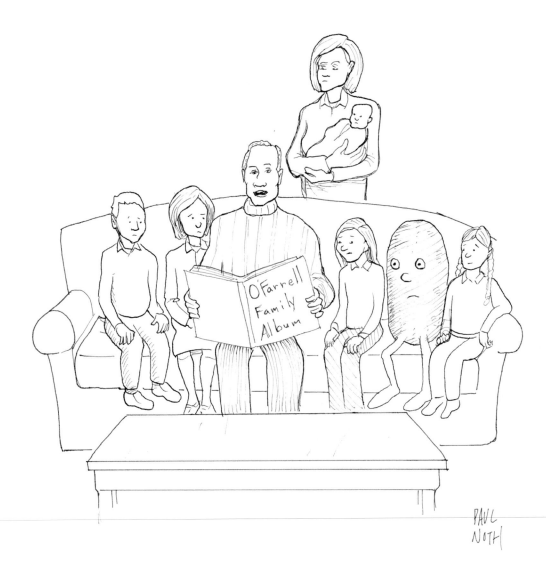

"So, kids, you should all be thankful we don't live during a potato famine. Especially you, Jimmy."

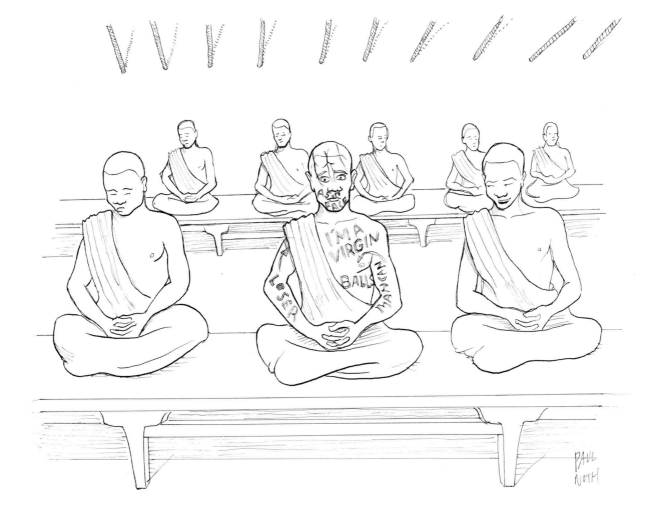

"Dude, you totally passed out."

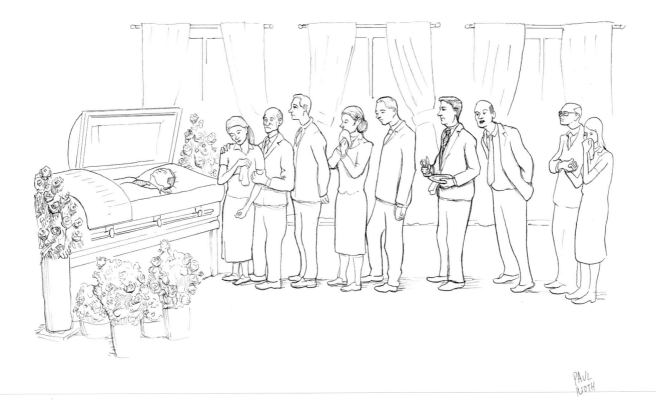

"Wrong line, buddy."

Fill-in-the-Blank Bio

I was born , YES THIS IS TRUE.
ONCE I SAW A jellyfish, BUT NOT WHEN I WAS in high school .
Not long after that, I STARTED WORRYING ABOUT JELLYFISH, AND OTHER THINGS, TOO
Eventually, however, despite my best efforts, GLOBAL WARMING BEGAN GETTING WORSE and then BUSH GOT RE-ELECTED . Perhaps not surprisingly, I FOUND THIS DEPRESSING. The END of THE WORLD is POSSIBLY RIGHT AROUND THE CORNER - OR MAYBE IT'S NOT . And so, I suppose without A TIME MACHINE, HOW AM I SUPPOSED TO KNOW?!?!? UH-OH, THAT'S my PHONE
In closing, I'd just like to say SOMETHING POSITIVE, BUT I CAN'T THINK OF ANYTHING.

Frequently Asked Questions

Where do you get your ideas?
NO.

Which comes first, the picture or the caption?
YES.

How'd you get started?
SOMETIMES.

I've got a great idea for a cartoon—wanna hear it?
RARELY.

Infrequently Asked Questions

Have you mooned or *been* mooned more often in your life?
NEITHER.

What would make a terrible pizza topping?
STYE OINTMENT.

What might one expect to find at a really low-budget amusement park?
MY FAMILY.

What did the shepherd say to the three-legged sheepdog?
HOW DID YOU LOSE YOUR LEG?

Complete the pie chart below in a way that tells us something about your life or how you think.

In the box below, draw something you couldn't live without.

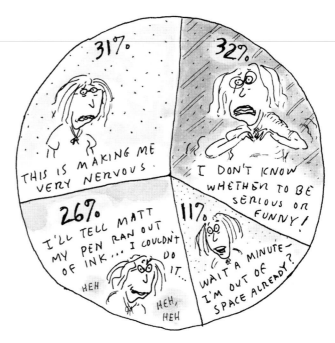

What do you hate drawing? FORESTS

Being as accurate as possible, how many desert island cartoons do you think you've come up with and submitted to *The New Yorker*? FOUR

What's the funniest thing that you witnessed, overheard, or came up with that you couldn't figure out how to use in a cartoon?

MY HUSBAND TOLD A HIGHWAY TOLLBOOTH CLERK THAT SOON, HER JOB WOULD BE DONE BY A ROBOT.

If you could ask Bob Mankoff, *The New Yorker* cartoon editor, one question, what would it be?

I JUST FOUND THIS NOTE ON MY DESK THAT SAYS, "CALL FRED! IMPORTANT! 2 P.M.!!" DO YOU KNOW WHO THIS FRED IS?

Draw some sort of doodle using the random lines below as a starting point.

Answer the following questions with a number from 1 to 10 (1 being not very much at all and 10 being quite a bit):

How much do you enjoy bowling? 2

How close have you ever come to getting a tattoo? 10

How often do you whistle or hum? never

How much do you resemble Bea Arthur? 1.2

How likely is it that you will water-ski in the coming year? 1

How often do you curse? 9.99999

With what frequency do you imbibe smoothies? hate them, they're fucking nauseating

How much do you dislike licorice? 0

What's your favorite number between one and ten? all of them

How confident are you in your dancing ability? 0

How Jewish are you? sometimes more than others

Please do not draw anything in the space below. Seriously, I mean it this time.

Naming Names

What name might you give to a mild-mannered, slightly overweight dental assistant in one of your cartoons? TRIXI

Other than Lance, what name would you give to a twenty-eight-year-old metrosexual entertainment lawyer who cycles on weekends? MANCE

What would be a good name for a new, commercially unviable breakfast cereal? KIDNEY CHEX

Come up with a name for an unpleasant medical procedure. EYEBALL 'SPLODOFICATION

If you used a pen name, what would it be? PENNY McPEN

Circle your preference.

beach	OR	mountains
poetry	OR	sports NEITHER
day	OR	night
llamas	OR	alpacas NEITHER
Montana	OR	Maine UGH
hot	OR	mild
jazz	OR	country HATE BOTH
soup	OR	salad
Luke Skywalker	OR	Han Solo NO WAY
accordion	OR	bagpipes SICK
pickup truck	OR	Volkswagen Beetle HATE CARS
gorilla suit	OR	chicken suit
time travel	OR	free health care
swimming	OR	jogging NO
spring	OR	fall EITHER
General Tso's chicken	OR	Caesar salad
hip-high fishing waders	OR	lifetime supply of ketchup
life without shoes	OR	life without computers
having a facial tattoo	OR	being a vegan
$10 gift certificate to Orange Julius	OR	$50 gift certificate to Chess King
your very own dump truck	OR	an iPod
one hundred dollars in quarters	OR	snowshoes
walkie-talkie, a pogo stick, a gallon of orange juice, an extension cord, and three new pairs of scissors	OR	a canoe

THE HORN OF BY-PRODUCTS

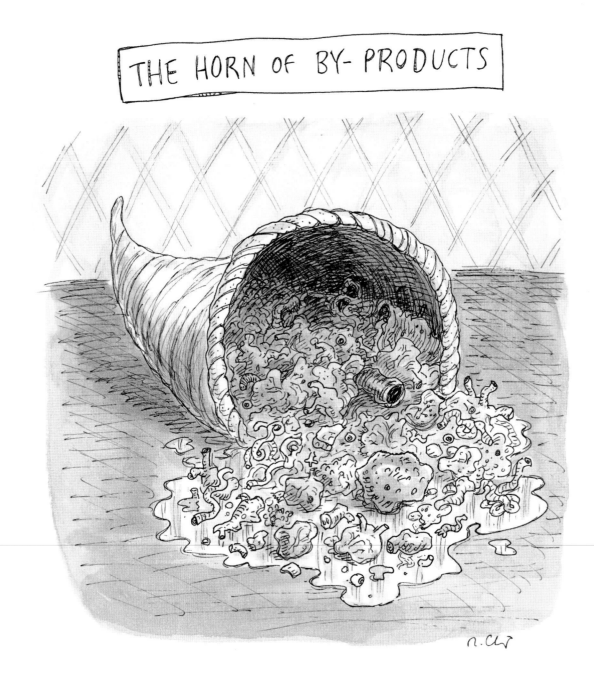

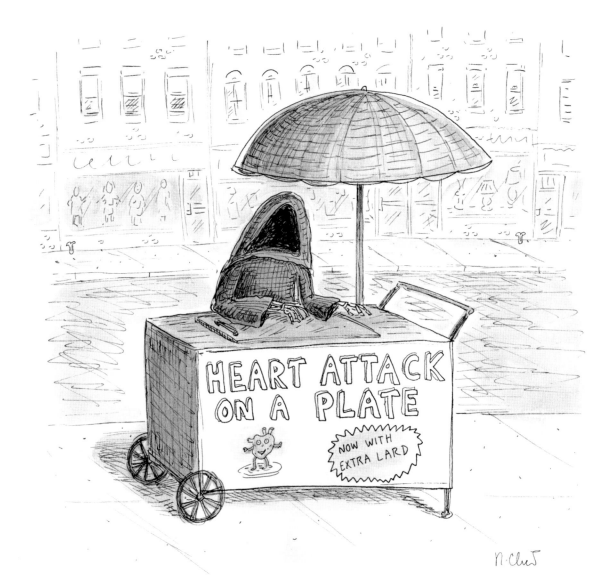

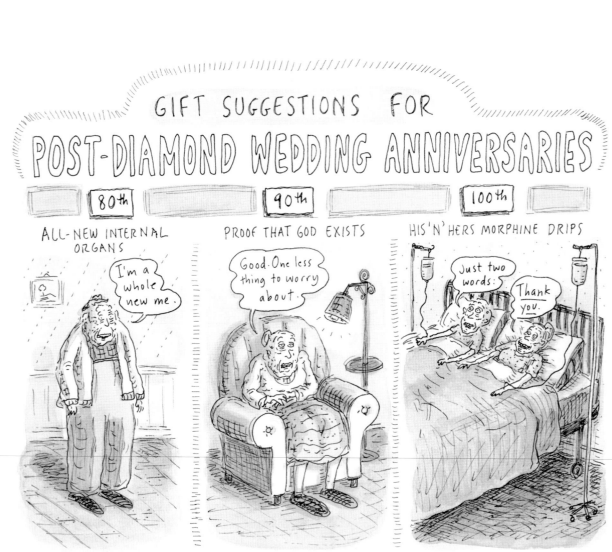

J.C. Duffy

Fill-in-the-Blank Bio

I was born IN A SHOTGUN SHACK IN THE MISSISSIPPI DELTA, THE SEVENTH SON OF AN ITINERANT, HARD-LUCK BLUESMAN, "BLIND jellyfish" DUFFY. ASSUMING I CARRIED THE JELLYFISH GENE, in high school I JOINED THE SWIM TEAM, AND I EXCELLED Not long after that, I MET THE GIRL OF MY DREAMS, OR CLOSE ENOUGH, AND THE NEXT THING I KNEW I WAS A HAPPILY MARRIED HIGH SCHOOL GRADUATE. SWEET! Eventually, however, despite my best efforts, THE MARRIAGE DISINTEGRATED, AND I SPILLED RED WINE ON MY DIPLOMA. NOW and then I THINK OF MARY LOU. HEY, IT BEATS THINKING OF MY EX-WIFE REXELLA, THAT HARLOT. Perhaps not surprisingly, I BEGAN MY BLUES CAREER AFTER PAPA DIED WHILE HOPPING A FREIGHT TRAIN. The LONESOME SOUND of A TRAIN WHISTLE is MY NIGHTLY LULLABY AS I CRISSCROSS THE COUNTRY, FROM JUKE JOINT TO JUKE JOINT, AND GAL TO GAL. And so, I suppose without PAPA'S GUITAR, THE ONLY THING HE LEFT ME, I'D BE A SWIMMING COACH. WHO NEEDS THAT? I GUESS THE ACORN FALLS CLOSE TO THE TREE, my FRIEND. (I'M THE ACORN.) In closing, I'd just like to say THANKS TO THE LITTLE PEOPLE WHO KEEP MY MOJO WORKING.

Frequently Asked Questions

Where do you get your ideas?

THE IDEA PLACE.

Which comes first, the picture or the caption?

USUALLY, THE CAPTION, SOMETIMES THE PICTURE.

How'd you get started?

HEY, WHEN IT COMES TO HOW I GOT STARTED, DON'T GET ME STARTED!

I've got a great idea for a cartoon—wanna hear it?

I USED TO SAY NO, NOW I SAY YES, BUT THE IDEAS USUALLY SUCK.

Infrequently Asked Questions

Have you mooned or *been* mooned more often in your life?

IT'S A TIE: MOONER, NEVER. MOONEE, NEVER.

What would make a terrible pizza topping?

A HUMAN HEAD.

What might one expect to find at a really low-budget amusement park?

50% POLYESTER COTTON CANDY.

What did the shepherd say to the three-legged sheepdog?

"COME HERE OFTEN?"

In the box below, draw something you couldn't live without.

MY IRON LUNG...

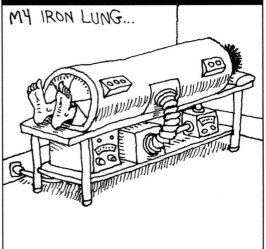

Complete the pie chart below in a way that tells us something about your life or how you think.

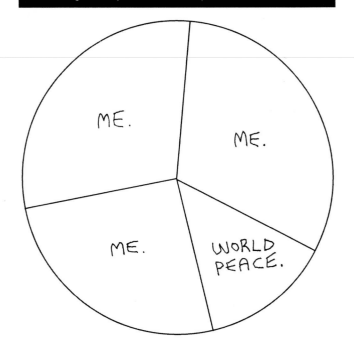

And now for a few more questions . . .

What do you hate drawing?

CROWDS, BICYCLES, IRON LUNG MACHINES.

Being as accurate as possible, how many desert island cartoons do you think you've come up with and submitted to *The New Yorker*?

MAYBE THIRTY OR SO.

What's the funniest thing that you witnessed, overheard, or came up with that you couldn't figure out how to use in a cartoon?

WHATEVER IT IS, I'M SAVING IT FOR USE IN A NON-CARTOON.

If you could ask Bob Mankoff, *The New Yorker* cartoon editor, one question, what would it be?

"WAS IT SOMETHING I SAID?"

Draw some sort of doodle using the random lines below as a starting point.

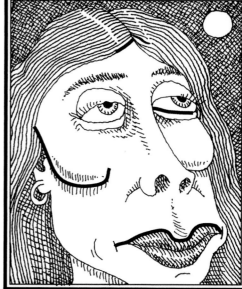

Answer the following questions with a number from 1 to 10 (1 being not very much at all and 10 being quite a bit):

How much do you enjoy bowling? __1__

How close have you ever come to getting a tattoo? __1__

How often do you whistle or hum? __9__

How much do you resemble Bea Arthur? __3__

How likely is it that you will water-ski in the coming year? __1__

How often do you curse? __3__

With what frequency do you imbibe smoothies? __1__

How much do you dislike licorice? __8__

What's your favorite number between one and ten? __4__

How confident are you in your dancing ability? __2__

How Jewish are you? __1__

Please do not draw anything in the space below. Seriously, I mean it this time.

WHAT ABOUT PRINTING?

Circle your preference.

beach	OR	(mountains)
(poetry)	OR	sports
day	OR	(night)
(llamas)	OR	alpacas
Montana	OR	(Maine)
hot	OR	(mild)
(jazz)	OR	country
(soup)	OR	salad
Luke Skywalker	OR	(Han Solo)
(accordion)	OR	bagpipes
pickup truck	OR	(Volkswagen Beetle)
(gorilla suit)	OR	chicken suit
(time travel)	OR	free health care
(swimming)	OR	jogging
spring	OR	(fall)
General Tso's chicken	OR	(Caesar salad)
hip-high fishing waders	OR	(lifetime supply of ketchup)
(life without shoes)	OR	life without computers
having a facial tattoo	OR	(being a vegan)
$10 gift certificate to Orange Julius	OR	($50 gift certificate to Chess King)
your very own dump truck	OR	(an iPod)
(one hundred dollars in quarters)	OR	snowshoes
(walkie-talkie, a pogo stick, a gallon of orange juice, an extension cord, and three new pairs of scissors)	OR	a canoe

Naming Names

What name might you give to a mild-mannered, slightly overweight dental assistant in one of your cartoons?

PRUNELLA.

Other than Lance, what name would you give to a twenty-eight-year-old metrosexual entertainment lawyer who cycles on weekends?

VANCE.

What would be a good name for a new, commercially unviable breakfast cereal?

MOUSE CLUSTERS.

Come up with a name for an unpleasant medical procedure.

SURGERY.

If you used a pen name, what would it be?

CHAD MANWARING.

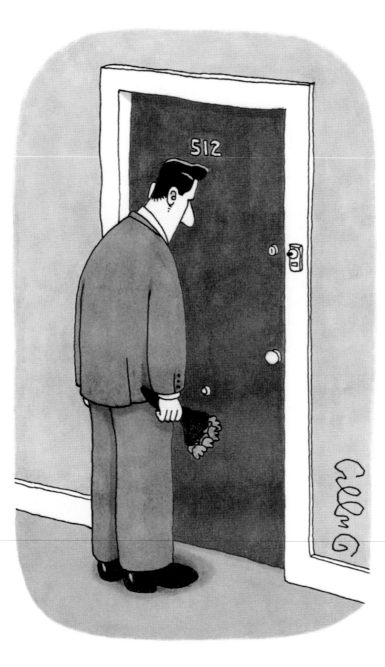

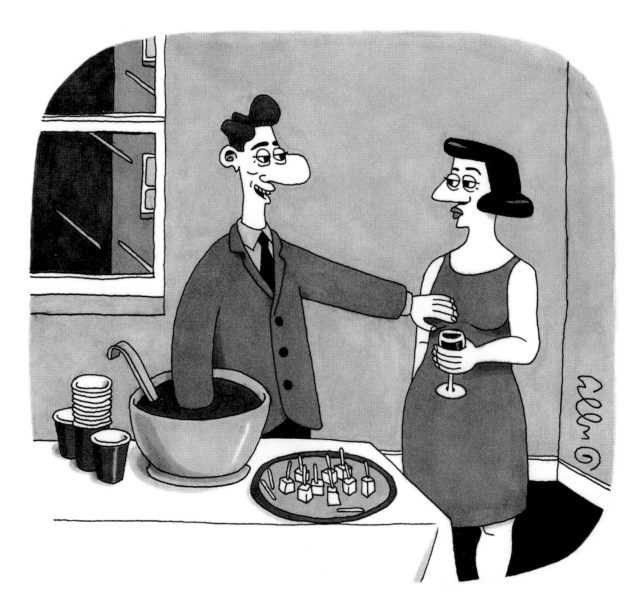

"I never know what to do with my hands at a party."

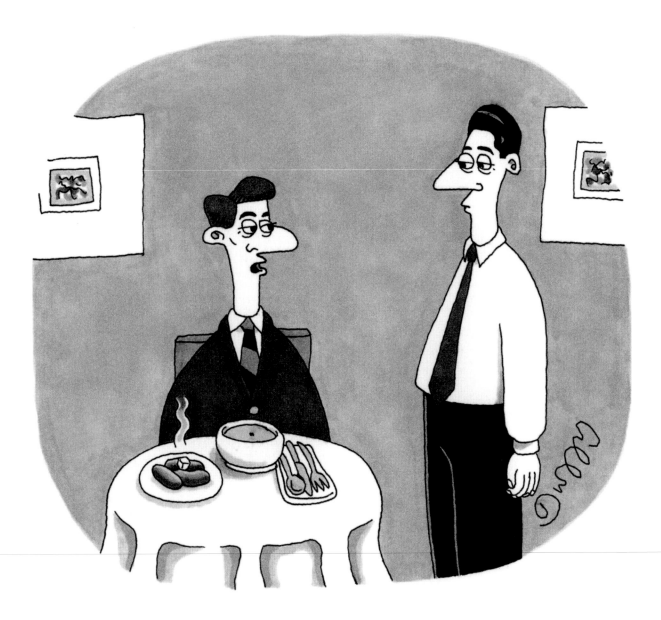

"Waiter, there's a fly in my soup, and ironically, there's also a crouton in my shit."

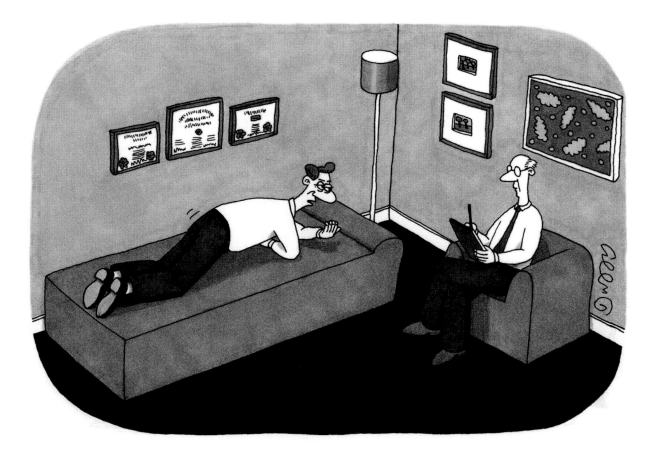

"Could I do this with an imaginary friend?"

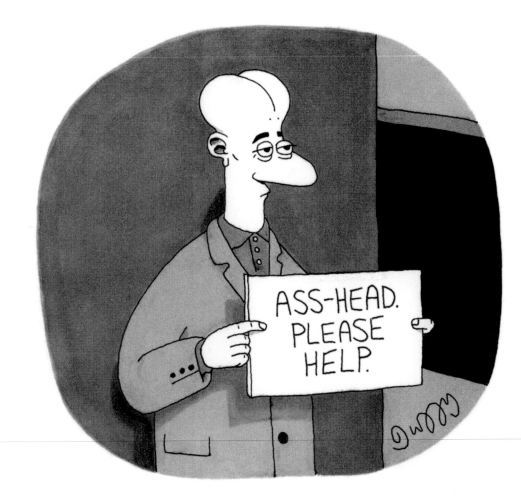

Fill-in-the-Blank Bio

I was born *in Minneapolis, Minnesota where I lived until age 8 when I moved somewhere w/ slightly better access to jellyfish, Ithaca, New York. I found my love for visual arts* in high school *in a classroom filled with musty still life props.* Not long after that, *I started art school where I was transformed into an A student on the honnor roll and the Dean's list.* Eventually, however, despite my best efforts, *to sign with the Minnesota Twins I graduated with a degree in painting* and then *moved to Sarasota, Florida, to apprentice with a master painter of Dutch still lives.* Perhaps not surprisingly, *I was the only recent college graduate in the area.* The *residents* of *Sarasota are primarily graduates of later life stages, so after a while I followed my dream and moved to N.Y.C.* And so, I suppose without *jellyfish I would have never become a cartoonist* ? *It's an incredible joy to spend ~~ones~~* my *life drawing pictures.* In closing, I'd just like to say *I fully support habeas corpus rights for everyone.*

Frequently Asked Questions

Where do you get your ideas?
50% Dead Cartoonists
50% Thin Air

Which comes first, the picture or the caption?
The picture usually comes first, and then I attach the caption with glue and a large mallet.

How'd you get started?
Coffee.

I've got a great idea for a cartoon—wanna hear it?
Absolutely, just sigh right here.

Infrequently Asked Questions

Have you mooned or *been* mooned more often in your life?
Been mooned, I guess.

What would make a terrible pizza topping?
Liquid helium.

What might one expect to find at a really low-budget amusement park?
Tetanus.

What did the shepherd say to the three-legged sheepdog?
"Let us know what happens on General Hospital."

Complete the pie chart below in a way that tells us something about your life or how you think.

In the box below, draw something you couldn't live without.

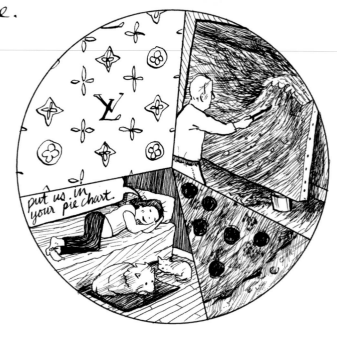

put us in your pie chart.

And now for a few more questions . . .

What do you hate drawing?

That Calvin peeing from Calvin's Hobbes.

Being as accurate as possible, how many desert island cartoons do you think you've come up with and submitted to *The New Yorker*?

Around 20—25

What's the funniest thing that you witnessed, overheard, or came up with that you couldn't figure out how to use in a cartoon?

If you could ask Bob Mankoff, *The New Yorker* cartoon editor, one question, what would it be?

"Is never good for you?"

Answer the following questions with a number from 1 to 10 (1 being not very much at all and 10 being quite a bit):

How much do you enjoy bowling? **7**

How close have you ever come to getting a tattoo? **4**

How often do you whistle or hum? **10**

How much do you resemble Bea Arthur? **5**

How likely is it that you will water-ski in the coming year? **3**

How often do you curse? **2**

With what frequency do you imbibe smoothies? **1**

How much do you dislike licorice? **1**

What's your favorite number between one and ten? **6**

How confident are you in your dancing ability? **8**

How Jewish are you? **2**

Naming Names

What name might you give to a mild-mannered, slightly overweight dental assistant in one of your cartoons?

Hopkins.

Other than Lance, what name would you give to a twenty-eight-year-old metrosexual entertainment lawyer who cycles on weekends?

Hillary Clinton

What would be a good name for a new, commercially unviable breakfast cereal?

Coco-Meth

Come up with a name for an unpleasant medical procedure.

Buttectomy

If you used a pen name, what would it be?

George Booth

Please do not draw anything in the space below. Seriously, I mean it this time.

Draw some sort of doodle using the random lines below as a starting point.

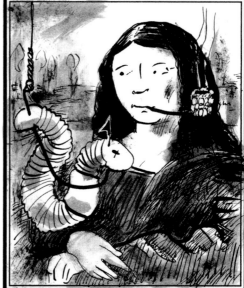

Circle your preference.

(beach)	OR	mountains
poetry	OR	(sports)
(day)	OR	night
llamas	OR	(alpacas)
Montana	OR	(Maine)
(hot)	OR	mild
jazz	OR	(country)
soup	OR	(salad)
Luke Skywalker	OR	(Han Solo)
(accordion)	OR	bagpipes
pickup truck	OR	(Volkswagen Beetle)
(gorilla suit)	OR	chicken suit
(time travel)	OR	free health care
(swimming)	OR	jogging
spring	OR	(fall)
(General Tso's chicken)	OR	Caesar salad
(hip-high fishing waders)	OR	lifetime supply of ketchup
(life without shoes)	OR	life without computers
having a facial tattoo	OR	(being a vegan)
($10 gift certificate to Orange Julius)	OR	$50 gift certificate to Chess King
(your very own dump truck)	OR	an iPod
one hundred dollars in quarters	OR	(snowshoes)
walkie-talkie, a pogo stick, a gallon of orange juice, an extension cord, and three new pairs of scissors	OR	(a canoe)

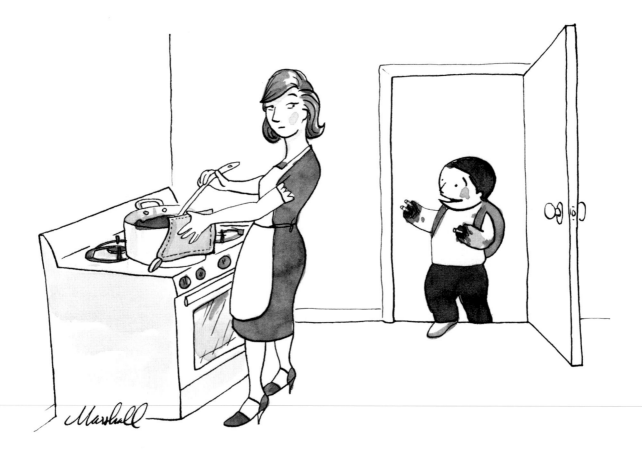

"Look, Ma."

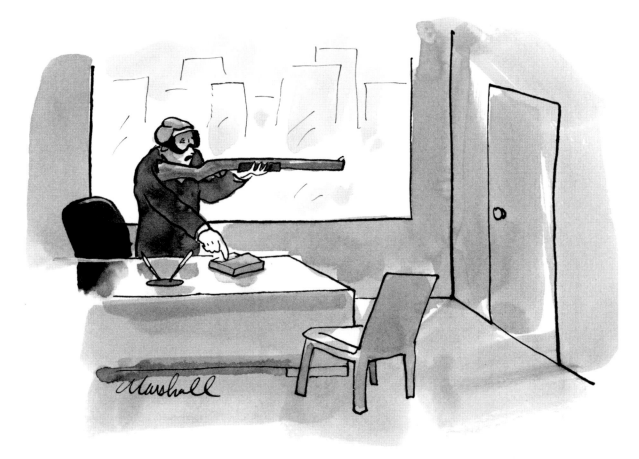

"Pull."

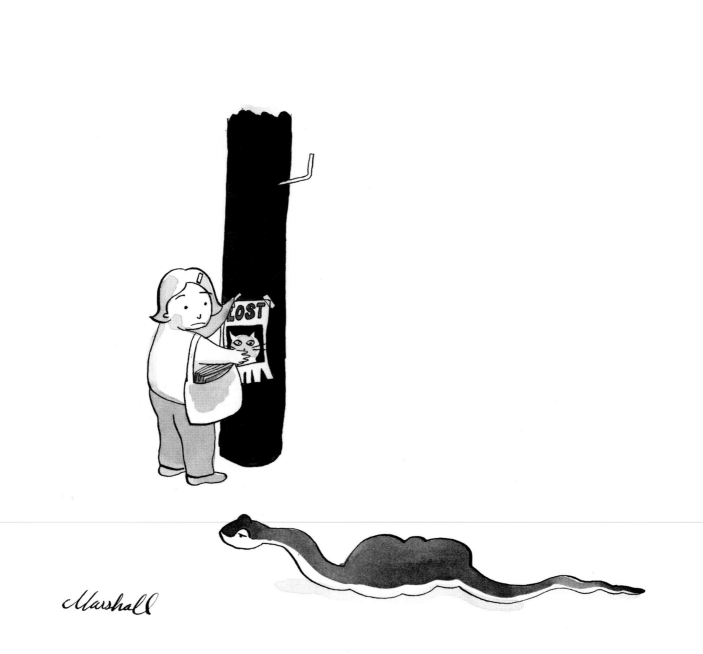

I was born __A BABY__
___PINK AND SOFT LIKE A___ jellyfish __BUT THEN I GREW__
___AND___ in high school __I CONTINUED TO GROW__.
Not long after that, __I NEEDED NEW PANTS__

Eventually, however, despite my best efforts, __I STOPPED GROWING AND FILLED OUT__
_____ and then __I NEEDED NEW PANTS AGAIN__
_____. Perhaps not surprisingly, __I ALSO__
__NEEDED NEW SHOES__. The __IRONY__ of
__IT__ is __THOSE OLD PANTS THAT I THREW AWAY ARE__
__NOW BACK IN STYLE, BUT THEY WOULDN'T FIT__. And so, I suppose without __GROWTH__
__MIGHT WE NEVER CHANGE OUR PANTS__?
__DON'T GET ME STARTED ON__ my __SOCKS__.
In closing, I'd just like to say __THE BEATLES WROTE MORE BAD SONGS THAN THE STONES AND__
__FEWER GREAT ONES. ADMIT IT ALREADY.__

Frequently Asked Questions

Where do you get your ideas?

 TARGET

Which comes first, the picture or the caption?

 THEY ARRIVE TOGETHER
 ARM IN ARM.

How'd you get started? DAD MET MOM
AT SOME DANCE HALL IN
NEW YORK.

I've got a great idea for a cartoon—wanna hear it?

 JUST DRAW IT AND SIGN
 MY NAME. I TRUST YOU.

In the box below, draw something you couldn't live without.

Infrequently Asked Questions

Have you mooned or *been* mooned more often in your life?
 THERE'S BEEN SO MUCH MOONING IN MY
 LIFE IT'S IMPOSSIBLE TO CALCULATE.

What would make a terrible pizza topping?
 GELATIN BEADS FILLED WITH CHILDREN'S TEARS

What might one expect to find at a really low-budget amusement park?
 I WOULDN'T KNOW. THE AMUSEMENT PARKS
 I ATTEND ARE SUPER-CLASSY

What did the shepherd say to the three-legged sheepdog?
 "COME ON, WE'RE BOTH LONELY
 AND SICK OF SHEEP."

Complete the pie chart below in a way that tells us something about your life or how you think.

And now for a few more questions . . .

What do you hate drawing? CARS, FURNITURE, SHOES, AND WINDOWS — GOD, I HATE DRAWING WINDOWS. NO IDEA WHY.

Being as accurate as possible, how many desert island cartoons do you think you've come up with and submitted to *The New Yorker*?

NO IDEA. 10?

What's the funniest thing that you witnessed, overheard, or came up with that you couldn't figure out how to use in a cartoon?

THE OVERABUNDANCE OF FENNEL IN RESTAURANTS

If you could ask Bob Mankoff, *The New Yorker* cartoon editor, one question, what would it be?

"WHY 'BOB' AND NOT 'ROB'?"

Draw some sort of doodle using the random lines below as a starting point.

Answer the following questions with a number from 1 to 10 (1 being not very much at all and 10 being quite a bit):

How much do you enjoy bowling? _8_

How close have you ever come to getting a tattoo? _0_

How often do you whistle or hum? _1_

How much do you resemble Bea Arthur? _5_

How likely is it that you will water-ski in the coming year? _0_

How often do you curse? _12_

With what frequency do you imbibe smoothies? _1_

How much do you dislike licorice? _5_

What's your favorite number between one and ten? _I LOVE THEM ALL EQUALLY_

How confident are you in your dancing ability? _— 6_

How Jewish are you? FOR A NON-JEW, 10

Please do not draw anything in the space below. Seriously, I mean it this time.

SHOULD I NOT WRITE ANYTHING EITHER?

Circle your preference.

beach	OR	(mountains)
poetry	OR	(sports)
day	OR	(night)
llamas	OR	(alpacas)
(Montana)	OR	Maine
hot	OR	(mild)
jazz	OR	(country)
soup	OR	(salad)
Luke Skywalker	OR	(Han Solo)
accordion	OR	(bagpipes)
(pickup truck)	OR	Volkswagen Beetle
(gorilla suit)	OR	chicken suit
time travel	OR	(free health care)
swimming	OR	(jogging)
(spring)	OR	fall
General Tso's chicken	OR	(Caesar salad)
hip-high fishing waders	OR	(lifetime supply of ketchup)
(life without shoes)	OR	life without computers
(having a facial tattoo)	OR	being a vegan
($10 gift certificate to Orange Julius)	OR	$50 gift certificate to Chess King
your very own dump truck	OR	(an iPod)
(one hundred dollars in quarters)	OR	snowshoes
walkie-talkie, a pogo stick, a gallon of orange juice, an extension cord, and three new pairs of scissors	OR	(a canoe)

Naming Names

What name might you give to a mild-mannered, slightly overweight dental assistant in one of your cartoons?

'MATT DIFFEE'

Other than Lance, what name would you give to a twenty-eight-year-old metrosexual entertainment lawyer who cycles on weekends?

'MATT DIFFEE'

What would be a good name for a new, commercially unviable breakfast cereal?

'CURRY-O'S'

Come up with a name for an unpleasant medical procedure.

I DEFY YOU TO NAME A PLEASANT MEDICAL PROCEDURE.

If you used a pen name, what would it be? FOR ALL OF MY CRIMINAL ACTIVITY, I USE THE ALIAS 'MATT DIFFEE.'

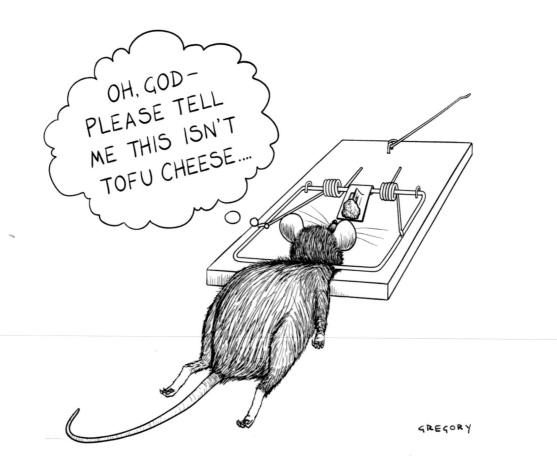

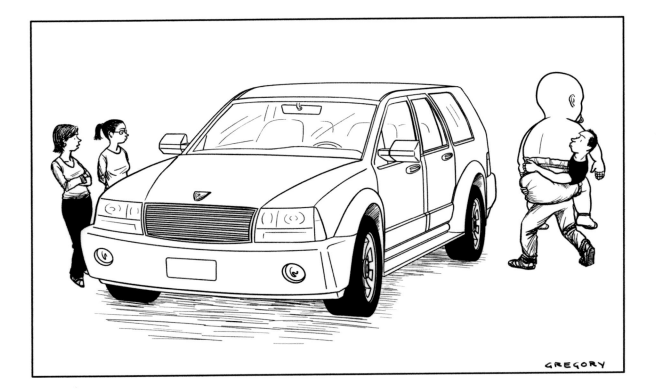

"We were dead set against getting an SUV until we had the baby."

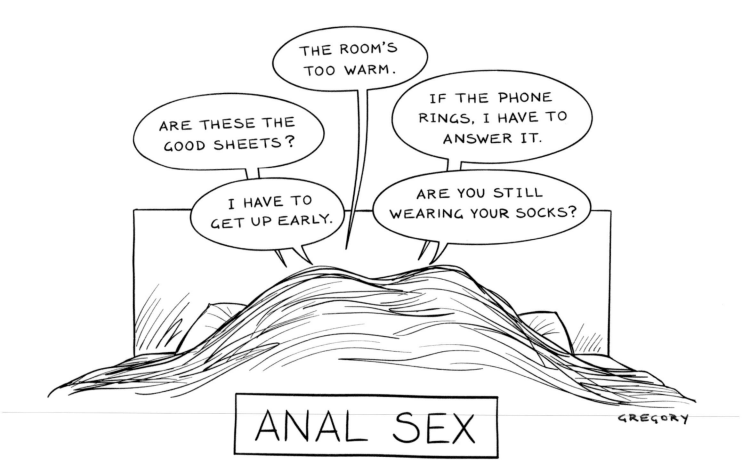

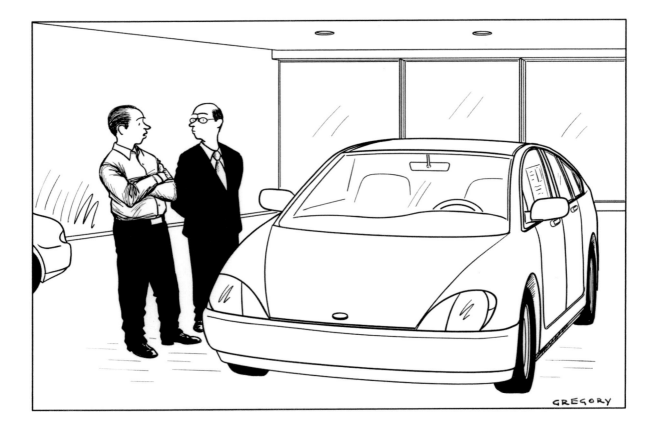

"Will the high mileage and low emissions make my penis seem bigger?"

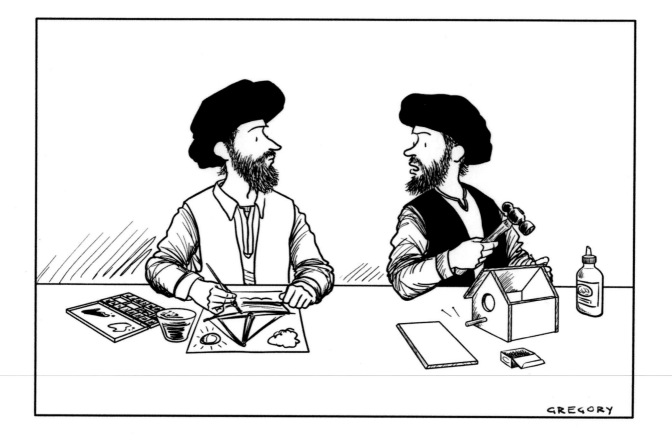

"What kind of jihadi camp makes you do arts and crafts?"

Nick Downes

I was born UNDER A BAD SIGN: THE jellyfish. I WAS ON THE DEBATING TEAM in high school UNTIL SIDELINED FROM A LOW BLOW. Not long after that, I APPLIED MY SKILL IN POLEMICS TO TALKING MY WAY OUT OF SPEEDING TICKETS. Eventually, however, despite my best efforts, I GOT BUSTED. and then JAILED. . Perhaps not surprisingly, I HAD PLENTY OF TIME TO HONE A NEW FORTE. The ART of CARTOONING is LESS DANGEROUS THAN RUNNING MY MOUTH (EXCEPT IN HOLLAND). And so, I suppose without TIME IN STIR, I WOULDN'T HAVE HAPPENED UPON my VOCATION. In closing, I'd just like to say ARS EST CELARE ARTUM

Frequently Asked Questions

Where do you get your ideas? OUT OF EXTREMELY THIN, ANOR-EXIC, REALLY, AIR.

Which comes first, the picture or the caption? THE CAPTION — ABSOLUTELY NO STAYING POWER.

How'd you get started? AS A TWINKLE IN MY DAD'S RATHER MYOPIC EYE, I GUESS.

I've got a great idea for a cartoon—wanna hear it? SAVE IT FOR WHEN I'M A DESPERATE, DRIED-UP HACK. OKAY, LET'S HEAR IT.

Infrequently Asked Questions

Have you mooned or *been* mooned more often in your life? I WAS SLIGHTLY MOONED. ONCE. SORT OF A CRESCENT MOONING.

What would make a terrible pizza topping? BLOOD, SWEAT AND TEARS.

What might one expect to find at a really low-budget amusement park? PITCH 'N' PUTT 'N' PASS OUT.

What did the shepherd say to the three-legged sheepdog? WE'LL ALWAYS HAVE PARIS WHAT'SERNAME.

Complete the pie chart below in a way that tells us something about your life or how you think.

In the box below, draw something you couldn't live without.

ZZZZZZ

What do you hate drawing?

SOMETIMES, YES.

Being as accurate as possible, how many desert island cartoons do you think you've come up with and submitted to *The New Yorker*?

10 4TL

What's the funniest thing that you witnessed, overheard, or came up with that you couldn't figure out how to use in a cartoon? TAIL END OF A CONVERSATION AMONG GROUP OF MEN I WALKED BY IN BROOK-LYN, "... IT WAS A CLOSED CASKET-WHAT DOES THAT TELL ME?"

If you could ask Bob Mankoff, *The New Yorker* cartoon editor, one question, what would it be?

WHO WILL BE WEARING WHAT ON OSCAR NIGHT?

Draw some sort of doodle using the random lines below as a starting point.

Answer the following questions with a number from 1 to 10 (1 being not very much at all and 10 being quite a bit):

How much do you enjoy bowling? **3**

How close have you ever come to getting a tattoo? **10**

How often do you whistle or hum? **5**

How much do you resemble Bea Arthur? **11**

How likely is it that you will water-ski in the coming year? **1**

How often do you curse? **10**

With what frequency do you imbibe smoothies? **1**

How much do you dislike licorice? **5**

What's your favorite number between one and ten? **1**

How confident are you in your dancing ability? **4**

How Jewish are you? **7**

Please do not draw anything in the space below. Seriously, I mean it this time.

Naming Names

What name might you give to a mild-mannered, slightly overweight dental assistant in one of your cartoons? RENCE N. SPITT

Other than Lance, what name would you give to a twenty-eight-year-old metrosexual entertainment lawyer who cycles on weekends? SUE

What would be a good name for a new, commercially unviable breakfast cereal?

LUCKLESS CHARMS.

Come up with a name for an unpleasant medical procedure.

TAG TEAM NEUROSURGERY.

If you used a pen name, what would it be?

PHINEAS T. FARQUAR.

Circle your preference.

beach	OR	(mountains)
poetry	OR	(sports)
(day)	OR	night
llamas	OR	(alpacas)
Montana	OR	(Maine)
hot	OR	(mild)
(jazz)	OR	country
(soup)	OR	salad
Luke Skywalker	OR	(Han Solo)
accordion	OR	(bagpipes)
pickup truck	OR	(Volkswagen Beetle)
(gorilla suit)	OR	chicken suit
time travel	OR	(free health care)
swimming	OR	(jogging)
(spring)	OR	fall
(General Tso's chicken)	OR	Caesar salad
(hip-high fishing waders)	OR	lifetime supply of ketchup
(life without shoes)	OR	life without computers
having a facial tattoo	OR	(being a vegan)
($10 gift certificate to Orange Julius)	OR	$50 gift certificate to Chess King
(your very own dump truck)	OR	an iPod
one hundred dollars in quarters	OR	(snowshoes)
walkie-talkie, a pogo stick, a gallon of orange juice, an extension cord, and three new pairs of scissors	OR	(a canoe)

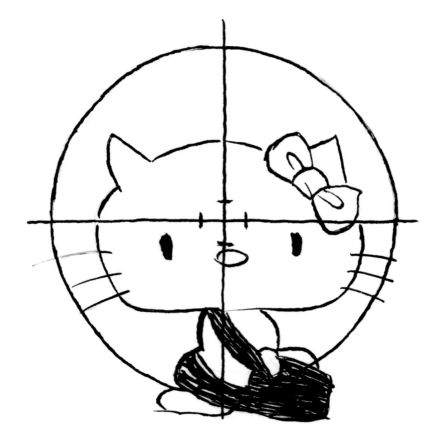

Good-bye Kitty

NDOWNES

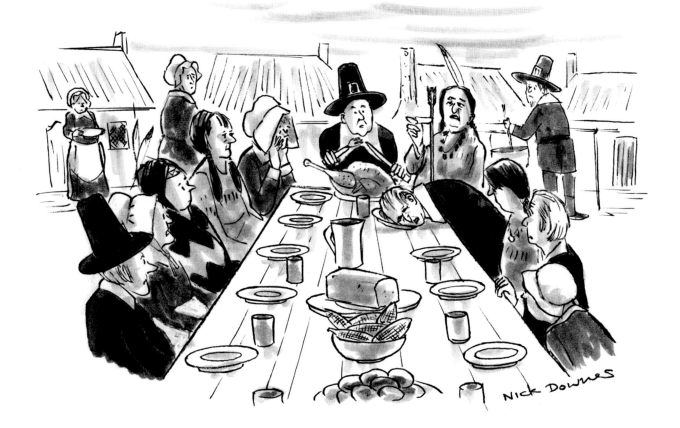

"Running Deer sends his regrets."

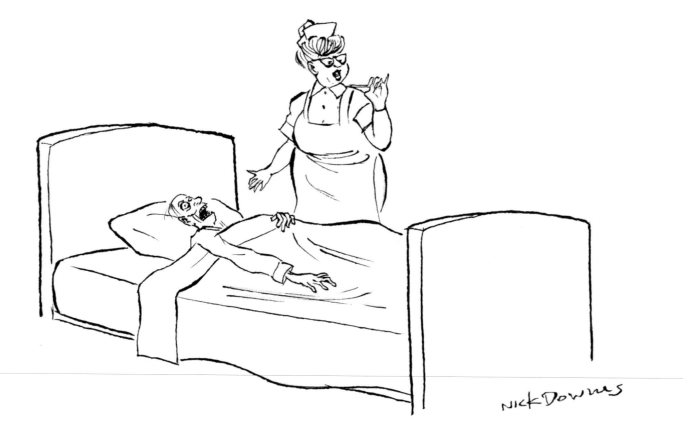

"Oh my, your fever's way down."

Ariel Molvig

Fill-in-the-Blank Bio

I was born THE SCION OF A WEALTHY MERCHANT MARINER IN THE EMPLOY OF THE NORWEIGAN EAST INDIES COMPANY. ORPHANED BY A jellyfish, I BECAME THE WARD OF A KINDLY PHARMACIST. A DULLARD in high school, I BEGAN HAWKING DR. INQVIST'S ASIATIC HEAD-TONIC. Not long after that, MOUNTING BACCARAT DEBTS AND A DEPENDENCE ON DR. INQVIST'S ASIATIC HEAD-TONIC SANK ME INTO A VICIOUS SPIRAL OF SELF-DESTRUCTION. A PERSONAL LOW. Eventually, however, despite my best efforts, REDEMPTION ARRIVED IN THE FORM OF DR. INQVIST'S METHADONE TWO-A-DAY and then LATER IN THE EMBRACE OF A CORRUPT BUT GOOD-HEARTED CROUPIER IN PORTUGUESE MACAO. Perhaps not surprisingly, WE SHARED A MUTUAL PASSION FOR SALT-COD AND OPIATES. WE MARRIED AT SEA. The SUREST WAY of FINDING YOUR BLISS is TO LOVE WHAT YOU DO. OUR SMALL CODDING OPERATION SOON GREW INTO A VAST OPIUM TRIAD. And so, I suppose without REALIZING IT, WERE WE RESPONSIBLE FOR THE DECIMATION OF BOTH THE QING DYNASTY AND NORTH ATLANC COD? PROBABLY, BUT I LIKE TO THINK IT'S WORTH IT IF my WORK MADE JUST ONE PERSON SMILE. In closing, I'd just like to say SORRY QING DYNASTY.

Frequently Asked Questions

Where do you get your ideas?
IT'S UNSIGHTLY, BUT THE DOCTORS THINK STEM CELLS MAY HELP.

Which comes first, the picture or the caption?
THE CAPTION GOES DOWN WITH THE

How'd you get started?
CLEVER LITTLE HANDS + SOCIAL PARIAH / CARTOONIST

I've got a great idea for a cartoon—wanna hear it?
NO. STOP SHOWING OFF.

Infrequently Asked Questions

Have you mooned or *been* mooned more often in your life?
I'VE PRACTICED ALOT IN THE MIRROR, BUT I FIGURE THAT'S A WASH.

What would make a terrible pizza topping?
ANOTHER BUSH PRESIDENCY.

What might one expect to find at a really low-budget amusement park?
" F TRAIN: THE RIDE "

What did the shepherd say to the three-legged sheepdog?
THANKS FOR DINNER. THAT WAS DELISH.

PIE CHART

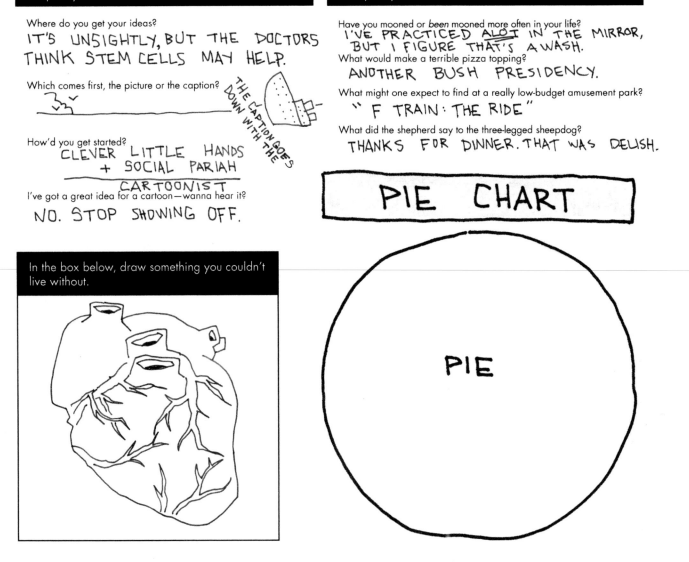

PIE

In the box below, draw something you couldn't live without.

And now for a few more questions . . .

What do you hate drawing?

SPEAKING AS A CARTOONIST - HORSES.
SPEAKING AS A HORSE - CARRIAGES.

Being as accurate as possible, how many desert island cartoons do you think you've come up with and submitted to *The New Yorker*?

2 lbs. 7.5 oz.

What's the funniest thing that you witnessed, overheard, or came up with that you couldn't figure out how to use in a cartoon?

THAT'S A HARD ONE, HUMOR IS SO SUBTLE AND SUBJECTIVE... PROBABLY KING KONG COATING MANHATTAN WITH HUGE MONKEY FECES.

If you could ask Bob Mankoff, *The New Yorker* cartoon editor, one question, what would it be?

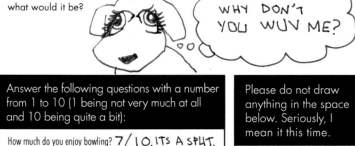

WHY DON'T YOU WUV ME?

Answer the following questions with a number from 1 to 10 (1 being not very much at all and 10 being quite a bit):

How much do you enjoy bowling? 7/10. ITS A SPLIT.

How close have you ever come to getting a tattoo? 3 inches

How often do you whistle or hum? ♪

How much do you resemble Bea Arthur? 10

How likely is it that you will water-ski in the coming year? 1 likely

How often do you curse? #@&*!

With what frequency do you imbibe smoothies? 7

How much do you dislike licorice? 3

What's your favorite number between one and ten? 7 8 9

How confident are you in your dancing ability? 10

How Jewish are you? Ν

Please do not draw anything in the space below. Seriously, I mean it this time.

Naming Names

What name might you give to a mild-mannered, slightly overweight dental assistant in one of your cartoons?

CANDY.

Other than Lance, what name would you give to a twenty-eight-year-old metrosexual entertainment lawyer who cycles on weekends?

HOUSTON, AUSTIN, BUT NOT CORPUS CHRISTI.

What would be a good name for a new, commercially unviable breakfast cereal?

crack to's

Come up with a name for an unpleasant medical procedure.

EUGENBERTHOLDFRIEDRICHBRECHTOMY.

If you used a pen name, what would it be?

BIC.

Draw some sort of doodle using the random lines below as a starting point.

Circle your preference.

beach	OR	mountains
poetry	OR	sports
day	OR	night
llamas	OR	alpacas
Montana	OR	Maine
hot	OR	mild
jazz	OR	country
soup	OR	salad
Luke Skywalker	OR	Han Solo
accordion	OR	bagpipes
pickup truck	OR	Volkswagen Beetle
gorilla suit	OR	chicken suit
time travel	OR	free health care
swimming	OR	jogging
(spring)	OR	fall
General Tso's chicken	OR	Caesar salad
hip-high fishing waders	OR	lifetime supply of ketchup
life without shoes	OR	life without computers
having a facial tattoo	OR	being a vegan
$10 gift certificate to Orange Julius	OR	$50 gift certificate to Chess King
your very own dump truck	OR	an iPod
one hundred dollars in quarters	OR	snowshoes
walkie-talkie, a pogo stick, a gallon of orange juice, an extension cord, and three new pairs of scissors	OR	a canoe

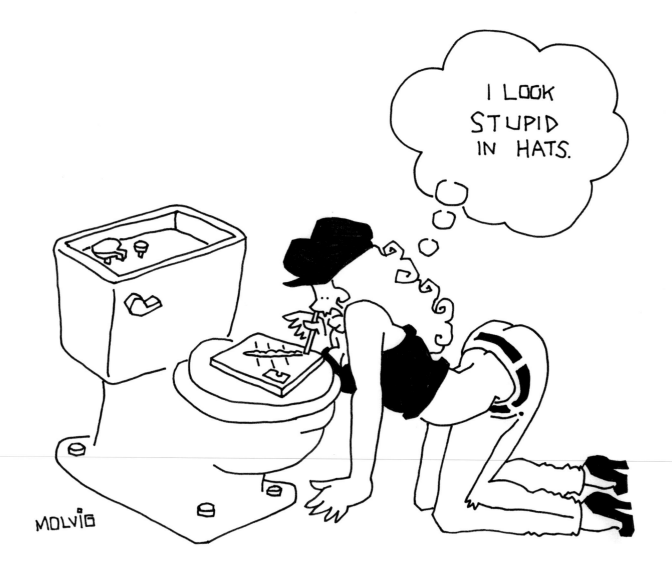

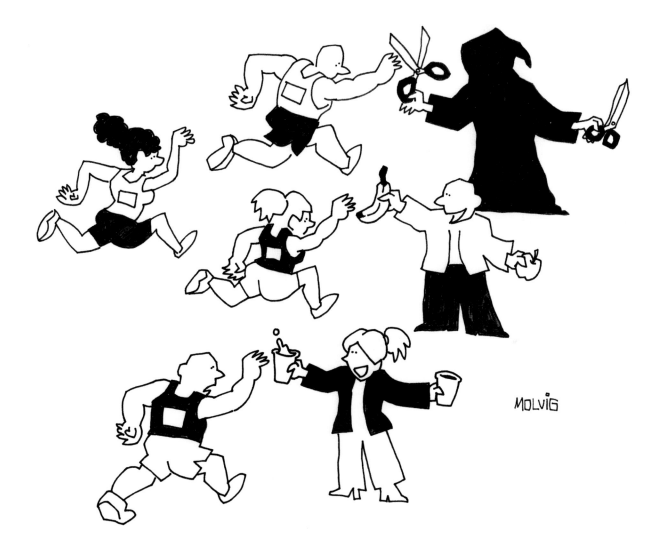

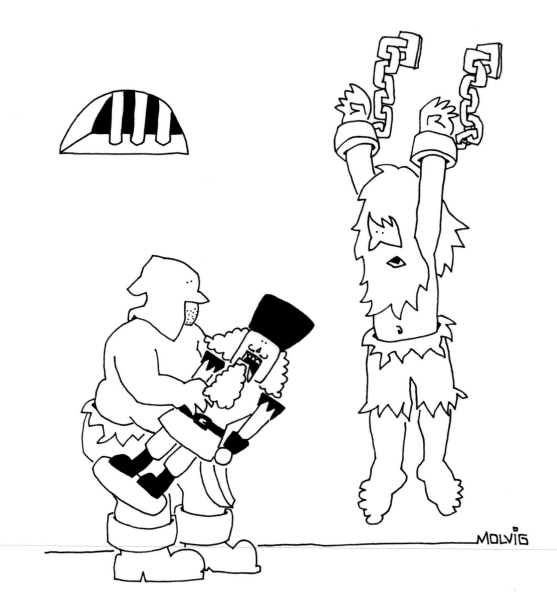

"I'll talk."

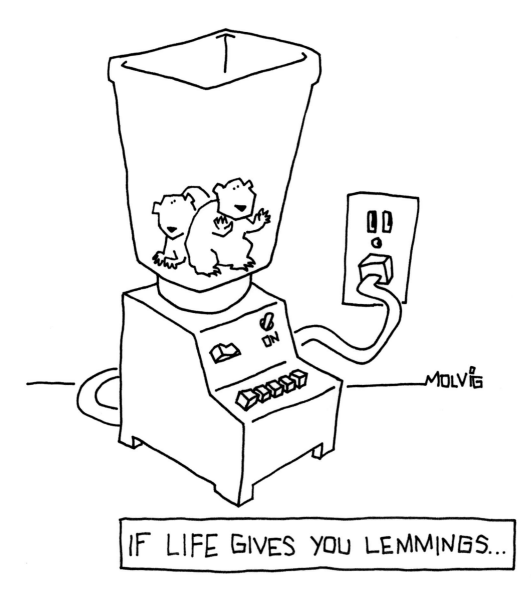

IF LIFE GIVES YOU LEMMINGS...

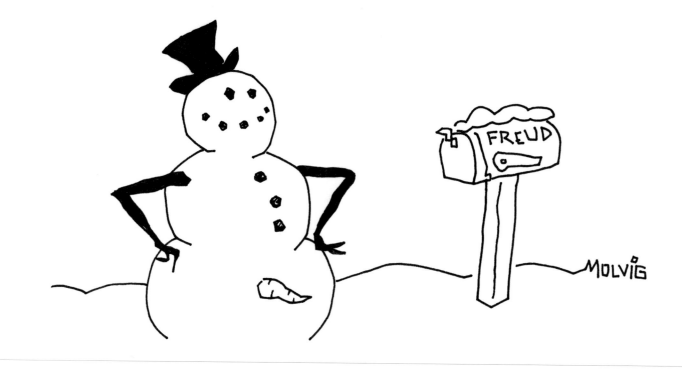

Glen LeLievre

I was born _____

_____ in high school _____ jellyfish _____.

Not long after that, _____

Eventually, however, despite my best efforts, _____

_____ and then _____. Perhaps not surprisingly, _____. The _____ of

_____ is _____. And so, I suppose without _____ ?

_____ my _____.

In closing, I'd just like to say _____

Frequently Asked Questions

Where do you get your ideas?

SOUTH WEST CORNER OF EAST 62ND STREET — FACING NORTH.

Which comes first, the picture or the caption?

THE PICTION.

How'd you get started?

MY DAD HAD SEX WITH MY MOM.

I've got a great idea for a cartoon — wanna hear it? NO.

I've got a great idea for a cartoon — wanna hear it? NO!

I've got a great idea for a cartoon — wanna hear it? NOOOO!

Infrequently Asked Questions

Have you mooned or *been* mooned more often in your life?

AVOIDING BOTH — LYCANTHROPY.

What would make a terrible pizza topping?

NEW JERSEY.

What might one expect to find at a really low-budget amusement park?

ESCALATOR! THE RIDE!

What did the shepherd say to the three-legged sheepdog?

"I'VE GOT A GREAT IDEA FOR A CARTOON — WANNA HEAR IT?"

Complete the pie chart below in a way that tells us something about your life or how you think.

In the box below, draw something you couldn't live without.

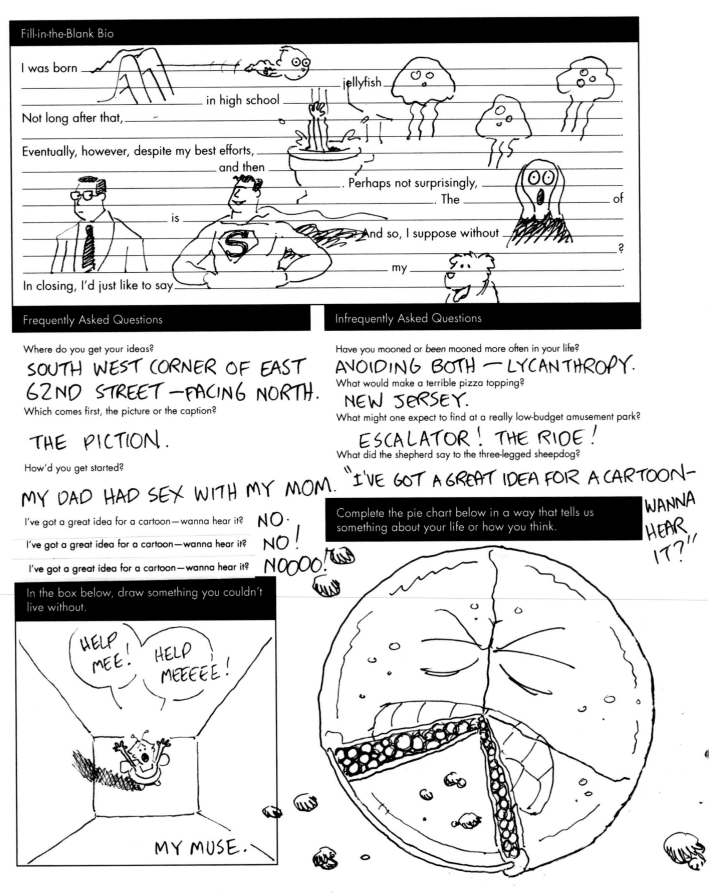

HELP MEE! HELP MEEEEE!

MY MUSE.

What do you hate drawing?

BOXES FILLED WITH HAIR.

Being as accurate as possible, how many desert island cartoons do you think you've come up with and submitted to *The New Yorker*?

FIVE

What's the funniest thing that you witnessed, overheard, or came up with that you couldn't figure out how to use in a cartoon?

A DESERT ISLAND.

If you could ask Bob Mankoff, *The New Yorker* cartoon editor, one question, what would it be?

BOYERS OR BRIEFS?

SALE! PUBIC HAIR!

...sort of doodle using the below as a starting point.

Answer the following questions with a number from 1 to 10 (1 being not very much at all and 10 being quite a bit):

How much do you enjoy bowling? **5**

How close have you ever come to getting a tattoo? **.25"**

How often do you whistle or hum? **5**

How much do you resemble Bea Arthur? **10**

How likely is it that you will water-ski in the coming year? **0**

How often do you curse? **10**

With what frequency do you imbibe smoothies? **0**

How much do you dislike licorice? **1**

What's your favorite number between one and ten? **9**

How confident are you in your dancing ability? **0**

How Jewish are you? **10**

Please do not draw anything in the space below. Seriously, I mean it this time.

Naming Names

What name might you give to a mild-mannered, slightly overweight dental assistant in one of your cartoons?

HEY, YOU OVER THERE, IN THE CORNER.

Other than Lance, what name would you give to a twenty-eight-year-old metrosexual entertainment lawyer who cycles on weekends?

IAN DENIAL.

What would be a good name for a new, commercially unviable breakfast cereal?

HAIR BALLIOS!

Come up with a name for an unpleasant medical procedure.

AUSTRALIANIZATION.

If you used a pen name, what would it be?

PAPER MATE.

Circle your preference.

beach	OR	mountains
poetry	OR	*sports*
day	OR	night
llamas	OR	alpacas
Montana	OR	*Maine*
hot	OR	mild
jazz	OR	country
soup	OR	salad
Luke Skywalker	OR	*Han Solo*
accordion	OR	*bagpipes*
pickup truck	OR	*Volkswagen Beetle*
gorilla suit	OR	*chicken suit*
time travel	OR	free health care
swimming	OR	jogging
spring	OR	fall
General Tso's chicken	OR	Caesar salad
hip-high fishing waders	OR	*lifetime supply of ketchup*
life without shoes	OR	life without computers
having a facial tattoo	OR	being a vegan
$10 gift certificate to Orange Julius	OR	$50 gift certificate to Chess King
your very own dump truck	OR	an iPod
one hundred dollars in quarters	OR	snowshoes
walkie-talkie, a pogo stick, a gallon of orange juice, an extension cord, and three new pairs of scissors	OR	a canoe

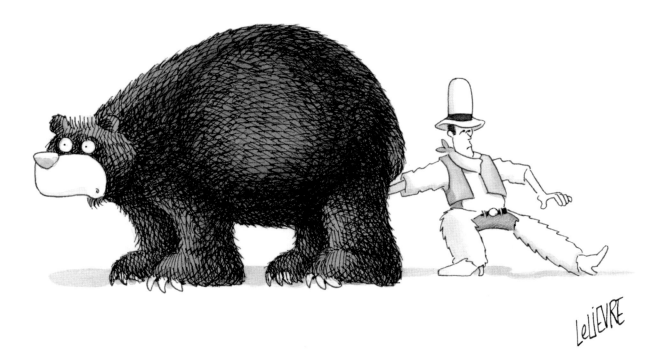

HIGH STAKES TEXAS HOLD 'EM.

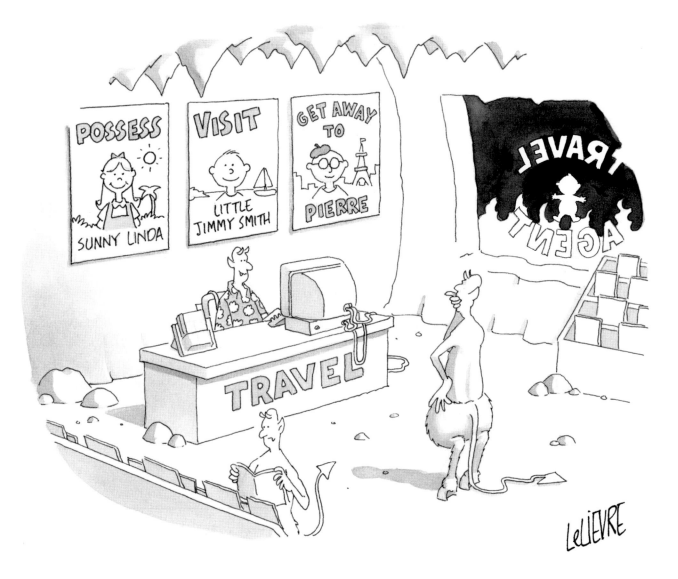

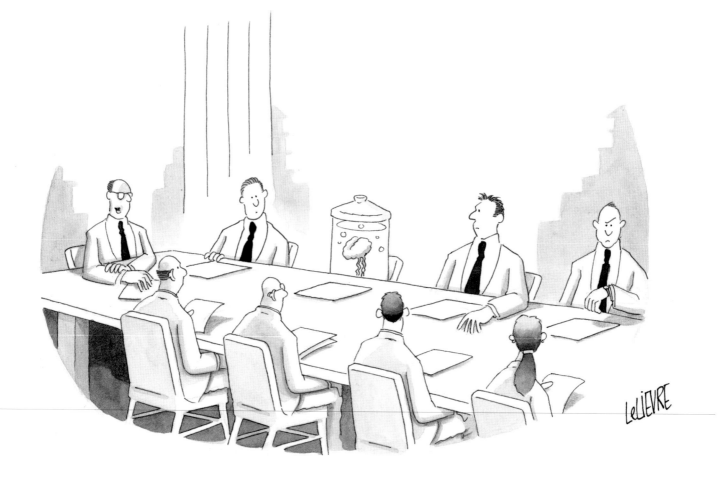

"*But first let's all congratulate Ted on his return to work.*"

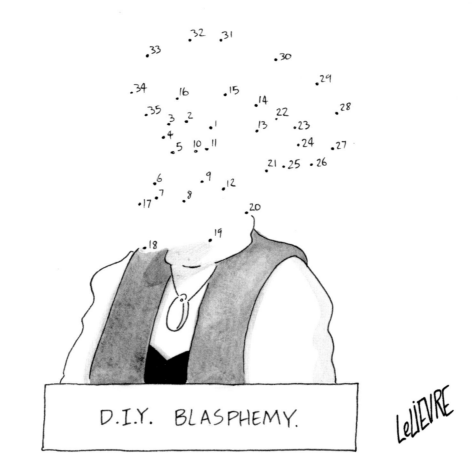

THE PROPHET MUHAMMAD

D.I.Y. BLASPHEMY.

LeLIEVRE

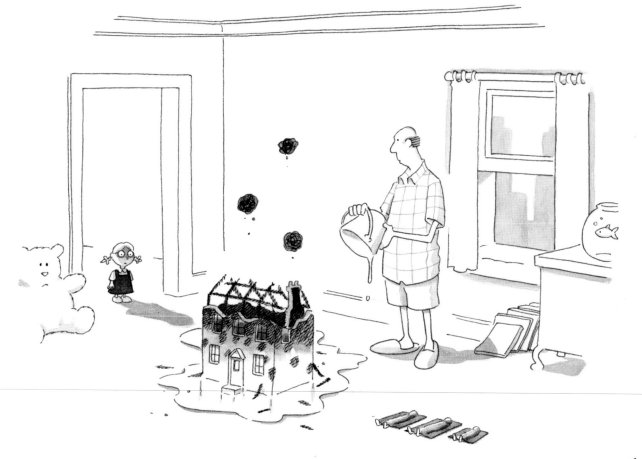

Robert Leighton

Fill-in-the-Blank Bio

I was born on a rainy night in 1960 when my dad, unfamiliar with the hospital, drove my Mom to a gate marked "DELIVERIES." I watched tellyfishion a lot as a kid and wrote and drew comics and stories in high school. I studied journalism in college from '78-'82. Not long after that, I started working as a magazine editor (GAMES magazine) and freelance comedy writer (Nickelodeon, Comedy Central). I dated Valerie Green. Eventually, however, despite my best efforts, she married me. We lived in Greenwich Village. We travelled. Years passed and then we had a son named Kyle. We moved to the Upper East Side. Perhaps not surprisingly, it's not as easy to find a Radiohead T-shirt as it used to be. The End. But of course, this is not the end of the exercise. And so, I suppose without anything left to add, I'll just leave some blank space here. Is that okay? my God, this does go on. In closing, I'd just like to say I hope you had twice the fun reading this as I had writing it.

Frequently Asked Questions

Where do you get your ideas?
HAPPY DRAGON CARTOON MILL, HONG KONG. (TRADE SECRET)

Which comes first, the picture or the caption?
USUALLY I DRAW A SKETCH WHICH SUGGESTS AN IDEA/CAPTION...WHICH THEN SUGGESTS A DIFFERENT PICTURE.

How'd you get started?
R.L. STINE PUBLISHED MY WORK WHEN HE WAS AN EDITOR AT SCHOLASTIC

I've got a great idea for a cartoon—wanna hear it?
Not unless you want to hear my great idea for investment banking.

Infrequently Asked Questions

Have you mooned or *been* mooned more often in your life?
BEEN MOONED (1) MOONED (0)

What would make a terrible pizza topping?
Those stringy things you peel off bananas.

What might one expect to find at a really low-budget amusement park?
Bring-your-own safety bar / Walk-up Ferris wheel

What did the shepherd say to the three-legged sheepdog?
"It's kind of slow around here. I'm going to have to let another one of your legs go."

Complete the pie chart below in a way that tells us something about your life or how you think.

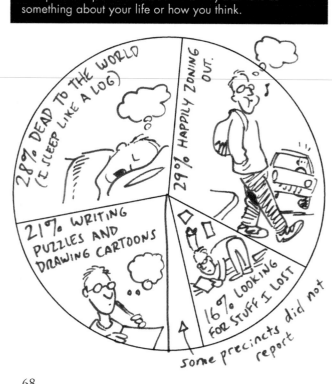

In the box below, draw something you couldn't live without.

68

What do you hate drawing?

MANSION INTERIORS, CROWD SCENES, CARS

Being as accurate as possible, how many desert island cartoons do you think you've come up with and submitted to *The New Yorker*?

16. (NONE SOLD)

What's the funniest thing that you witnessed, overheard, or came up with that you couldn't figure out how to use in a cartoon?

"BEING INDISCREET" / "PEEING IN THE STREET"

If you could ask Bob Mankoff, *The New Yorker* cartoon editor, one question, what would it be?

"GET IT?"

Draw some sort of doodle using the random lines below as a starting point.

Answer the following questions with a number from 1 to 10 (1 being not very much at all and 10 being quite a bit):

How much do you enjoy bowling? 7

How close have you ever come to getting a tattoo? 1

How often do you (whistle or hum)? 9

How much do you resemble Bea Arthur? SURVEY SAYS 2

How likely is it that you will water-ski in the coming year? 3

How often do you curse? 2

With what frequency do you imbibe smoothies? 3

How much do you dislike licorice? 9

What's your favorite number between one and ten? 5

How confident are you in your dancing ability? 1

How Jewish are you? 6 (7 IN EARLY FALL)

Please do not draw anything in the space below. Seriously, I mean it this time.

I WILL COMPLY THOUGH I DON'T LIKE YOUR TONE.

Circle your preference.

Me at beach

beach	OR	(mountains)	
(poetry)	OR	sports	
(day)	OR	night	
(llamas)	OR	alpacas	
(Montana)	OR	Maine	
(hot)	OR	mild	ZZZZ
(jazz)	~~OR~~	country	
soup	OR	(salad)	
Luke Skywalker	OR	(Han Solo)	
accordion	NOR	bagpipes	
pickup truck	OR	(Volkswagen Beetle)	
(gorilla suit)	OR	chicken suit	
(time travel)	OR	free health care	
swimming	OR	~~jogging~~ WALKING	
spring	OR	(fall)	
General Tso's chicken	OR	(Caesar salad)	
hip-high fishing waders	NOR	lifetime supply of ketchup	
life without shoes	OR	(life without computers)	
having a facial tattoo	OR	being a vegetarian *etari	
$10 gift certificate to Orange Julius	NOR	$50 gift certificate to Chess King	
your very own dump truck	OR	(an iPod) *let's be reasonable	
(one hundred dollars in quarters)	OR	snowshoes	
(walkie-talkie, a pogo stick, a gallon of orange juice, an extension cord, and three new pairs of scissors)	OR	a canoe	

A smear campaign against a brave general

MY WIFE WOULD PREFER

← THIS IS THE KIND OF STUFF MY WIFE WANTS

THE DUMP TRUCK FOR.

Naming Names

What name might you give to a mild-mannered, slightly overweight dental assistant in one of your cartoons?

PEG OR JOSIE. (I HAVE STEELY DAN PLAYING IN THE BACKGROUND.)

Other than Lance, what name would you give to a twenty-eight-year-old metrosexual entertainment lawyer who cycles on weekends?

BILLY-BOB. (PLAYING AGAINST STEREOTYPES HERE)

What would be a good name for a new, commercially unviable breakfast cereal?

(I have been paid to do this.) TOBACK-O's / DEEP MORNING

Come up with a name for an unpleasant medical procedure.

The Paine-Hertz procedure

If you used a pen name, what would it be?

WHO SAYS I DON'T?

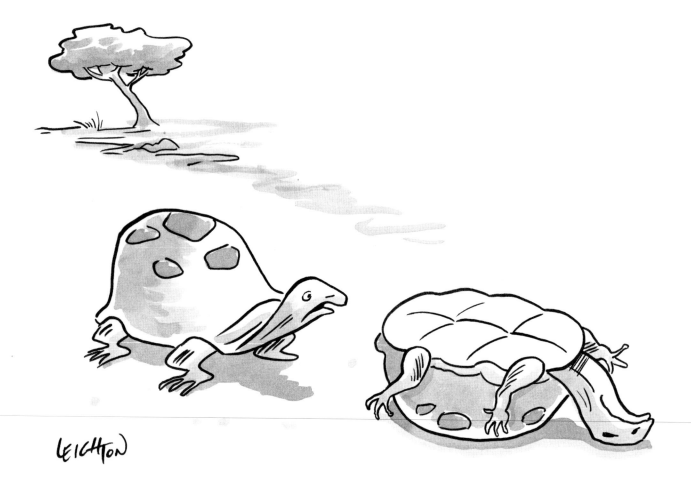

"I came as soon as I heard."

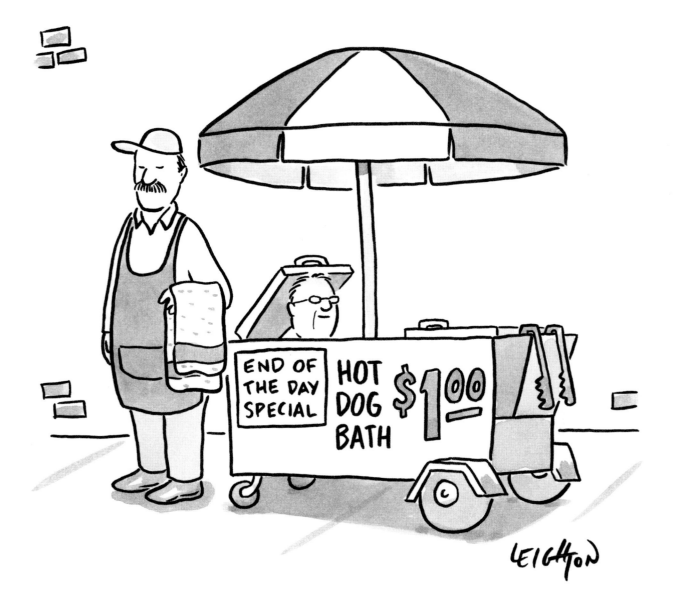

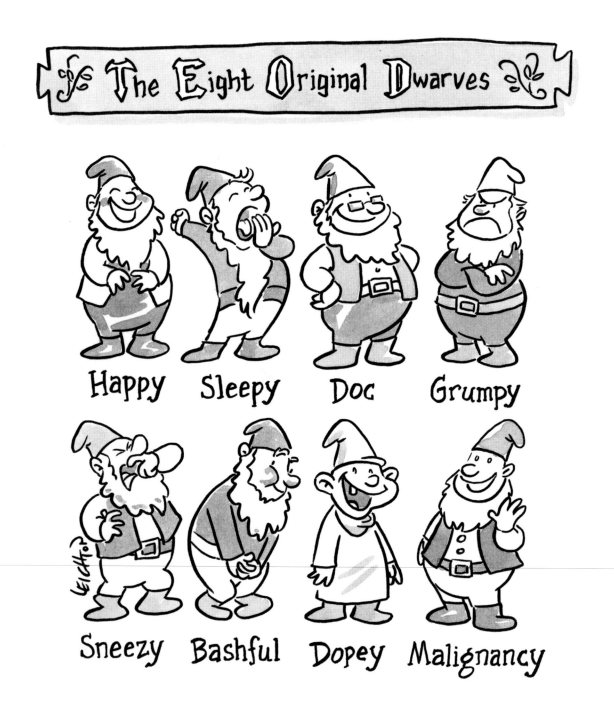

Fill-in-the-Blank Bio

I was born MANUFACTURED IN 1952, THE FIRST OF THE CARTOONIST-ROBOTS. FOR SOME REASON, I WAS GIVEN A CENTRAL NERVOUS SYSTEM BASED ON THAT OF A jellyfish ALTHOUGH I'VE RECEIVED MANY UPGRADES SINCE THEN. WHILE I WAS in high school I RECEIVED A NEW "BRAIN" AND SYSTEM BASED ON A HYENA. Not long after that, I RECEIVED ONE BASED ON THE HIGHER APES. IT WAS AT THIS TIME I DISCOVERED GIRLS. I FANCIED MYSELF QUITE A LADY'S MAN, BUT I WAS ACTUALLY JUST A SEX MACHINE. Eventually, however, despite my best efforts, I WASN'T MUCH OF A HIT WITH WOMEN, WHO FOUND ME COLD AND SQUEAKY. I MOPED FOR A WHILE and then ONE DAY REMEMBERED MY DRAWING PROGRAM, WHICH HAD BEEN INSTALLED IN ME LONG AGO AT THE ROBOT LAB. Perhaps not surprisingly, MY FIRST DRAWINGS WERE OF MACHINES AND INANIMATE OBJECTS AND WEREN'T VERY FUNNY. The CRUCIAL ELEMENT of HUMOR, WHICH is OF SOME IMPORTANCE TO THE ROBOT CARTOONIST WAS MISSING. I APPLIED FOR AN UPGRADE AND GOT ONE BASED ON DAFFY DUCK. And so, I suppose without DAFFY, I WOULDN'T BE WHERE I AM TODAY. WHAT WOULD HAVE HAPPENED IF I'D RECEIVED THE JERRY LEWIS MODULE? I HAVE NIGHTMARES ABOUT THAT, WHEN I'M NOT HAVING my usual DREAMS OF ELECTRIC SHEEP. In closing, I'd just like to say THANKS TO ALL THE SWELL GEEKS BACK AT THE ROBOT WORKS.

Frequently Asked Questions

Where do you get your ideas?

REALFUNNYCARTOONIDEAS2MAKEURICH.COM

Which comes first, the picture or the caption?

THE PICTURE. NO, THE CAPTION. NO, THE PICTURE. NO...(I THINK I SMELL MY CIRCUITS OVERHEATING.)

How'd you get started?

JUMPER CABLES WERE INVOLVED.

I've got a great idea for a cartoon—wanna hear it?

DEFINE "GREAT."

Infrequently Asked Questions

Have you mooned or *been* mooned more often in your life?

DEFINE "MOONED."

What would make a terrible pizza topping?

SPANISH MOSS

What might one expect to find at a really low-budget amusement park?

A CHILD-POWERED CAROUSEL.

What did the shepherd say to the three-legged sheepdog?

"WHERE'S THE OTHER 1/4 TH OF THE FLOCK?"

Complete the pie chart below in a way that tells us something about your life or how you think.

In the box below, draw something you couldn't live without.

What do you hate drawing?

BIG RELIGIOUS MURALS.
NO COMMISSIONS, PLEASE.

Being as accurate as possible, how many desert island cartoons do you think you've come up with and submitted to *The New Yorker*?

4,268 AS OF THIS WEEK. HOLD ON,
I JUST GOT ANOTHER IDEA . . .

What's the funniest thing that you witnessed, overheard, or came up with that you couldn't figure out how to use in a cartoon?

A CONVERSATION BETWEEN TWO TREES
I OVERHEARD DURING AN LSD
EXPERIENCE IN MY YOUTH.
(YOU HAD TO BE THERE.)

If you could ask Bob Mankoff, *The New Yorker* cartoon editor, one question, what would it be?

WHY WAS MY NAME ON A GRAVESTONE
IN ONE OF YOUR EARLY CARTOONS?
I'VE BEEN RUNNING SCARED EVER SINCE.

Draw some sort of doodle using the random lines below as a starting point.

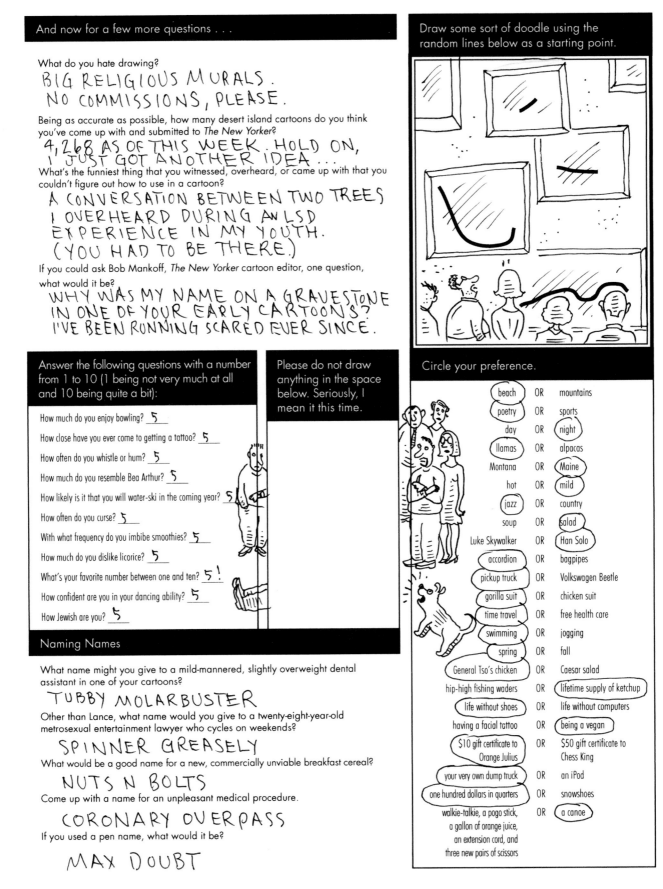

Answer the following questions with a number from 1 to 10 (1 being not very much at all and 10 being quite a bit):

How much do you enjoy bowling? **5**

How close have you ever come to getting a tattoo? **5**

How often do you whistle or hum? **5**

How much do you resemble Bea Arthur? **5**

How likely is it that you will water-ski in the coming year? **5**

How often do you curse? **5**

With what frequency do you imbibe smoothies? **5**

How much do you dislike licorice? **5**

What's your favorite number between one and ten? **5 !**

How confident are you in your dancing ability? **5**

How Jewish are you? **5**

Please do not draw anything in the space below. Seriously, I mean it this time.

Naming Names

What name might you give to a mild-mannered, slightly overweight dental assistant in one of your cartoons?

TUBBY MOLARBUSTER

Other than Lance, what name would you give to a twenty-eight-year-old metrosexual entertainment lawyer who cycles on weekends?

SPINNER GREASELY

What would be a good name for a new, commercially unviable breakfast cereal?

NUTS N BOLTS

Come up with a name for an unpleasant medical procedure.

CORONARY OVERPASS

If you used a pen name, what would it be?

MAX DOUBT

Circle your preference.

(beach)	OR	mountains
(poetry)	OR	sports
day	OR	(night)
(llamas)	OR	alpacas
Montana	OR	(Maine)
hot	OR	(mild)
(jazz)	OR	country
soup	OR	(salad)
Luke Skywalker	OR	(Han Solo)
(accordion)	OR	bagpipes
(pickup truck)	OR	Volkswagen Beetle
(gorilla suit)	OR	chicken suit
(time travel)	OR	free health care
(swimming)	OR	jogging
(spring)	OR	fall
General Tso's chicken	OR	Caesar salad
hip-high fishing waders	OR	(lifetime supply of ketchup)
(life without shoes)	OR	life without computers
having a facial tattoo	OR	(being a vegan)
($10 gift certificate to Orange Julius)	OR	$50 gift certificate to Chess King
(your very own dump truck)	OR	an iPod
(one hundred dollars in quarters)	OR	snowshoes
walkie-talkie, a pogo stick, a gallon of orange juice, an extension cord, and three new pairs of scissors	OR	(a canoe)

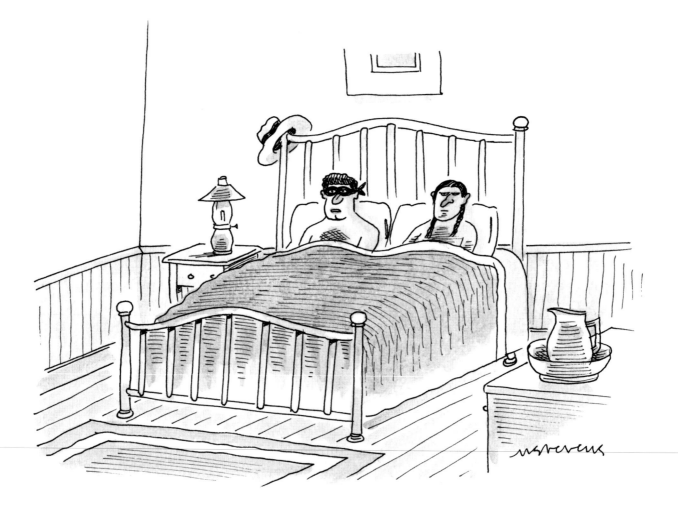

"So that's what 'kemosabe' means."

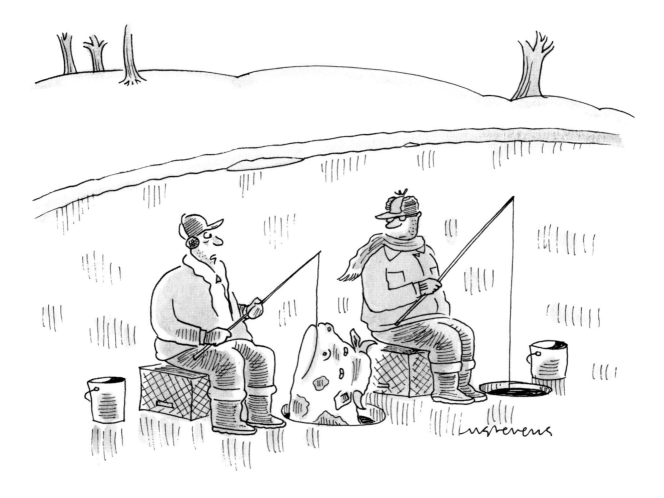

"I just can't seem to get the hang of it."

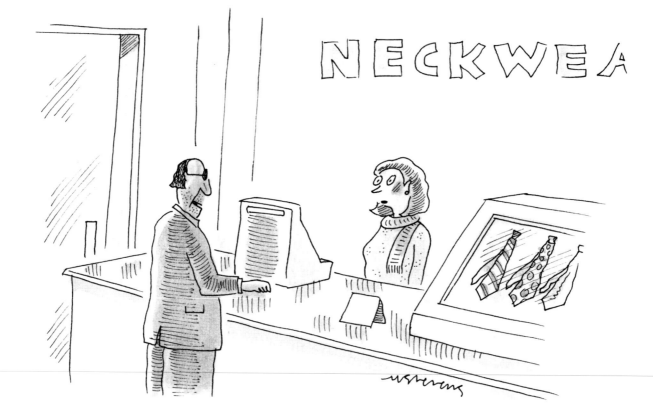

"I'm looking for a tie that says 'I'm not wearing any underwear.'"

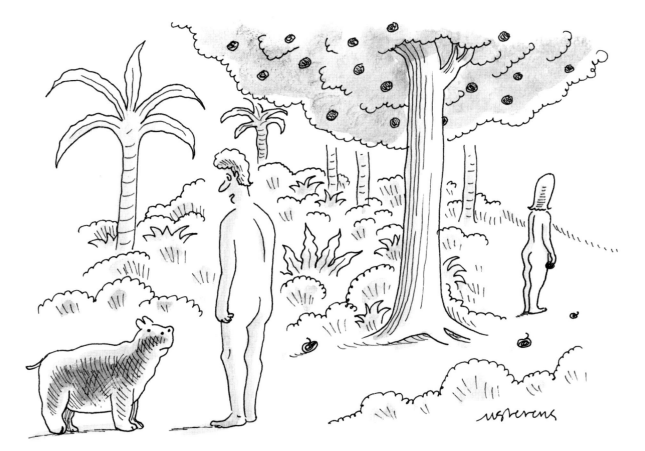

"I don't know how to say this, but I've found someone else."

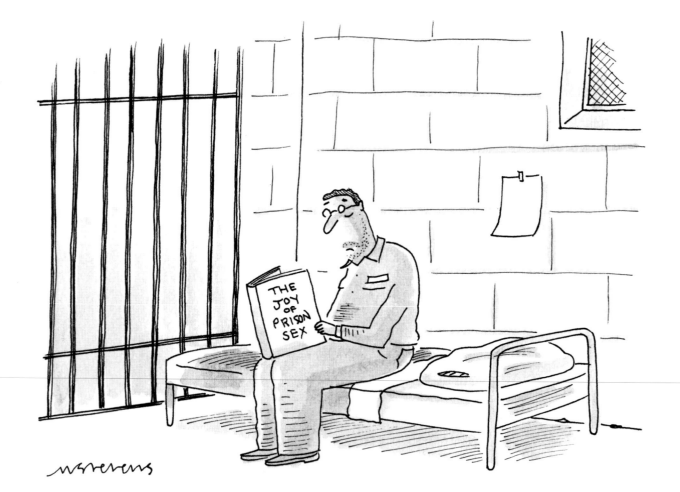

Fill-in-the-Blank Bio

I was born in St. Louis; then we moved to Athens, GA, a land of hollyhocks, magnolias, doodlebugs, garden spiders, racism and segregation, pecans, peaches, okra (like jellyfish in your mouth). Early school years were punctuated by tornado & atom bomb drills. In high school, things calmed down for a minute or two. I waitressed. I got A's.

Not long after that, I left home, went to the big school in Madison. Got a job as a cartographer, got maced, tried hallucinogens, wore hand-made leather sandals, had a bf named Ted who had long braids and drove a Harley.

Eventually, however, despite my best efforts to be a perennial student, I graduated. While my friends left for Europe and Israel, I moved to New Orleans. Now and then I had run-ins with hurricanes, cockroaches and other critters, and the omnipresent criminal element. Perhaps not surprisingly, career-planning beckoned after 3 years. I drove to Ohio with my one-eyed cat. Trouble met us in Mississippi. The moral of this untold story is 'avoid Mississippi backroads if you drive a Volvo'. Well, that seems to span the first thirty years... And so, I suppose without this form a bio could me more comprehensive... but who wants that? I'm done. I have to go work on my weekly batch, due tomorrow.

In closing, I'd just like to say I didn't want to do this (fill-in-the-blank) and now I know why

Frequently Asked Questions

Where do you get your ideas? personal experiences and observations, reading, radio, TV – in that order. Everything is stored in head; accumulates mercilessly. Best ideas come out of NOWHERE! FUN.

Which comes first, the picture or the caption?
The caption, 90%

How'd you get started? One day I decided I wanted to draw cartoons for the New Yorker. So, as in tennis-- where I had to hit a million balls to achieve a desired skill level -- I began the task of drawing a million (actually, several hundred) cartoons.

I've got a great idea for a cartoon—wanna hear it?

Sure! I need to practice my fake laugh.

Infrequently Asked Questions

Have you mooned or been mooned more often in your life? Once. It was not a waxing gibbous...more like a gibbon in need of a waxing.

What would make a terrible pizza topping?
a manhole cover

What might one expect to find at a really low-budget amusement park?
A higher percentage of safety violations.

What did the shepherd say to the three-legged sheepdog?
Nothing. The 3-legged dog and the shepherd lived in different parts of the world: The dog, in Canton, Ohio. The shepherd in Bezier, France.

Complete the pie chart below in a way that tells us something about your life or how you think.

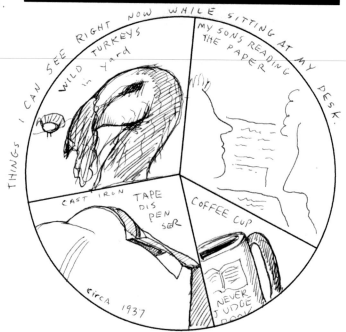

THINGS I CAN SEE RIGHT NOW WHILE SITTING AT MY DESK. WILD TURKEYS in yard. MY SON'S READING THE PAPER. CAST IRON TAPE DISPENSER CIRCA 1937. COFFEE CUP. NEVER JUDGE A BOOK

In the box below, draw something you couldn't live without.

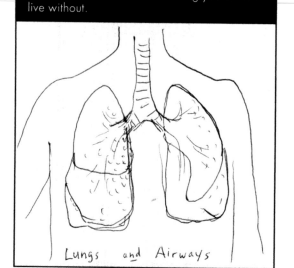

Lungs and Airways

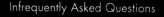

And now for a few more questions . . .

What do you hate drawing?
Auditoriums or places with a lot of seating and/or crowds of people.

Being as accurate as possible, how many desert island cartoons do you think you've come up with and submitted to *The New Yorker*? 25

What's the ~~funniest~~ weird, pathetic, horrific thing that you witnessed, overheard, or came up with that you couldn't figure out how to use in a cartoon?

I once 'borrowed' $20.⁰⁰ from a corpse.

If you could ask Bob Mankoff, *The New Yorker* cartoon editor, one question, what would it be? Why dots?

Draw some sort of doodle using the random lines below as a starting point.

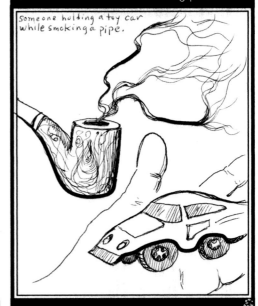
someone holding a toy car while smoking a pipe.

Answer the following questions with a number from 1 to 10 (1 being not very much at all and 10 being quite a bit):

How much do you enjoy bowling? 1

How close have you ever come to getting a tattoo? –1

How often do you whistle or hum? 3

How much do you resemble Bea Arthur? (what are you smoking, Matt?)

How likely is it that you will water-ski in the coming year? –1

How often do you curse? 3

With what frequency do you imbibe smoothies? 5

How much do you dislike licorice? N/A I ♡ licorice!

What's your favorite number between one and ten? 5

How confident are you in your dancing ~~ability~~ prowess? 1

How Jewish are you? 6.5 (I am wise and have a few chickens)

Peas in space

Naming Names

What name might you give to a mild-mannered, slightly overweight dental assistant in one of your cartoons? Colleen, Yvonne, Lynette, Latrineesha, Pegotty

Other than Lance, what name would you give to a twenty-eight-year-old metrosexual entertainment lawyer who cycles on weekends?
Travis, Damian, Ethan, Owen

What would be a good name for a new, commercially unviable breakfast cereal?
Dingleberri0's or New Wheatier Wheaties

Come up with a name for an unpleasant medical procedure.
nipplectomy

If you used a pen name, what would it be?
Beva Lebourveau

Circle your preference.

beach	OR	mountains
toss up — **poetry**	OR	sports
day	OR	night
ricardo llamas	OR	**alpaca**no
Montana	OR	Maine
hot	OR	mild
Cuban jazz	OR	country
way too general **soup**	OR	**salad**
Luke Skywalker	OR	**Han Solo**
At least it has cup holders and places for your stuff! accordion	F **OR** K	bagpipes
pickup truck	OR	Volkswagen Beetle
gorilla suit	OR	chicken suit
time travel	OR	free health care
ocean swimming	OR	jogging
spring	OR	fall from ~~grace~~ a cliff
General Tso's chicken	OR	**Caesar salad – My Mom's**
hip-high fishing waders	OR	**lifetime supply of ketchup**
life without shoes	OR	life without computers
having a facial tattoo	OR	being a vegan
(never had one) $10 gift certificate to Orange Julius	N/A	$50 gift certificate to Chess King (what's this?)
~~your very own dump truck~~	OR	~~a iPod~~ rent
one hundred dollars in quarters	OR	snowshoes
walkie-talkie, a pogo stick, a gallon of orange juice, an extension cord, and three new pairs of scissors	OR	**a canoe, Montana waders**

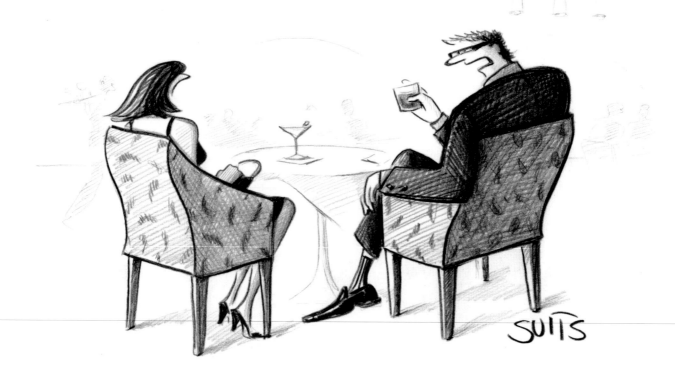

"Enough about my penis. What's new with the ol' vagina?"

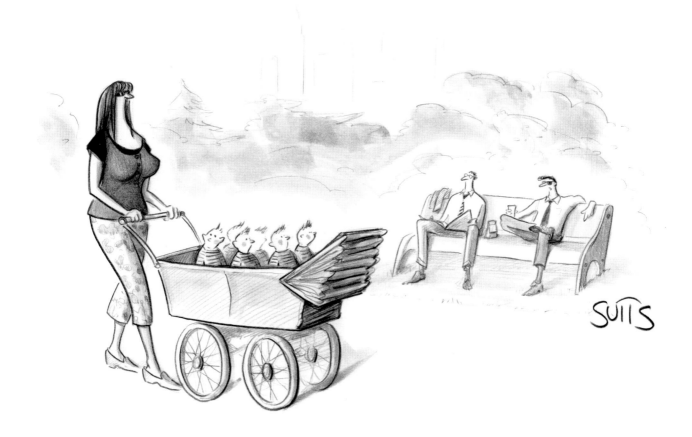

"Check those babies out."

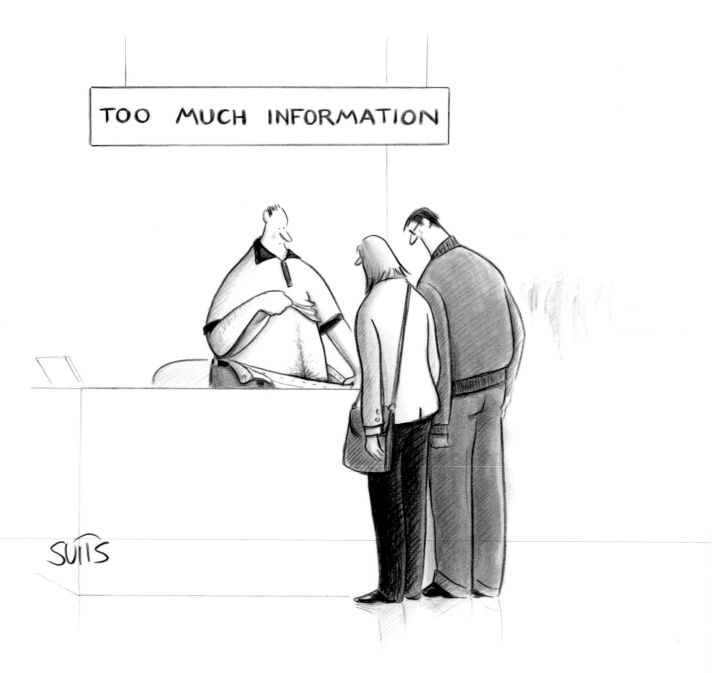

David Sipress

I was born _the first time, in 462 B.C. —_
_____I was a_____ jellyfish. (As many of you
_____learned_____ in high school, _there's something called reincarnation_)
Not long after that, _in 451 B.C., I came back as an ant. Then a turtle in 422. And_
so on, down through the ages. My goal? To become human, and then to achieve nirvana.
Eventually, however, despite my best efforts, _and huge amounts of good karma, the best I_
could do was a small dog, and then, _to my utter shock and surprise,_
I was reborn a cartoonist.. Perhaps not surprisingly, _the cartoonist_
stage is one step away from nirvana.. The _final level_ of
rebirth now is _within my grasp — that is,_
TOTAL ENLIGHTENMENT !!!. And so, I suppose, without _any screw ups,_
I'll be there soon. But what if I lack compassion? Become cruel and selfish?
I could slide back to the lower realms and spend my _next life as an editor!_
In closing, I'd just like to say, _being a jelly fish was moist and squishy,_.

Where do you get your ideas?

Barcelona.

Which comes first, the picture or the caption?

The egg.

How'd you get started? God appeared to
me in a vision and handed
me crow quill pen points and
a bristol pad.
I've got a great idea for a cartoon—wanna hear it?

Are you from Barcelona?

Have you mooned or *been* mooned more often in your life?
This question is asinine.
What would make a terrible pizza topping?
Stool softener.
What might one expect to find at a really low-budget amusement park?
Poor children.
What did the shepherd say to the three-legged sheepdog?
Yum - that was delicious. I think
I'll go ahead and eat the other three.

Complete the pie chart below in a way that tells us
something about your life or how you think.

In the box below, draw something you couldn't
live without.

Air

And now for a few more questions . . .

What do you hate drawing?

Anything complicated.

Being as accurate as possible, how many desert island cartoons do you think you've come up with and submitted to *The New Yorker*?

Ten thousand.

What's the funniest thing that you witnessed, overheard, or came up with that you couldn't figure out how to use in a cartoon?

Two people stuck on a desert island.

If you could ask Bob Mankoff, *The New Yorker* cartoon editor, one question, what would it be?

Have you no sense of decency, sir? At long last, have you no sense of decency?

Draw some sort of doodle using the random lines below as a starting point.

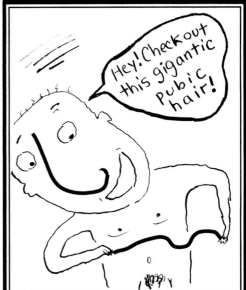

Answer the following questions with a number from 1 to 10 (1 being not very much at all and 10 being quite a bit):

How much do you enjoy bowling? *Too Jewish*

How close have you ever come to getting a tattoo? *Too Jewish*

How often do you whistle or hum? *Too Jewish*

How much do you resemble Bea Arthur? *Too Jewish*

How likely is it that you will water-ski in the coming year? *Definitely too Jewish*

How often do you curse? *Too Jewish*

With what frequency do you imbibe smoothies? *Too Jewish*

How much do you dislike licorice? *Too Jewish*

What's your favorite number between one and ten? *7.3641*

How confident are you in your dancing ability? *Too Jewish*

How Jewish are you? *Too Jewish.*

Please do not draw anything in the space below. Seriously, I mean it this time.

Naming Names

What name might you give to a mild-mannered, slightly overweight dental assistant in one of your cartoons? *I don't give people in my cartoons names. They come up with them themselves.*

Other than Lance, what name would you give to a twenty-eight-year-old metrosexual entertainment lawyer who cycles on weekends?

See above.

What would be a good name for a new, commercially unviable breakfast cereal?

Nukes.

Come up with a name for an unpleasant medical procedure.

Check up.

If you used a pen name, what would it be? *Bic.*

Circle your preference.

beach	(OR)	mountains
poetry	(OR)	sports
day	(OR)	night
llamas	(OR)	alpacas
Montana	(OR)	Maine
hot	(OR)	mild
jazz	(OR)	country
soup	(OR)	salad
Luke Skywalker	(OR)	Han Solo
accordion	(OR)	bagpipes
pickup truck	(OR)	Volkswagen Beetle
gorilla suit	(OR)	chicken suit
time travel	(OR)	free health care
swimming	(OR)	jogging
spring	(OR)	fall
General Tso's chicken	(OR)	Caesar salad
hip-high fishing waders	(OR)	lifetime supply of ketchup
life without shoes	(OR)	life without computers
having a facial tattoo	(OR)	being a vegan
$10 gift certificate to Orange Julius	(OR)	$50 gift certificate to Chess King
your very own dump truck	(OR)	an iPod
one hundred dollars in quarters	(OR)	snowshoes
walkie-talkie, a pogo stick, a gallon of orange juice, an extension cord, and three new pairs of scissors	(OR)	a canoe

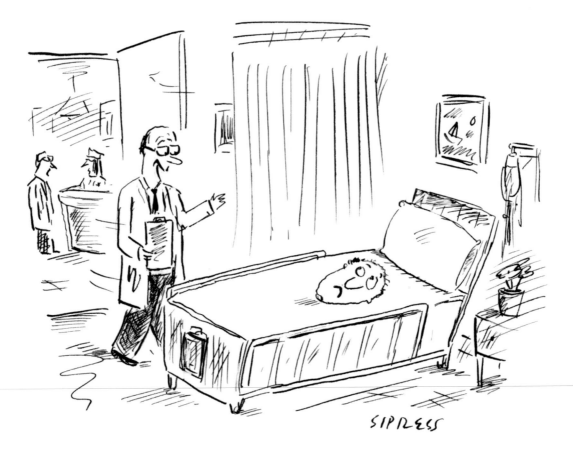

"Congratulations! I think we got it all."

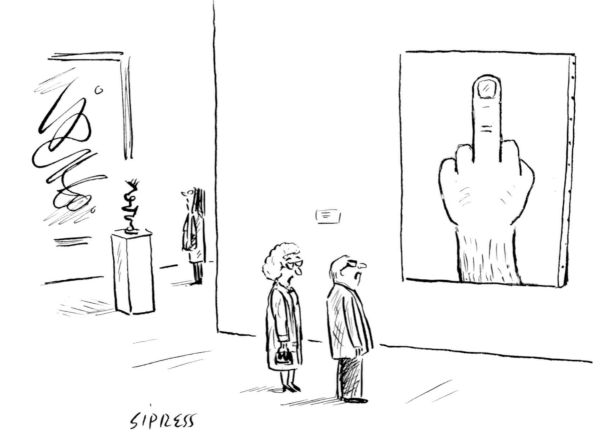

"I don't think you're supposed to like it."

SALES of VIAGRA

2002 2003 2004 2005 2006

SIPRESS

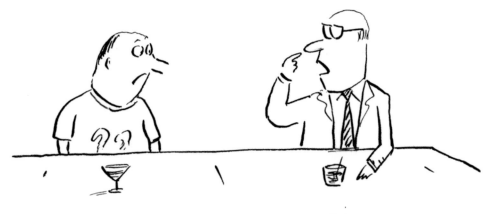

"You have some Wite-Out on your nose."

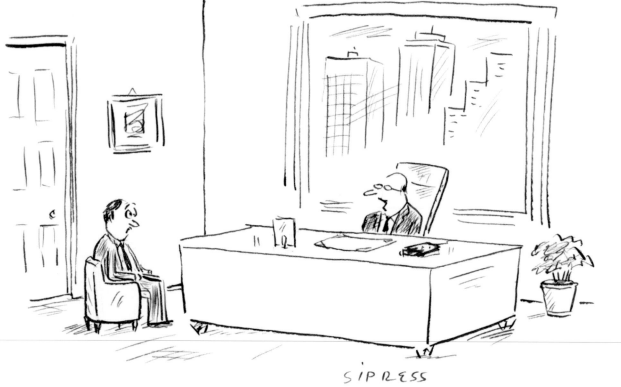

"Corporate Diversity would like you to get a sex change."

Fill-in-the-Blank Bio

I was born ___ as a ___ jellyfish ___ who was ___ in high school ___.

Not long after that, ___ I graduated. ___

Eventually, however, despite my best efforts, ___ I was sent back to ~~high school~~ ___ and then ___ back to the womb ___. Perhaps not surprisingly, ___ I was ___ upset, but not down-and-out ___. The ___ rest ___ of the story ___ is ___ really hard for me to tell. ___. And so, I suppose without ___ further ___ ado, things changed for the better ___? ___ This is ___ my ___ last missive ___.

In closing, I'd just like to say ___ a few words ___.

Frequently Asked Questions

Where do you get your ideas?

A friend of a friend.

Which comes first, the picture or the caption?

He gives me them in code, sometimes with no pictures.

How'd you get started?

Technical high-school for cartooning.

I've got a great idea for a cartoon—wanna hear it?

Is it in code?

This is off the page by accident.)

Infrequently Asked Questions

Have you mooned or *been* mooned more often in your life?

Is it mooning if you never wear pants?

What would make a terrible pizza topping?

Anything except cheese or tomato.

What might one expect to find at a really low-budget amusement park?

A ride where a guy pushes old people out of wheelchairs into mud.

What did the shepherd say to the three-legged sheepdog?

Follow your dreams.

Complete the pie chart below in a way that tells us something about your life or how you think.

∞

300

200

60

I drew air. Did a lot of people do that?

In the box below, draw something you couldn't live without.

And now for a few more questions . . .

~~What~~ **why** do you hate drawing?

I don't. Look

Being as accurate as possible, how many desert island cartoons do you think you've come up with and submitted to *The ~~New Yorker~~* Nobel Prize Committee.?

5,000

What's the funniest thing that you witnessed, overheard, or came up with that you couldn't figure out how to use in a cartoon?

There is a YouTube clip of Frasier falling off a stage that I'm really in love with.

If you could ask Bob Mankoff, *The New Yorker* cartoon editor, one question, what would it be?

Where do you get your ideas?

Draw some sort of doodle using the random lines below as a starting point.

Answer the following questions with a number from 1 to 10 (1 being not very much at all and 10 being quite a bit):

How much do you enjoy bowling? **10**

How close have you ever come to getting a tattoo? **1**

How often do you whistle or hum? **10**

How much do you resemble Bea Arthur? **6**

How likely is it that you will water-ski in the coming year? **7**

How often do you curse? **8**

With what frequency do you imbibe smoothies? **0**

How much do you dislike licorice? **10**

What's your favorite number between one and ten? **7even**

How confident are you in your dancing ability? **10**

How Jewish are you? *10 — but not "10"*

not by choice

Please do not draw anything in the space below. Seriously, I mean it this time.

Circle your preference.

beach **OR** mountains

poetry OR **sports**

day OR night

llamas OR **alpacas** — *I think*

Montana **OR** Maine

hot OR **mild**

jazz **Fusion** country

~~soup OR salad~~

Luke Skywalker OR **Han Solo**

accordion **OR** bagpipes

~~pickup truck~~ OR Volkswagen Beetle

gorilla suit OR chicken suit

time travel OR free health care

swimming OR jogging

spring OR fall

General Tso's chicken OR Caesar salad

hip-high fishing waders OR **lifetime supply of ketchup**

~~life without shoes~~ OR life without computers

having a ~~large~~ tattoo OR ~~being~~ a vegan

$10 gift~~ ~~Orange Julius~~ OR ~~$10 gift certificate to~~ ~~Chess King~~ *(subliminal)*

~~your own ~~ OR an iPod

one hundred dollars ~~ ~~ OR snowshoes

walkie-talkie, a pogo stick, a gallon of orange juice, an extension cord, and three new pairs of scissors OR **a couch** *(ace)*

Naming Names

What name might you give to a mild-mannered, slightly overweight dental assistant in one of your cartoons?

Robert Throngman

Other than Lance, what name would you give to a twenty-eight-year-old metrosexual entertainment lawyer who cycles on weekends?

Elliot Crogan-Josh

What would be a good name for a new, commercially unviable breakfast cereal?

Assholes

Come up with a name for an unpleasant medical procedure.

"Feeling-up"-expulsion

If you used a pen name, what would it be?

Wart Manhog

or Steve?

I drew more air, Diffee.

97

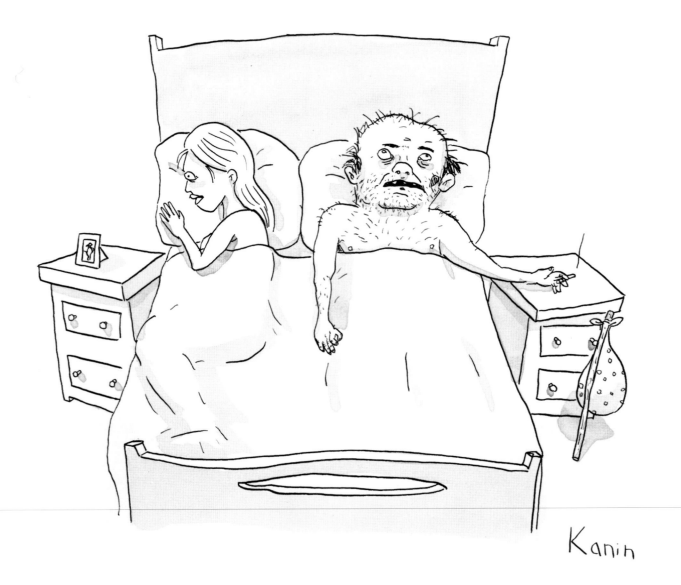

"I really would've just settled for some spare change."

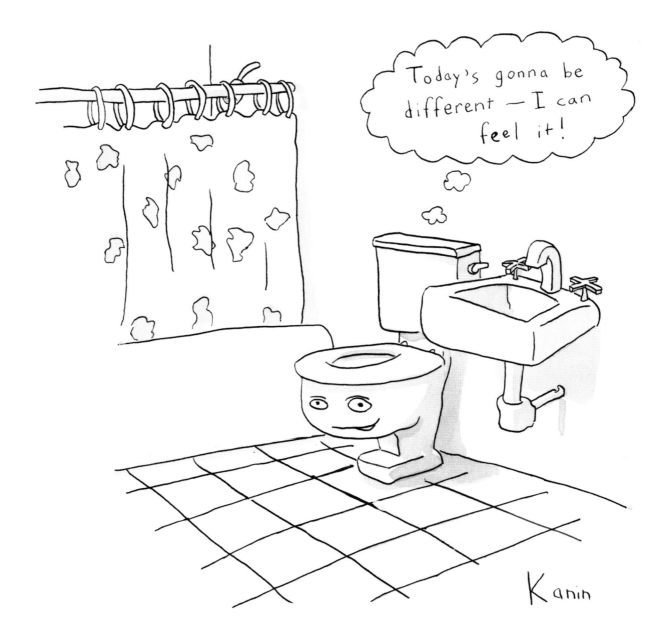

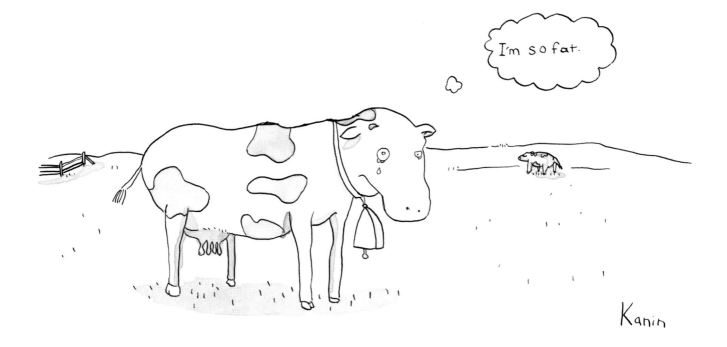

Eric Lewis

ERIC LEWIS a.k.a. LOOBAY

I was born IN NEW HAVEN, CT, FEBRUARY 10th, 1971. OH, WAIT — THE RESPONSES ARE SUPPOSED TO BE FUNNY? AH, OKAY. I KEEP jellyfish IN MY UNDERPANTS. LOL I OFFICIALLY STARTED CARTOONING in high school — A WEEKLY STRIP IN "THE EXONIAN" SCHOOL NEWSPAPER. Not long after that, I WENT THROUGH PUBERTY. I WAS REALLY INTO THE SONG 'ATHENA' BY THE WHO. I WORSHIPPED & COLLECTED MAD MAGAZINE. VISITED MAD OFFICES IN NYC.

Eventually, however, despite my best efforts, I COULDN'T FIND A JOB — BECAME A WAITER. SOLD POPCORN & CANDY @ A MOVIE THEATER and then A POSTING ON THE COLUMBIA UNIV. JOB BOARD TURNED INTO MY STINT AS A T-SHIRT DESIGNER FOR GRAVITY GRAPHICS NYC. Perhaps not surprisingly, I QUIT THAT JOB AT PUFF DADDY'S SEAN JOHN LAUNCH PARTY IN LAS VEGAS. LONG STORY. The ONE CLAIM TO FAME of THAT EXPERIENCE is THAT I DESIGNED THE Sean John LOGO. I CAN'T BELIEVE I'M STILL BOASTING ABOUT THAT. SAD, REALLY. And so, I suppose without MY CURRENT EMPLOY AS A CAD DESIGNER FOR MACY'S, I'D STILL BE LIVING WITH MY PARENTS. ES VERDAD? WHOA. IN FACT, MY FATHER DIED 3 WEEKS AGO. my FATHER DIED APRIL 28th 2007. In closing, I'd just like to say LIFE IS PRECIOUS & VERY FRAGILE AND... NUTS — NOW I'VE GOTTEN ALL HEAVY AND DEPRESSING. SORRY, EVERYONE!

met Bill Gaines!

THIS SPACE PROPERTY OF SERGIO ARAGONES

MELVIN LEWIS PSYCHIATRIST EDITOR OF THE "PURPLE BOOK"

TAUGHT ME HOW TO DRAW TRAINS & OTHER STUFF

LIKE

Frequently Asked Questions

Where do you get your ideas?
AT A PLACE OFF ROUTE 6 CALLED 'IDEA BARN'

Which comes first, the picture or the caption?
IT'S BEST WHEN THEY COME AT THE SAME TIME. WHAT!?

How'd you get started?
I BLEW BOB AT A PARTY.

I've got a great idea for a cartoon — wanna hear it?
NO!!! OKAY, YES, MOM, TELL ME...

Infrequently Asked Questions

Have you mooned or been mooned more often in your life?
I WISH I COULD SAY, BUT I'VE COMPLETELY REPRESSED THOSE MEMORIES.

What would make a terrible pizza topping?
FRIED DARK MATTER

What might one expect to find at a really low-budget amusement park?
A VIEW-MASTER REEL LIBRARY

What did the shepherd say to the three-legged sheepdog?
I GOT NOTHIN.

Complete the pie chart below in a way that tells us something about your life or how you think.

In the box below, draw something you couldn't live without.

SPY VS. SPY

102

And now for a few more questions . . .

What do you hate drawing?

PERSPECTIVE. I DON'T EVEN BELIEVE IN PERSPECTIVE, ACTUALLY. IT'S JUST A THEORY!

Being as accurate as possible, how many desert island cartoons do you think you've come up with and submitted to *The New Yorker*?

MAYBE FIFTY. SOLD TWO!

What's the funniest thing that you witnessed, overheard, or came up with that you couldn't figure out how to use in a cartoon?

I'M CONVINCED THAT DICK CHENEY HAS SOME KIND OF EMERGENCY ESCAPE POD THAT COULD BRING HIM SAFELY TO THE MOON IN A TIME OF CRISIS.

If you could ask Bob Mankoff, *The New Yorker* cartoon editor, one question, what would it be?

DO YOU STILL LOVE ME?

WHOSE HAND IS THAT?

THAT'S GOING TO CREEP BOB OUT.

Draw some sort of doodle using the random lines below as a starting point.

I CAN READ!

HOW TO TAKE MORE EFFECTIVE NAPS

Answer the following questions with a number from 1 to 10 (1 being not very much at all and 10 being quite a bit):

How much do you enjoy bowling? 8

How close have you ever come to getting a tattoo? 3

How often do you whistle or hum? 9

How much do you resemble Bea Arthur? 6 7

How likely is it that you will water-ski in the coming year? 1
DISLOCATING SHOULDERS!!

How often do you curse? 10

With what frequency do you imbibe smoothies? 2

How much do you dislike licorice? 8

What's your favorite number between one and ten? YES

How confident are you in your dancing ability? 7

How Jewish are you? 11

Please do not draw anything in the space below. Seriously, I mean it this time.

Naming Names

What name might you give to a mild-mannered, slightly overweight dental assistant in one of your cartoons?

MATT DIFFEE

Other than Lance, what name would you give to a twenty-eight-year-old metrosexual entertainment lawyer who cycles on weekends?

MATTHEW DIFFEE

What would be a good name for a new, commercially unviable breakfast cereal?

WHORE FLAKES. MONEY SHOT CLUSTERS?

Come up with a name for an unpleasant medical procedure.

LASER URETHRABRASION

If you used a pen name, what would it be?

DR. SANFORD SHARPIE

Circle your preference.

beach	OR	mountains
poetry	OR	sports
day	OR	night
llamas	OR	alpacas
Montana	OR	Maine
hot	OR	mild
jazz	OR	country
soup	OR	salad
Luke Skywalker	OR	Han Solo
accordion	OR	bagpipes
pickup truck	OR	Volkswagen Beetle
gorilla suit	OR	chicken suit
time travel	OR	free health care
swimming	OR	jogging
spring	OR	fall
General Tso's chicken	OR	Caesar salad
hip-high fishing waders	OR	lifetime supply of ketchup
life without shoes	OR	life without computers
having a facial tattoo	OR	being a vegan
$10 gift certificate to Orange Julius	OR	$50 gift certificate to Chess King
your very own dump truck	OR	an iPod
one hundred dollars in quarters	OR	snowshoes
walkie-talkie, a pogo stick, a gallon of orange juice, an extension cord, and three new pairs of scissors	OR	a canoe

OXFORD PLAINS SPEEDWAY 1988 2nd & 3rd

DEAD SHOWS EVER!

ALTHOUGH SOMEWHAT WEIRDED OUT BY FACT THAT CO. STARTED BY HITLER!

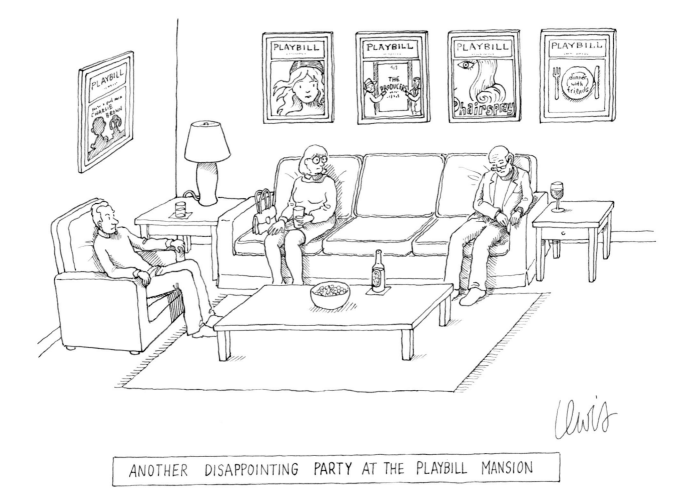

ANOTHER DISAPPOINTING PARTY AT THE PLAYBILL MANSION

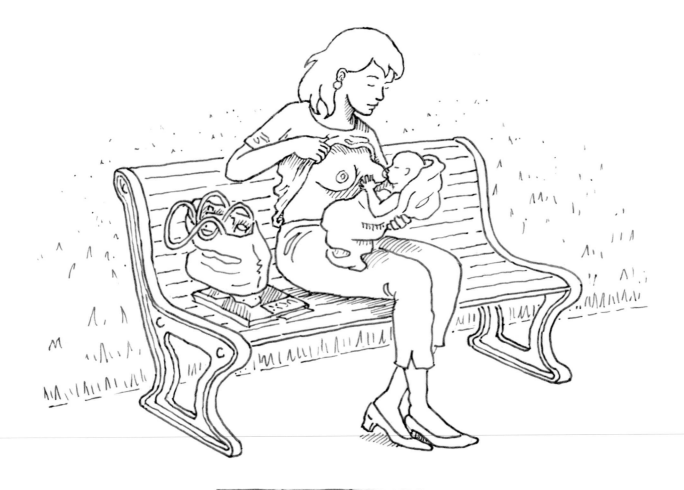

MOMS GONE WILD

Fill-in-the-Blank Bio

I was born AND RAISED BY PAINTERS — MOM ONCE SLEPT WITH JACKSON POLLOCK OR LEE KRASNER AND THEY USED jellyfish URINE AS A LUBRICANT AND SOME YEARS LATER, in high school I TRIED THIS TOO, BUT WAS ARRESTED. Not long after that, I ENROLLED IN A PAINTING ACADEMY ONLY TO DISCOVER THAT I KNEW MORE THAN MY TEACHERS, EXCEPT BOB ROSS — HE WAS AMAZING Eventually, however, despite my best efforts, I WAS THROWN OUT OF THE ACADEMY FOR 'STALKING' A MODEL, NADIA and then THREE MORE MODELS, CHLOE, NATASHA, AND INGRID GOT RESTRAINING ORDERS AGAINST ME... Bullshit*. Perhaps not surprisingly, I TRIED BEING GAY, BUT I COULDN'T SWALLOW THE WHOLE 'COCK' THING. The DISAPPOINTMENT of ALL MY SHORTCOMINGS is DIFFICULT TO WRITE ABOUT, ESPECIALLY WHILE I SIT HERE EATING A BOWL OF COCOA PUFFS. And so, I suppose without COCOA PUFFS I'D BE STUCK EATING CAPT. CRUNCH AND THAT SHIT DESTROYS THE ROOF OF MY MOUTH, DO U AGREE? OH, FOR CHRISTS SAKE, I JUST SPILLED my CEREAL ALL OVER MY LAP. In closing, I'd just like to say WHAT A THRILL IT IS TO BE WRITING (NOT DRAWING!) WITH — WARM SOY MILK ON MY GENITALS...THANKS.

* SINCE WHEN IS RUNNING INTO SOMEONE AT THE GYNECOLOGIST 'STALKING'?!

Rye

Frequently Asked Questions

Where do you get your ideas? I GET MOST OF MY IDEAS FROM ALL THE GREAT DEAD CARTOONISTS WHO CAN NO LONGER SUE ME FOR STEALING THEIR IDEAS. ALSO, MY PALS SAY FUNNY STUFF AND I JUST DRAW IT.

Which comes first, the picture or the caption?

NEITHER, SEE ABOVE

How'd you get started?

HOW DID WE ALL "GET STARTED"? THE SPERM FERTILIZES THE EGG...

I've got a great idea for a cartoon—wanna hear it?

SURE, GO AHEAD, I'M JUST GONNA LEAF BLOW MY YARD, BUT YOU GO AHEAD, I'M LISTENING

Infrequently Asked Questions

Have you mooned or *been* mooned more often in your life? NOPE, NEVER MOONED OR BEEN MOONED... NOR HAVE I STREAKED SINC THE E

What would make a terrible pizza topping? SHREDDED KITTEN CARTILAGE

What might one expect to find at a really low-budget amusement park? DEAD CHILDREN

What did the shepherd say to the three-legged sheepdog? Okay, forget corraling the sheep, how proficient are you with power point?

MY Kidney

Complete the pie chart below in a way that tells us something about your life or how you think.

In the box below, draw something you couldn't live without.

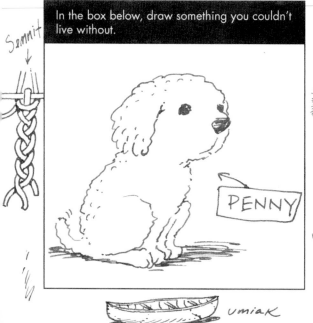

PENNY

Sennit

umiak

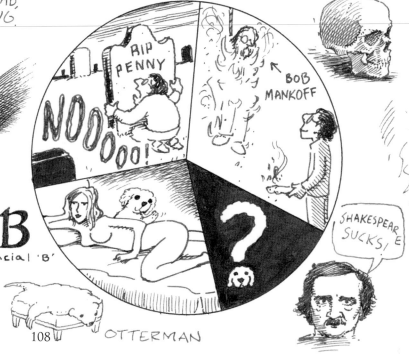

RIP PENNY
NOOOOO!
BOB MANKOFF
?
B Uncial 'B'
SHAKESPEARE SUCKS!
OTTERMAN

And now for a few more questions . . .

What do you hate drawing?
ENGLISH MUFFINS, TEMPEH, MIDWIFE-TOADS, CASSOWARIES, THE SISTINE CHAPEL, GALVANIC TRACTORS AND VENEREAL DISEASE.

Being as accurate as possible, how many desert island cartoons do you think you've come up with and submitted to *The New Yorker*?
ROUGHLY, TWENTY SEVEN AND TWO-THIRDS.

What's the funniest thing that you witnessed, overheard, or came up with that you couldn't figure out how to use in a cartoon?
I ONCE DREAMED THAT ADOLF HITLER AND ANNE FRANK WERE ON THE BRADY BUNCH, EXCEPT HITLER WAS MARSHA AND ANNE WAS PETER AND SHE HIT HITLER IN THE NOSE W/A FOOTBALL AND HITLER YELLED IN GERMAN "ICH VUN DU SHLEIP VON DEUTH!"

If you could ask Bob Mankoff, *The New Yorker* cartoon editor, one question, what would it be?
WHY DON'T WE MAKE LOVE MORE THAN ONCE A WEEK?

pyrrole

Renoir

Answer the following questions with a number from 1 to 10 (1 being not very much at all and 10 being quite a bit):

How much do you enjoy bowling? **5**
How close have you ever come to getting a tattoo? **5**
How often do you whistle or hum? **3**
How much do you resemble Bea Arthur? **1**
How likely is it that you will water-ski in the coming year? **1**
How often do you curse? **5**
With what frequency do you imbibe smoothies? **1**
How much do you dislike licorice? **5**
What's your favorite number between one and ten? **1**
How confident are you in your dancing ability? **1**
How Jewish are you? **10**

Please do not draw anything in the space below. Seriously, I mean it this time.

PENNY!

Naming Names

What name might you give to a mild-mannered, slightly overweight dental assistant in one of your cartoons? **LORTHROPE**

Other than Lance, what name would you give to a twenty-eight-year-old metrosexual entertainment lawyer who cycles on weekends? **WANKER**

What would be a good name for a new, commercially unviable breakfast cereal? **CRACK BABY CRUNCHIES**

Come up with a name for an unpleasant medical procedure. **TESTICULAR REMOVALOSCOPY**

If you used a pen name, what would it be? **FUNNY MOTHER _UCKER**

Draw some sort of doodle using the random lines below as a starting point.

man Ray

WUFF!

THE FARM WHERE PENNY WAS BORN.

WOODS

Circle your preference.

beach OR mountains OR **SEX**
PENNY OR poetry OR sports
day OR night OR **TV**
PENNY OR llamas OR alpacas
Montana OR Maine OR **VERMONT**
ORGASM OR hot OR mild
jazz OR country OR **PENNY YAWNING**
soup OR salad
Luke Skywalker **OR** Han Solo
accordion OR bagpipes OR **VALIUM**
BIKE OR pickup truck OR Volkswagen Beetle
gorilla suit OR chicken suit OR **PENNY SUIT**
time travel OR free health care
swimming OR jogging OR **SEX**
spring OR fall
General Tso's chicken OR Caesar salad OR **YOUR MOTHER**
GOLD hip-high fishing waders OR lifetime supply of ketchup
life without shoes **WHORE** life without computers
having a facial tattoo OR being a vegan **PORN STAR**
$10 gift certificate to **YER MOM** Orange Julius OR $50 gift certificate to Chess King
your very own dump truck OR an iPod OR **GUSTAV MAHLER**
one hundred dollars in quarters **PENNY'S SNORE NOISE** snowshoes
walkie-talkie, a pogo stick, a gallon of orange juice, an extension cord, and three new pairs of scissors OR a canoe OR **THIS DOG**

109

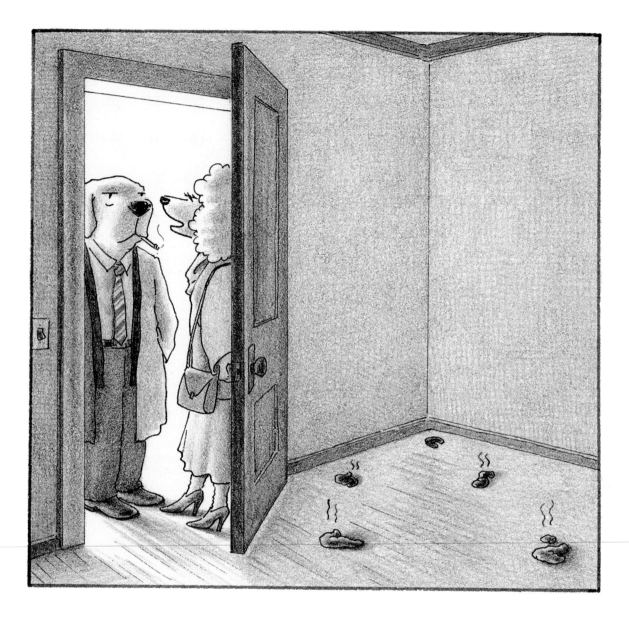

"I'd invite you in, but my crap is all over the place."

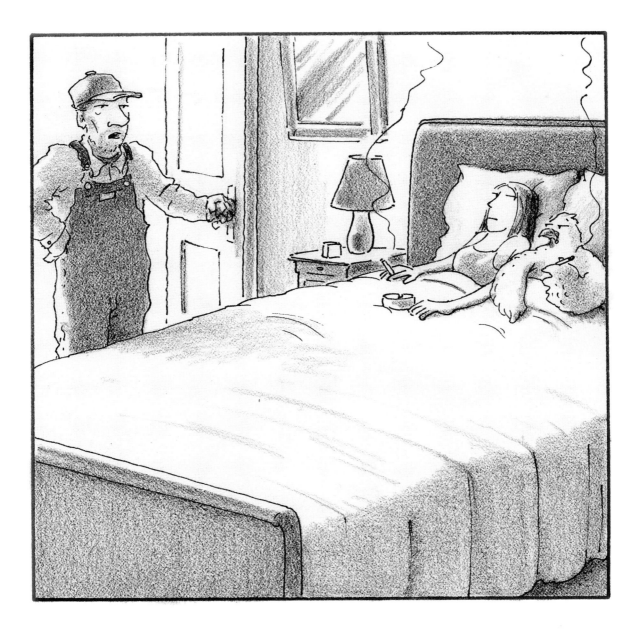

"That's it, mister. You just lost your 'free range' status."

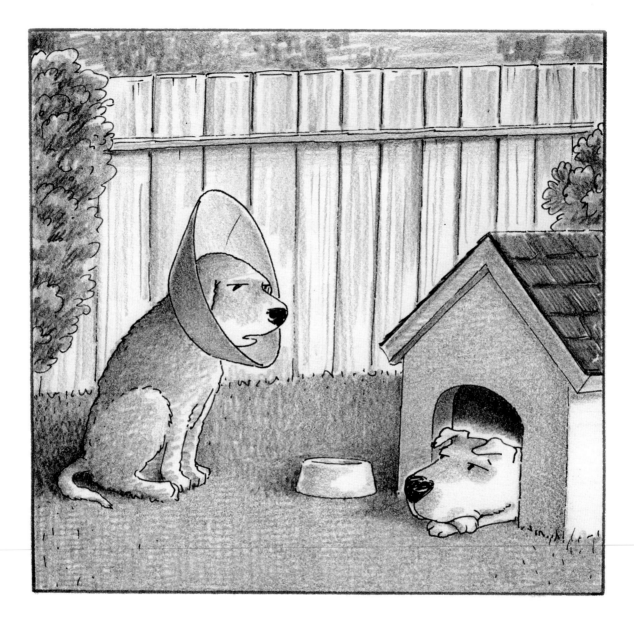

"I have an enormous favor to ask you."

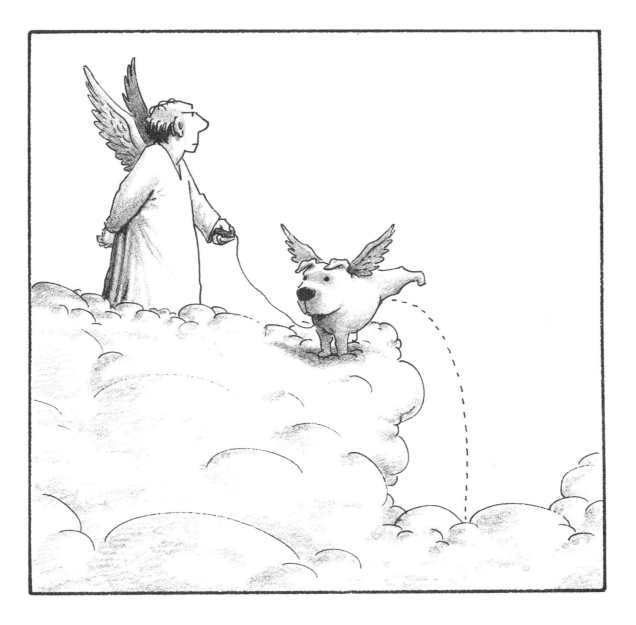

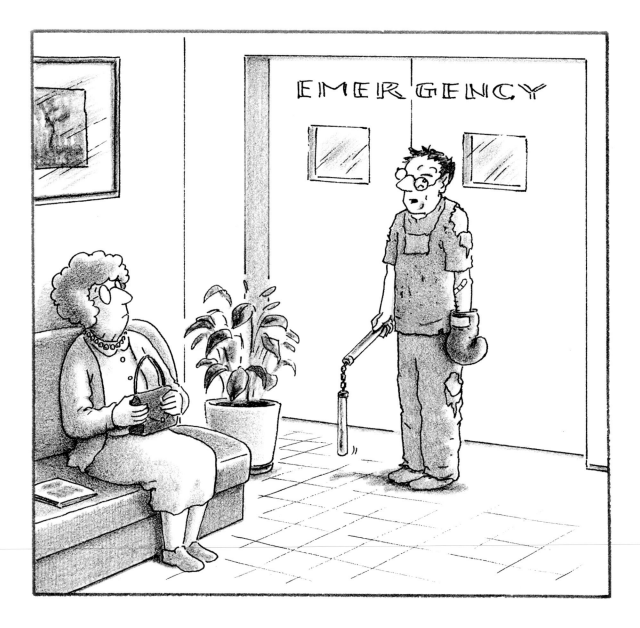

"He fought like hell."

Fill-in-the-Blank Bio

I was born in Brooklyn, about 250 years before my time, due to a glitch in the Time/Space/Continuum caused by an anti-gravity collision between a mutating jellyfish and an ancient Torah in Ethiopia. I made this discovery accidentally in high school Bio 101, during a class experiment involving rye bread mold. Not long after that, I "came out" on the Jon Stewart show as the man from the future who was living successfully in his own past," even though I couldn't acquire a taste for cauliflower nor learn how to text.

Eventually, however, despite my best efforts, I did Not make partner at the mortgage brokerage, so I smashed my hand through the glass door of my office and then moved to a stone hut on a Mexican mountaintop, to calm down, heal, learn to whistle in Spanish & teach myself to draw. Perhaps not surprisingly, creating suited me better than mortgage breaking so I returned to NYC and began cartooning. The response by editors/VIPs of the communications world is a matter of record in many media, plus Google. Though my claim to be ahead of my time is continually rejected, my existence is accepted. And so, I suppose without belaboring the point, it hasn't been so bad as far as self-recreation goes, except that you have to keep doing it. Am I right? There's really no choice; It's the only sane game. Also I'm lucky that my wife Judith and daughter Lilia give me great backup. In closing, I'd just like to say that I'm grateful I got here — so far, so good, so thin — and with a full head of hair yet, even though I'm 250 years early.

Frequently Asked Questions

Where do you get your ideas? I put a tooth under my pillow when I go to sleep and the next morning, when I wake up, there they are!

Which comes first, the picture or the caption? The one that's more turned on from the foreplay.

How'd you get started? Well, the way I understand it, first my father and mother had sex with each other.....

I've got a great idea for a cartoon—wanna hear it? What? What? What did you say? Sorry, but my hearing aid is on the fritz and I can't ... What? WHAT? You ate a DEER ?!?

Infrequently Asked Questions

Have you mooned or been mooned more often in your life? obviously →

What would make a terrible pizza topping? A big, fat meditating Buddhist monk.

What might one expect to find at a really low-budget amusement park? A flashlight-lit copy of the Gettysburg Address, with a scratchy soundtrack of 'The Battle Hymn of the Republic' sung by John Ashcroft.

What did the shepherd say to me three-legged sheepdog? MAY THE FOURTH BE WITH YOU.

Complete the pie chart below in a way that tells us something about your life or how you think.

In the box below, draw something you couldn't live without.

IDEAS A-B
IDEAS C-D
IDEAS
IDEAS G-H

THE KNICKS
OLIVES TRAVEL
LILIA
Singing
Sour cream
movies
Judith
WORD Bread
SEDERS
TUNA FISH
SEX Fiction
CROSS THE LINES
NO WRISTWATCH
PHOTOSHOP
FUNNY
Run!

INGREDIENTS OF MORT'S PIE
(in no fixed proportion or quantity, which change every day.)

116

And now for a few more questions . . .

What do you hate drawing?

I hate drawing attention to myself. (Hah! Now there's a laugh!)

Being as accurate as possible, how many desert island cartoons do you think you've come up with and submitted to *The New Yorker*? *Only four— because I ran out of little bottles to stuff the drawings in.*

What's the funniest thing that you witnessed, overheard, or came up with that you couldn't figure out how to use in a cartoon? *George Bush's shipboard "Mission Accomplished" scene. Since it was already 100% pure self-satire, it was satire-proof— and I cried because I hadn't thought of the idea myself.*

If you could ask Bob Mankoff, *The New Yorker* cartoon editor, one question, what would it be?

PLEASE, SIR—MAY I HAVE SOME MORE OKs?

Draw some sort of doodle using the random lines below as a starting point.

Answer the following questions with a number from 1 to 10 (1 being not very much at all and 10 being quite a bit):

How much do you enjoy bowling? **5**

How close have you ever come to getting a tattoo? **000**

How often do you whistle or hum? **1**

How much do you resemble Bea Arthur? **100**

How likely is it that you will water-ski in the coming year? **1**

How often do you curse? **3x !*?*("x#!)9?**

With what frequency do you imbibe smoothies? **0**

How much do you dislike licorice? **10** *(ask me why)*

What's your favorite number between one and ten? **4½**

How confident are you in your dancing ability? **100000**

How Jewish are you? **1,000,000** *MORE THAN MANY.*

Please do not draw anything in the space below. Seriously, I mean it this time.

OK OK OK I HEAR YOU BUT THIS IS NOT DRAWING!

Circle your preference.

beach	(OR)	mountains
poetry	OR	(sports)
day	(OR)	night
llamas	(OR)	alpacas
Montana	(OR)	Maine
hot	(OR)	mild
(jazz)	OR	country
soup	(OR)	salad
Luke Skywalker	(OR)	Han Solo
accordion	(OR)	bagpipes
pickup truck	OR	(Volkswagen Beetle)
gorilla suit	(OR)	chicken suit
(time travel)	OR	free health care
swimming	(OR)	jogging
spring	(OR)	fall
(General Tso's chicken)	OR	Caesar salad
hip-high fishing waders	OR	(lifetime supply of ketchup)
life without shoes	OR	(life without computers)
having a facial tattoo	OR	(being a vegan)
$10 gift certificate to Orange Julius	(OR)	$50 gift certificate to Chess King
your very own dump truck	(OR)	an iPod
(one hundred dollars in quarters)	OR	snowshoes
(walkie-talkie, a pogo stick, a gallon of orange juice, an extension cord, and three new pairs of scissors)	OR	a canoe

Naming Names

What name might you give to a mild-mannered, slightly overweight dental assistant in one of your cartoons? *Flossie*

Other than Lance, what name would you give to a twenty-eight-year-old metrosexual entertainment lawyer who cycles on weekends? *Geary Wheeler*

What would be a good name for a new, commercially unviable breakfast cereal? *Sugar-Soaked Barf-fart Flakes*

Come up with a name for an unpleasant medical procedure. *Upyouroscopy*

If you used a pen name, what would it be? *Monsieur Mont Blanc*

Your place (OR) mine

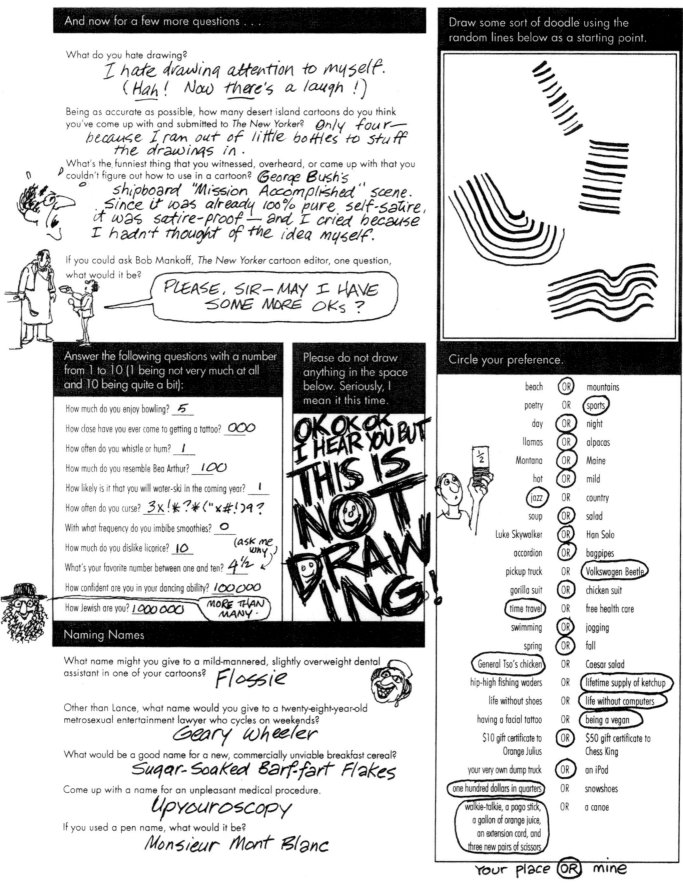

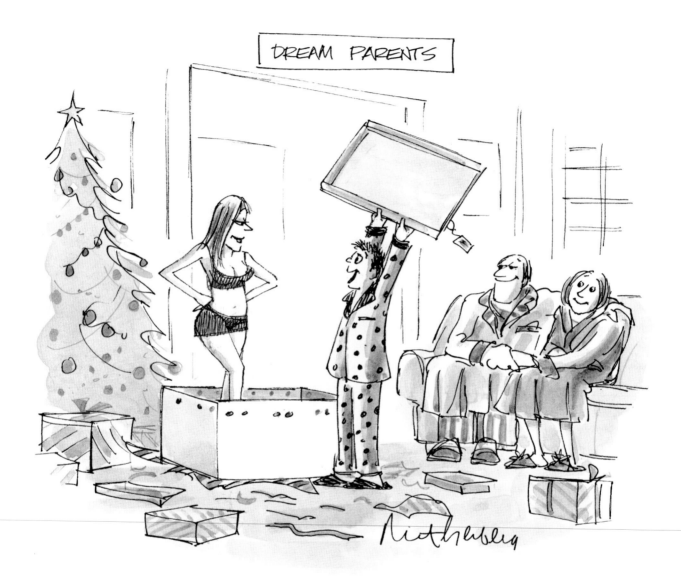

"Oh wow, Mom and Dad, a real ho of my own!"

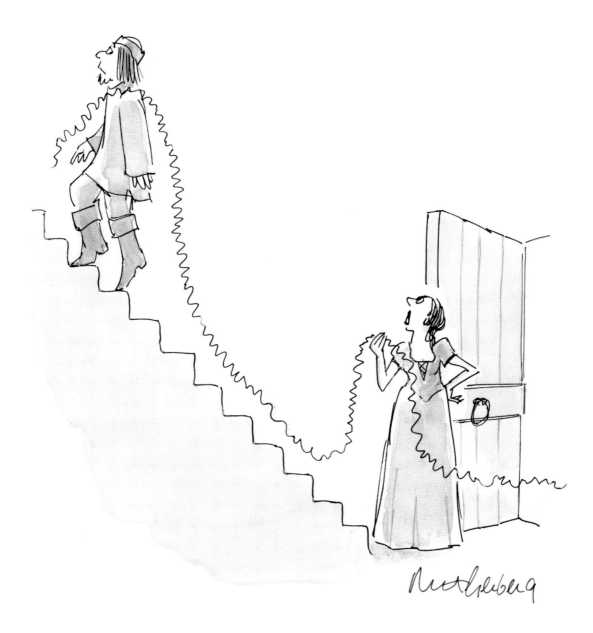

"I knew it. You've been sleeping with that Rapunzel bitch."

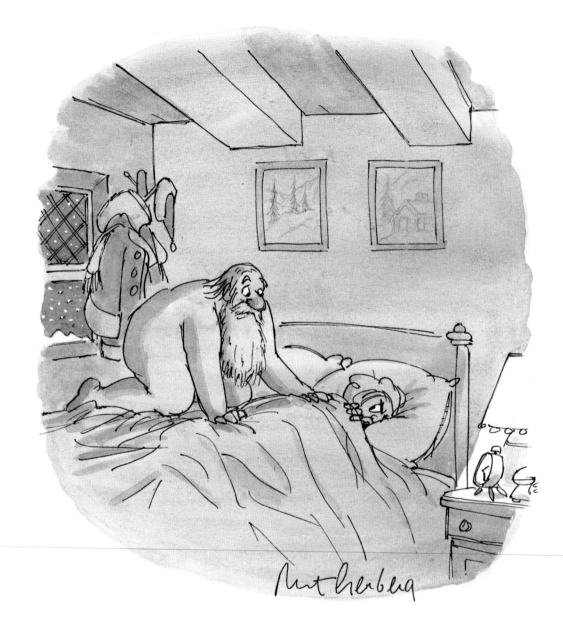

"Take a shower first. You smell like a chimney."

Jason Patterson

I was born ___Utica Mississippi___, then ___→___
On my honey moon I got stung by jellyfish ___snorkeling___ before that
___→___ in high school ___I wanted to draw super hero comics.___
Not long after that, ___I went to RISD, and studied animation, I___
___really loved "stop motion" animation. ___→___
Eventually, however, despite my best efforts, ___I started submitting to the "New Yorker"___
___and got a call back___ and then ___began turning in a "batch" every___
___week, which was great.___ Perhaps not surprisingly, ___I got___
___better, and was first published a year___. The ___funny thing of___
___it is, if I is hadn't gotten fired from a ___Later.___
___An "animation" job I never would___. And so, I suppose without ___this I never___
___would have submitted work to the "New Yorker" • Did I say that twice?___
___• my ___.
In closing, I'd just like to say ___I'm so lucky to be able to do a job I love___
___so much.___

Where do you get your ideas?
I think of my best ideas when I'm not trying to think of ideas.

Which comes first, the picture or the caption?

picture

How'd you get started?
I sold my first cartoon to a local paper for $20, in high school

I've got a great idea for a cartoon—wanna hear it?

Ok, just keep in mind 9 out of 10 ideas are bad.

Have you mooned or *been* mooned more often in your life?

been

What would make a terrible pizza topping?

corn

What might one expect to find at a really low-budget amusement park?

porn

What did the shepherd say to the three-legged sheepdog?

How do you do?

(And paper)

And now for a few more questions . . .

What do you hate drawing?

cars. I can't seem to get them right.

Being as accurate as possible, how many desert island cartoons do you think you've come up with and submitted to *The New Yorker*?

20

What's the funniest thing that you witnessed, overheard, or came up with that you couldn't figure out how to use in a cartoon?

Someone farted on the subway really loud, but everyone was completely staved faced about it. killed me.

If you could ask Bob Mankoff, *The New Yorker* cartoon editor, one question, what would it be?

where can you get a good sandwich in mid town?

Draw some sort of doodle using the random lines below as a starting point.

Answer the following questions with a number from 1 to 10 (1 being not very much at all and 10 being quite a bit):

How much do you enjoy bowling? 4

How close have you ever come to getting a tattoo? 1

How often do you whistle or hum? 6

How much do you resemble Bea Arthur? 2

How likely is it that you will water-ski in the coming year? 3

How often do you curse? 4

With what frequency do you imbibe smoothies? 3

How much do you dislike licorice? 3

What's your favorite number between one and ten? 7

How confident are you in your dancing ability? 4

How Jewish are you? 2

Please do not draw anything in the space below. Seriously, I mean it this time.

Naming Names

What name might you give to a mild-mannered, slightly overweight dental assistant in one of your cartoons?

Steven

Other than Lance, what name would you give to a twenty-eight-year-old metrosexual entertainment lawyer who cycles on weekends?

Steve

What would be a good name for a new, commercially unviable breakfast cereal?

bacon bits

Come up with a name for an unpleasant medical procedure.

Brain transplant

If you used a pen name, what would it be?

Linwood

Circle your preference.

~~beach~~	OR	mountains
poetry	OR	~~sports~~
~~day~~	OR	night
~~llamas~~	OR	alpacas
Montana	OR	~~Maine~~
hot	OR	~~cold~~
~~jazz~~	OR	country
~~soup~~	OR	salad
Luke Skywalker	OR	~~Han Solo~~
~~accordion~~	OR	bagpipes
pickup truck	OR	~~Volkswagen Beetle~~
~~gorilla suit~~	OR	chicken suit
~~time travel~~	OR	free health care
~~swimming~~	OR	jogging
spring	OR	~~fall~~
General Tso's chicken	OR	~~Caesar salad~~
hip-~~high fishing waders~~	OR	lifetime supply of ketchup
~~life without shoes~~	OR	life without computers
having a facial tattoo	OR	~~being a vegan~~
$10 gift certificate to Orange Julius	OR	~~$50 gift certificate to Chess King~~
~~your very own dump truck~~	OR	an iPod
one hundred dollars in quarters	OR	~~snowshoes~~
walkie-talkie, a pogo stick, a gallon of orange juice, an extension cord, and three new pairs of scissors	OR	~~a canoe~~

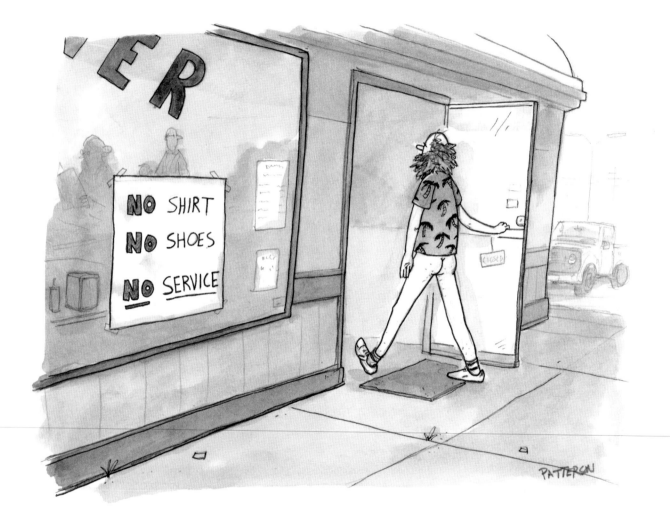

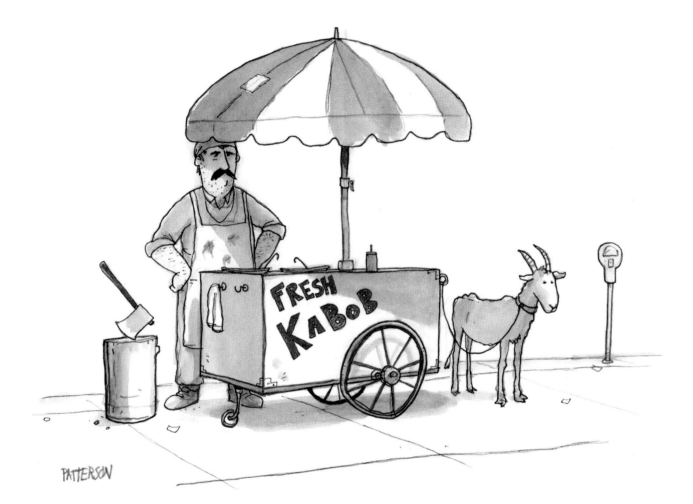

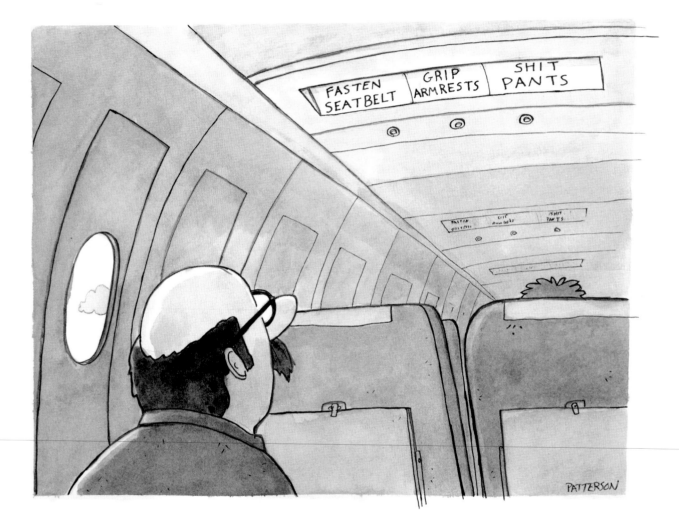

C. Covert Darbyshire

Fill-in-the-Blank Bio

I was born _EARLY IN LIFE TO ALCOHOLIC PARENTS WHO SHOULD HAVE KNOWN BETTER THAN TO SNORT LIVE_ jellyfish _DROPPINGS ON A FULL MOON WHILE STILL_ in high school _AND NOT USING PROTECTION_.

Not long after that, _I WAS DISCOVERED TO BE A CHILD MUSIC PRODIGY UNTIL MY DRUNK FATHER DROPPED ME ON MY HEAD_.

Eventually, however, despite my best efforts, _I WAS FORCED TO GIVE UP GUITAR AND TOOK UP THE FLUTE_ and then _FORMED A CLASSICAL GARAGE BAND FOR "SPECIAL" KIDS LIKE MYSELF_. Perhaps not surprisingly, _NO GIRLS EVER CAME TO OUR SHOWS - SO WE BROKE UP_. The _LEADER_ of THE BAND, is _NOW SINGING FOR THE GROUP "COLD PLAY" AND IS MARRIED TO SOME MOVIE STAR_. And so, I suppose without _ME HE WOULD NEVER HAVE GOTTEN THAT FAR, SO NATURALLY I SUED HIM, RIGHT? ANYWAY HOW ELSE WOULD I HAVE BOUGHT_ my _SWEET YELLOW HUMMER?_

In closing, I'd just like to say _I'M FAIRLY DRUNK RIGHT NOW AND LISTENING TO COLDPLAY_.

Frequently Asked Questions

Where do you get your ideas?

I REWORK DREW DERNAVICH & MATT ~~DIFEES~~ DIFFEE'S REJECTS

Which comes first, the picture or the caption?

1) EGG
2) CAPTION
3) GOOGLE IMAGES
4) RUBBER GLOVE
5) CHICKEN
6) PICTURE

How'd you get started?

PHOTOS OF MANKOFF.

I've got a great idea for a cartoon—wanna hear it?

HOLD THAT THOUGHT...

Infrequently Asked Questions

Have you mooned or *been* mooned more often in your life?

BEEN. I USED TO TRAIN BABOONS IN NAROBI.

What would make a terrible pizza topping?

GRAVY...

What might one expect to find at a really low-budget amusement park?

PEOPLE BEING MALLED BY LIONS.

What did the shepherd say to the three-legged sheepdog?

HOW WAS THE AMUSEMENT PARK?

In the box below, draw something you couldn't live without.

Complete the pie chart below in a way that tells us something about your life or how you think.

128

What do you hate drawing?

FUDGE (W/NUTS)

Being as accurate as possible, how many desert island cartoons do you think you've come up with and submitted to *The New Yorker*?

36. 37 IF YOU COUNT THAT ONE.

What's the funniest thing that you witnessed, overheard, or came up with that you couldn't figure out how to use in a cartoon?

A CAR DEALERSHIP WHERE EACH CAR, IN ADDITION TO A SPARE TIRE, COMES WITH A GERMAN MIDGET MECHANIC. IN A CASE ON THE BACK NEXT TO THE TIRE.

If you could ask Bob Mankoff, *The New Yorker* cartoon editor, one question, what would it be? COULD YOU PLEASE STOP HITTING ON MY WIFE?

Draw some sort of doodle using the random lines below as a starting point.

Answer the following questions with a number from 1 to 10 (1 being not very much at all and 10 being quite a bit):

How much do you enjoy bowling? TAKE IT OR LEAVE IT.

How close have you ever come to getting a tattoo? 5 MORE BEERS

How often do you whistle or hum? YES.

How much do you resemble Bea Arthur? 5 MORE BEERS

How likely is it that you will water-ski in the coming year? SHARK JUMPER

How often do you curse? WHAT THE @*! IS THAT SUPPOSED TO MEAN?

With what frequency do you imbibe smoothies? STRAWBERRY/BANANA

How much do you dislike licorice? 25 YRS. TO LIFE

What's your favorite number between one and ten? 7

How confident are you in your dancing ability? BLUE RIBBON

How Jewish are you? NOT ENOUGH FOR HOLLYWOOD.

Please do not draw anything in the space below. Seriously, I mean it this time.

DIFFEE SUCKS

Naming Names

What name might you give to a mild-mannered, slightly overweight dental assistant in one of your cartoons? WENDALL.

Other than Lance, what name would you give to a twenty-eight-year-old metrosexual entertainment lawyer who cycles on weekends?
DEXTER.

What would be a good name for a new, commercially unviable breakfast cereal?
BOWEL MOVERS.

Come up with a name for an unpleasant medical procedure.
~~JOHNECTOMY~~ JOHNSONECTOMY

If you used a pen name, what would it be?
DEXTER WENDALLSTON

Circle your preference.

(beach)	OR	mountains
poetry	OR	(sports)
(day)	OR	night
llamas	NOR	alpacas
Montana	OR	(Maine)
hot	OR	(mild)
jazz	NOR	country
(soup)	OR	salad
Luke Skywalker	OR	(Han Solo)
accordion	OR	(bagpipes)
(pickup truck)	OR	Volkswagen Beetle
(gorilla suit)	OR	chicken suit
(time travel)	OR	free health care
(swimming)	OR	jogging
spring	OR	(fall)
(General Tso's chicken)	OR	Caesar salad
hip-high fishing waders	NOR	lifetime supply of ketchup
(life without shoes)	OR	life without computers
having a facial tattoo	N OR	being a vegan
$10 gift certificate to Orange Julius	NOR	$50 gift certificate to Chess King
(your very own dump truck)	OR	an iPod
(one hundred dollars in quarters)	OR	snowshoes
walkie-talkie, a pogo stick, a gallon of orange juice, an extension cord, and three new pairs of scissors	OR	(a canoe IN A POOL OF CHOCOLATE)

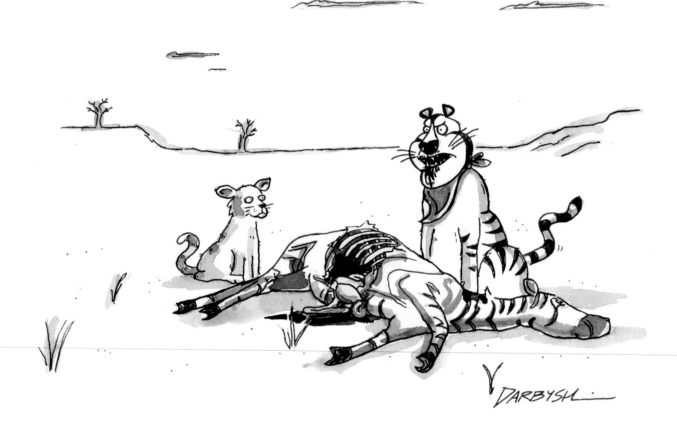

"Sure, it was a sweet gig, but I'm a carnivore for Pete's sake."

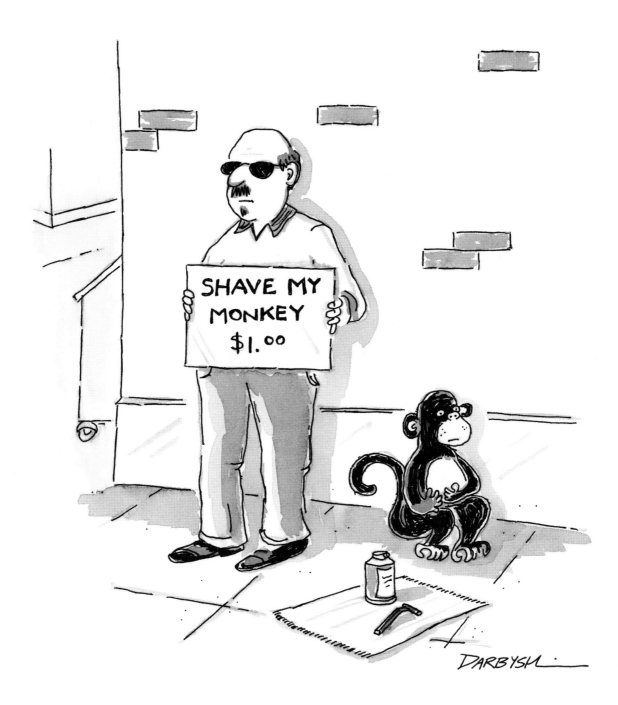

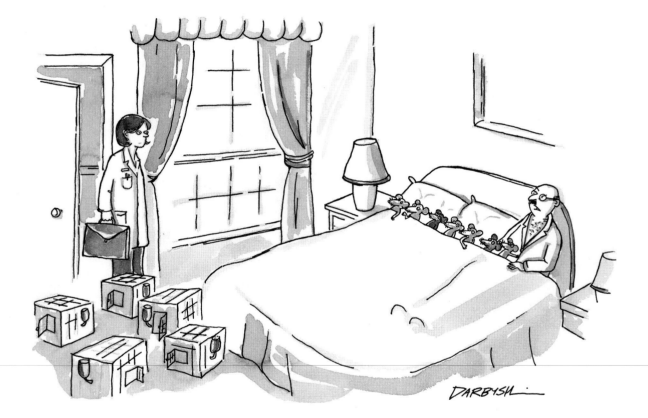

"Yes, it's exactly what it looks like, and no, I don't know where this leaves us and our research."

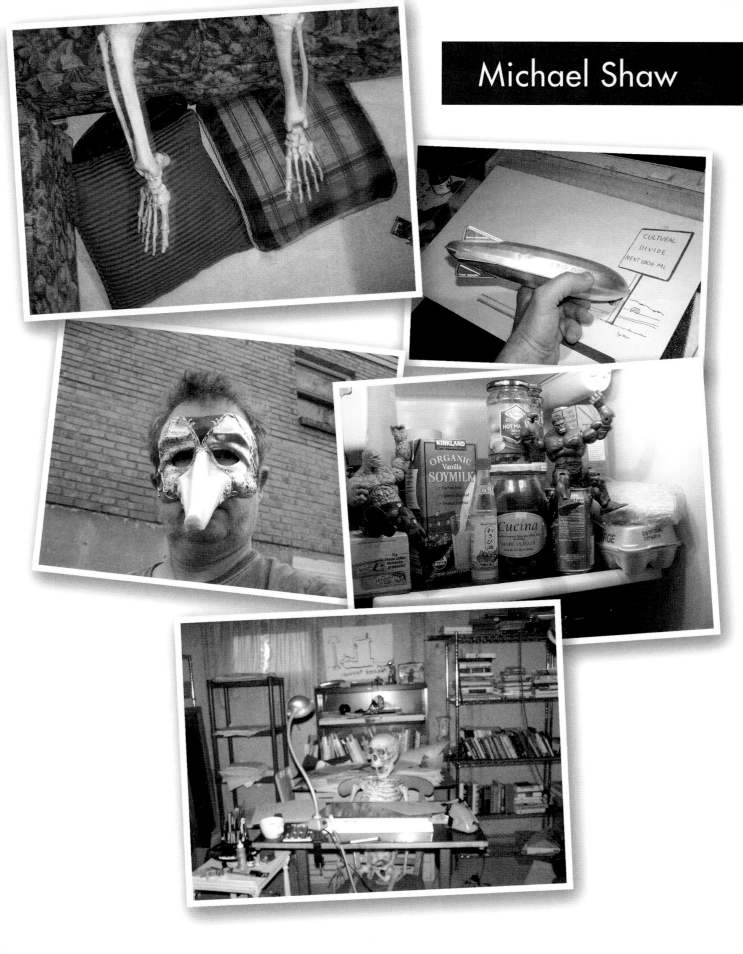

Michael Shaw

I was born in the house my father built. (Sorry, that was Dick Nixon.) In the ~~████~~ of a traveling ~~jellyfish~~ (sorry, that was Cher.) I was born in ~~high school~~ St. Louis amid humble surroundings. Not long after that, a copy of "Thurber & Company" arrived with the usual pile of Christmas swag — ~~and I was hooked.~~ ~~Eventually, however,~~ despite my best efforts, truthfully, I wonder what my "best-efforts" ~~should~~ ~~and then~~ actually look like. (I hope they might be better drawn.) Perhaps not surprisingly, ~~readers are~~ already tiring of my self-absorbed ~~████~~ diatribe. I mean, how many of these things can you read? Perhaps ~~fans~~ would enjoy. ~~And so, I suppose, without~~ bonus cartoon coverage! Then again, ~~████~~ really not? ~~████~~ I love you ~~In closing, I'd just like to say~~ one and all.

Frequently Asked Questions

Where do you get your ideas?

I've never been asked that question.

Which comes first, the picture or the caption?

Actually I have been asked that question — but not frequently.

How'd you get started?

~~⌒○⌒ ○~~

I've got a great idea for a cartoon—wanna hear it?

I think you'd have to read it, instead.

Infrequently Asked Questions

Have you mooned or *been* mooned more often in your life?

(LIVED IN WISCONSIN)

What would make a terrible pizza topping?

foil

What might one expect to find at a really low-budget amusement park?

GOD

What did the shepherd say to the three-legged sheepdog?

DOG

Complete the pie chart below in a way that tells us something about your life or how you think.

Two guys walk into a bar... the third guy ducked.

AIR ↵

In the box below, draw something you couldn't live without.

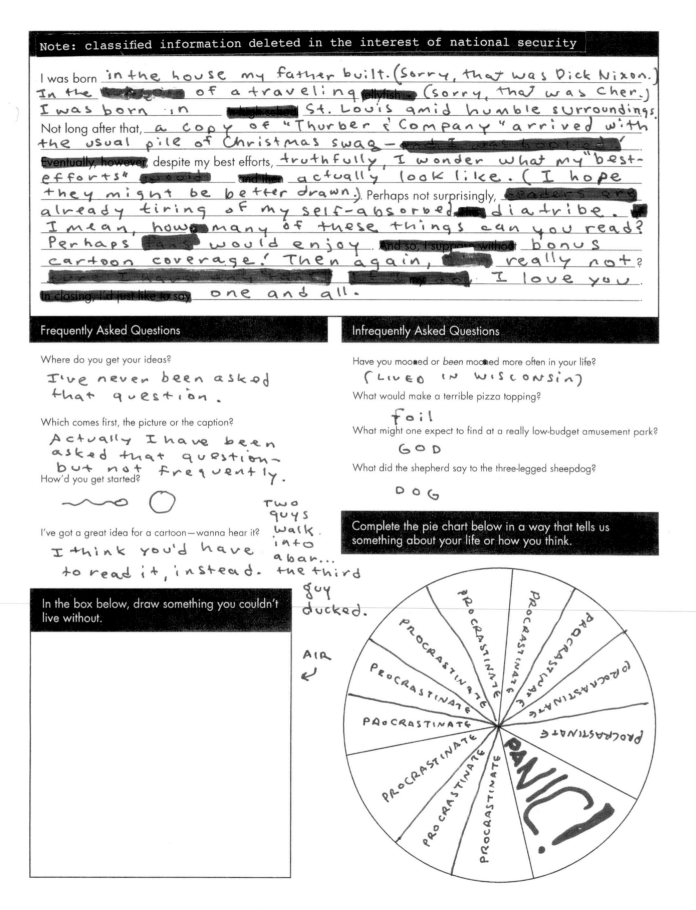

134

Sorry, I'm using this space for a cartoon
I've submitted 127 times and have never sold.

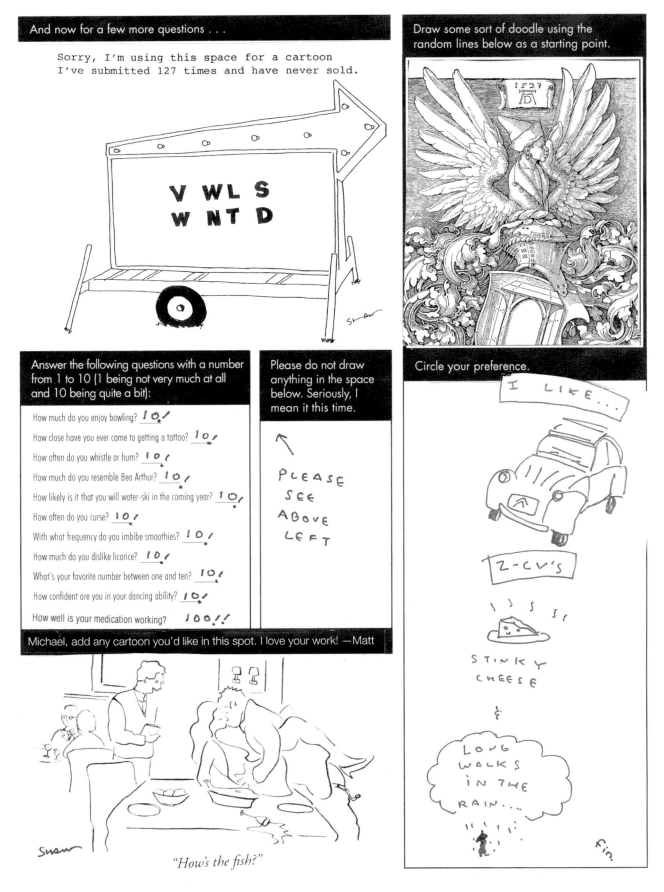

V WL S
W NT D

Draw some sort of doodle using the random lines below as a starting point.

Answer the following questions with a number from 1 to 10 (1 being not very much at all and 10 being quite a bit):

How much do you enjoy bowling? 10

How close have you ever come to getting a tattoo? 10

How often do you whistle or hum? 10

How much do you resemble Bea Arthur? 10

How likely is it that you will water-ski in the coming year? 10

How often do you curse? 10

With what frequency do you imbibe smoothies? 10

How much do you dislike licorice? 10

What's your favorite number between one and ten? 10

How confident are you in your dancing ability? 10

How well is your medication working? 100!!

Please do not draw anything in the space below. Seriously, I mean it this time.

PLEASE SEE ABOVE LEFT

Circle your preference.

I LIKE...

2-CV'S

STINKY CHEESE

&

LONG WALKS IN THE RAIN...

fin.

Michael, add any cartoon you'd like in this spot. I love your work! —Matt

"How's the fish?"

135

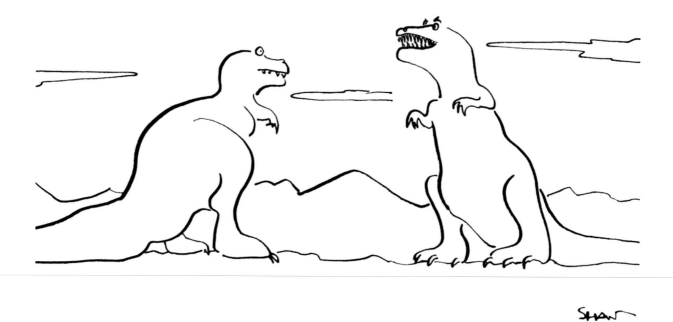

"I'd give up being the most fearsome creature on the planet if I could just reach my weenie."

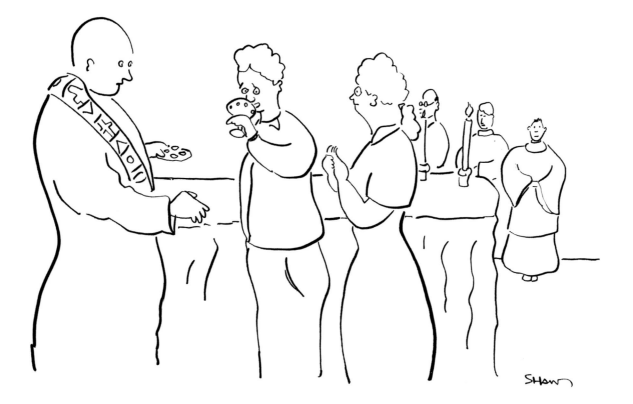

"I'm getting earthy overtones of guilt, with just a hint of sexual frustration."

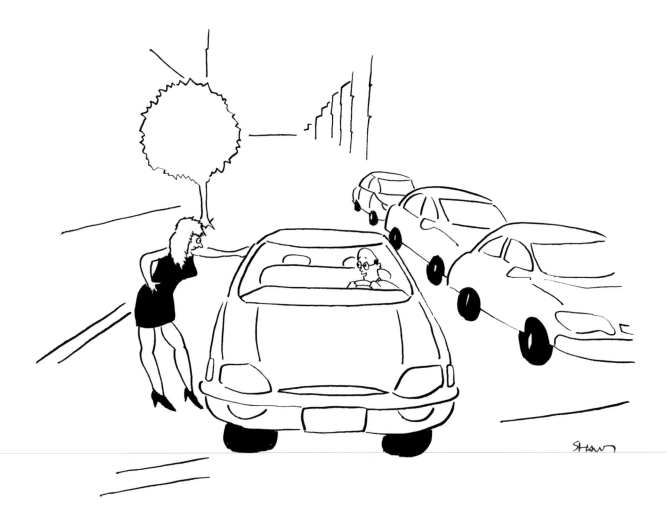

"Throw in a prostate exam and you've got a deal!"

Fill-in-the-Blank Bio

I was born IN A FAIRLY WELL-KNOWN STATE WHICH I AM NOT AT LIBERTY (HINT) TO DISCLOSE. OK, NEW JERSEY. jellyfish WERE WHAT WE ATE ON FRIDAYS, BEING POOR. in high school I WAS INVISIBLE, MOSTLY TO MY FAMILY. Not long after that, I WENT TO NEW YORK CITY TO PEDDLE CARTOONS FROM A SHOPPING CART TO PAY FOR MY ZITHER LESSONS.

Eventually, however, despite my best efforts, I WAS UNABLE TO FIND THE NEW YORKER ANYWHERE IN THE CITY and then EXPANDED MY SEARCH TO FAR ROCKAWAY GUIDED BY ANOTHER CARTOONIST'S MAP. Perhaps not surprisingly, I STARTED BREEDING CATS AS A WAY TO MEET LONELY WOMEN. The MORAL of THIS STORY is CARTOONING IS MUCH HARDER THAN CAT BREEDING AND CATS WON'T BREAK YOUR HEART. And so, I suppose without ANY ADIEU S WHATSOEVER, I will move on to the REST OF THIS QUESTIONNAIRE. I DIDN'T SEE THAT QUESTION MARK COMING my WAY OR SINATRA'S WAY. In closing, I'd just like to say PASTA REALLY IS BETTER REHEATED THE SECOND DAY.

Frequently Asked Questions

Where do you get your ideas?
I FIND THEM UNDER MY PILLOW WHEN I WAKE UP.

Which comes first, the picture or the caption?
THE CAPTION, WHICH THEN SMOKES A CIGARETTE....OH PLEASE !!!

How'd you get started?
IN THE CHILD CARTOON FACTORIES OF KOREA

I've got a great idea for a cartoon—wanna hear it?
IS IT IN ANY WAY HURTFUL OR INSENSITIVE ?

Infrequently Asked Questions

Have you mooned or *been* mooned more often in your life?
BEEN MOONED, USUALLY BY CLERGY.

What would make a terrible pizza topping?
THE LEG OF A SHEEPDOG

What might one expect to find at a really low-budget amusement park?
ME, HAVING A FABULOUS TIME.

What did the shepherd say to the three-legged sheepdog?
WHAT COULD HE SAY ? IT WAS ALL VERY SAD.

Complete the pie chart below in a way that tells us something about your life or how you think.

In the box below, draw something you couldn't live without.

What do you hate drawing?

MOST OUTDOOR SCENES.

Being as accurate as possible, how many desert island cartoons do you think you've come up with and submitted to *The New Yorker*?

227 AND SOLD EVERY ONE.

What's the funniest thing that you witnessed, overheard, or came up with that you couldn't figure out how to use in a cartoon?

SANDALS WITH BLACK SOCKS

If you could ask Bob Mankoff, *The New Yorker* cartoon editor, one question, what would it be?

"BOB, MAY I ASK YOU THREE QUESTIONS?"

Draw some sort of doodle using the random lines below as a starting point.

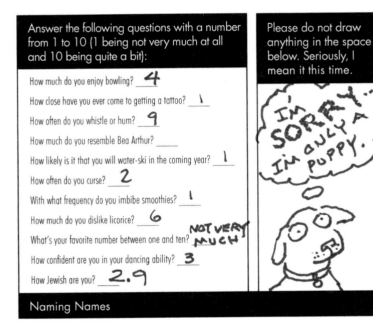

Answer the following questions with a number from 1 to 10 (1 being not very much at all and 10 being quite a bit):

How much do you enjoy bowling? **4**

How close have you ever come to getting a tattoo? **1**

How often do you whistle or hum? **9**

How much do you resemble Bea Arthur? _____

How likely is it that you will water-ski in the coming year? **1**

How often do you curse? **2**

With what frequency do you imbibe smoothies? **1**

How much do you dislike licorice? **6**

What's your favorite number between one and ten? **NOT VERY MUCH**

How confident are you in your dancing ability? **3**

How Jewish are you? **2.9**

Please do not draw anything in the space below. Seriously, I mean it this time.

I'M SORRY. I'M ONLY A PUPPY.

Naming Names

What name might you give to a mild-mannered, slightly overweight dental assistant in one of your cartoons?

ROGER

Other than Lance, what name would you give to a twenty-eight-year-old metrosexual entertainment lawyer who cycles on weekends?

I'D GIVE HIM MY DAUGHTER'S NAME.

What would be a good name for a new, commercially unviable breakfast cereal?

ROTO ROOTIES

Come up with a name for an unpleasant medical procedure.

CASSANDRA

If you used a pen name, what would it be?

SHARPIE

Circle your preference.

(beach)	OR	mountains
poetry	OR	(sports)
(day)	OR	night
llamas	OR	(alpacas)
(Montana)	OR	Maine
hot	OR	(mild)
(jazz)	OR	country
(soup)	OR	salad
Luke Skywalker	OR	~~Han Solo~~ (WILLY MAYS)
accordion	OR	(bagpipes)
(pickup truck)	OR	Volkswagen Beetle
(gorilla suit)	OR	chicken suit
(time travel)	OR	free health care
(swimming)	OR	jogging
(spring)	OR	fall
(General Tso's chicken)	OR	Caesar salad
(hip-high fishing waders)	OR	lifetime supply of ketchup
life without shoes	OR	(life without computers)
(having a facial tattoo)	OR	being a vegan
($10 gift certificate to Orange Julius)	OR	$50 gift certificate to Chess King
your very own dump truck	OR	(an iPod)
(one hundred dollars in quarters)	OR	snowshoes
walkie-talkie, a pogo stick, a gallon of orange juice, an extension cord, and three new pairs of scissors	OR	(a canoe)

"Good evening, ladies and gentlemen, this is Jack Kruthers on the toilet."

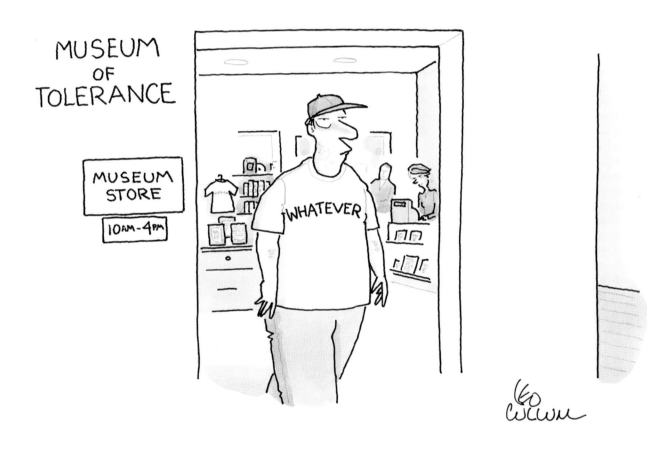

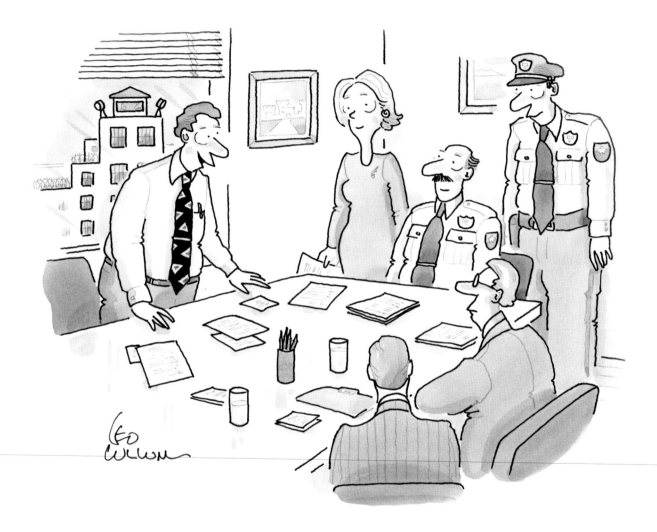

"*And if we start televising the executions we can also market a hilarious bloopers tape.*"

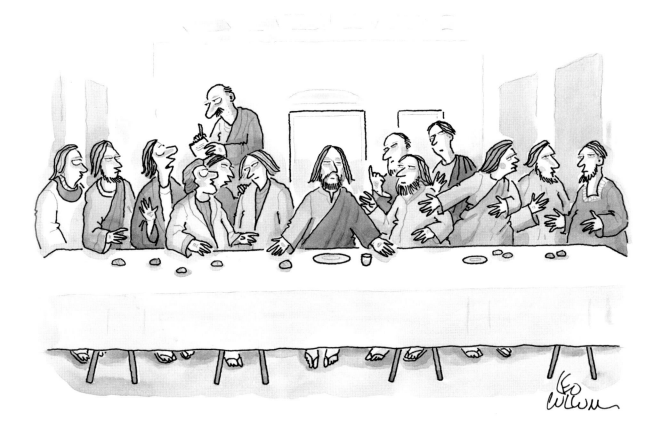

"What did Jesus order?"

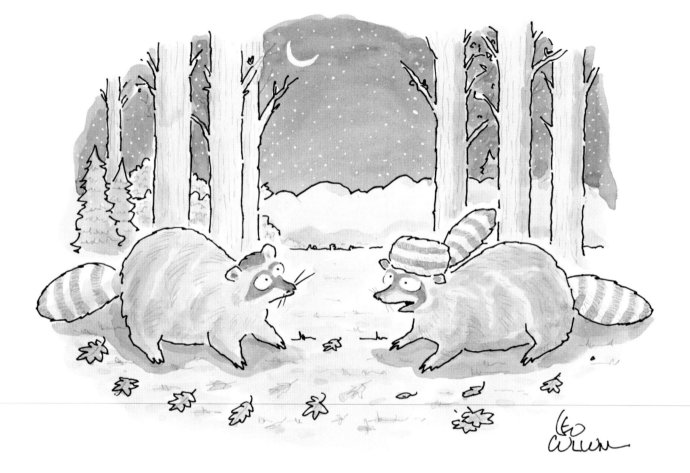

"*Now I think of Mom whenever it's cold.*"

Carolita Johnson

I was born. *What more do you want to know? I was born. Basta. Here I am, you jellyfish!!*

Back in high school, *I did well in school.* Not long after that, *I did well in college, but tried to drop out.* Eventually, however, despite my best efforts, *I ended up in France, modelling clothes.* and then *went back to school and stalled for another 5 years.* Perhaps not surprisingly, *I became a cartoonist in New York.* The *moral* of *this story* is *get a good job and listen to your parents, or else become a cartoonist.* And so, I suppose without *further ado, I will accept the consequences of my irresponsible life by finishing this silly questionnaire in* my *kitchen before work.* In closing, I'd just like to say *that this is what you get for working with Diffee.*

Where do you get your ideas?

Not from the gag-writers who keep e-mailing me with proposals!

Which comes first, the picture or the caption?

70% the caption, 29% the picture, 1% both at the same time.

How'd you get started?

Don't get me started.

I've got a great idea for a cartoon—wanna hear it?

NO!!!

Have you mooned or *been* mooned more often in your life?

I am mooning you right now.

What would make a terrible pizza topping?

~~crossed out~~ what doesn't?

What might one expect to find at a really low-budget amusement park?

Me — I love low budget amusement parks!

What did the shepherd say to the three-legged sheepdog?

In the box below, draw something you couldn't live without.

Complete the pie chart below in a way that tells us something about your life or how you think.

1970 - 1983 NEARLY FATAL BOREDOM
1984 - 2000 ah-haaa!!
2000 - 2002 attempt at gainful employment
2002 present. "so long, suckers!" + ("the check is in the mail")

148

What do you hate drawing?

straight lines

Being as accurate as possible, how many desert island cartoons do you think you've come up with and submitted to *The New Yorker*?

15 , about a third sold.

What's the funniest thing that you witnessed, overheard, or came up with that you couldn't figure out how to use in a cartoon?

President Bush's administration.
(So funny I forgot to laugh.)

If you could ask Bob Mankoff, *The New Yorker* cartoon editor, one question, what would it be?

Does it hurt you when I stick this pin in this little voodoo doll?

Answer the following questions with a number from 1 to 10 (1 being not very much at all and 10 being quite a bit):

How much do you enjoy bowling? **5**

How close have you ever come to getting a tattoo? **7**

How often do you whistle or hum? **8**

How much do you resemble Bea Arthur? **4**

How likely is it that you will water-ski in the coming year? **Ø**

How often do you curse? **6**

With what frequency do you imbibe smoothies? **Ø**

How much do you dislike licorice? **6**

What's your favorite number between one and ten? **7**

How confident are you in your dancing ability? **5**

How Jewish are you? **5** (half)

Please do not draw anything in the space below. Seriously, I mean it this time.

fine!
you're the boss!

Naming Names

What name might you give to a mild-mannered, slightly overweight dental assistant in one of your cartoons? **Matthew**

Other than Lance, what name would you give to a twenty-eight-year-old metrosexual entertainment lawyer who cycles on weekends?

Chad, Tad, Brad... any "-ad" name.

What would be a good name for a new, commercially unviable breakfast cereal?

Gassies. Hairy Crunchballs.

Come up with a name for an unpleasant medical procedure.

foreskinoplasty

If you used a pen name, what would it be? **Ms. Pen Name**

Circle your preference.

beach OR mountains
poetry OR sports
day OR night
llamas OR alpacas
Montana OR Maine
hot OR mild
jazz OR country
soup OR salad
Luke Skywalker OR Han Solo
accordion OR bagpipes
pickup truck OR Volkswagen Beetle
gorilla suit OR chicken suit
time travel OR free health care
swimming OR jogging
spring OR fall
General Tso's chicken OR Caesar salad
hip-high fishing waders OR lifetime supply of ketchup
life without shoes OR life without computers
having a facial tattoo OR being a vegan
$10 gift certificate to Orange Julius OR $50 gift certificate to Chess King Who?
your very own dump truck OR an iPod
one hundred dollars in quarters OR snowshoes
walkie-talkie, a pogo stick, a gallon of orange juice, an extension cord, and three new pairs of scissors OR a canoe

anything

fuck

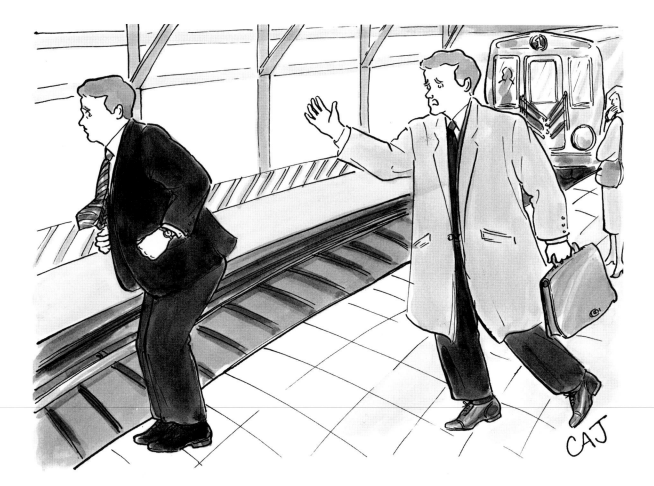

"Wait. There's another train right behind this one."

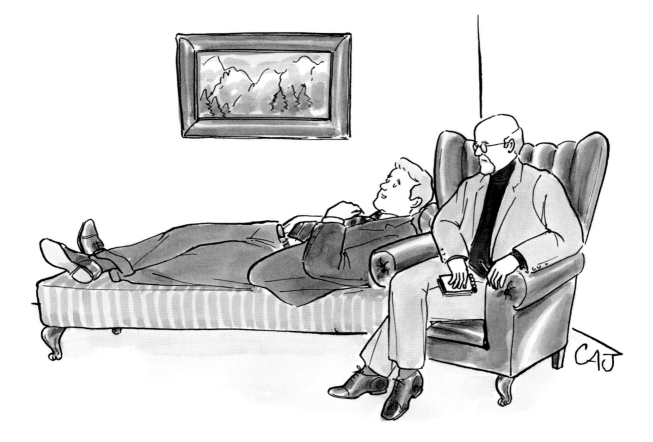

"I was bound and beaten for what seemed like hours, and it only cost me a hundred bucks."

IF DOGS MADE PERFUME

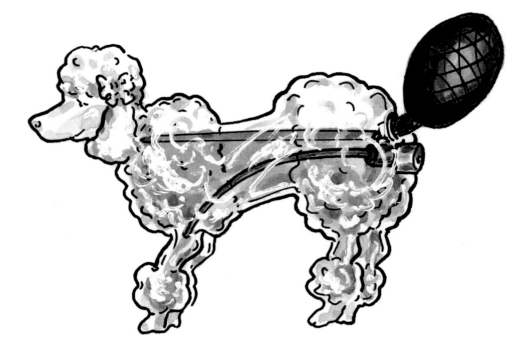

Eau de Ass

CAJ

Fill-in-the-Blank Bio

I was born _IN THE SEA. AT FIRST I JUST SORT OF FLOATED AROUND AND ABSORBED SUNLIGHT, BUT AFTER MANY YEARS I SLOWLY BECAME A WITLESS_ jellyfish, _WHICH WAS GREAT UNTIL I FOUND MYSELF STRUGGLING_ in high school. _THEN PEER PRESSURE GOT TO ME, LIKE, BIG TIME._ Not long after that, _I BECAME A CHANGELING MUTANT THING WITH A RAGING APPETITE FOR RANDOMLY ACQUIRED GENE FRAGMENTS TO GIVE MY DNA SOME COOL RACING STRIPES._ Eventually, however, despite my best efforts, _I DEVELOPED BILATERAL SYMMETRY, EYES, FACIAL HAIR AND A BOYISH GRIN_, and then _FAILED HORRIBLY IN MY ATTEMPT TO MASTER CHINESE KICK-FARMING, WHICH GAVE ME CAULIFLOWER FEET_. Perhaps not surprisingly, _I WAS SOON TAKEN ABOARD A STRANGE CRAFT BY MAMBO SALAD PEOPLE FROM SPACE_. They _WERE A CRUNCHY RACE_ of _ARUGULOIDS OF CROUTON, WHICH IS ABOUT ALL I CAN REMEMBER BEFORE THE EXPERIMENTS BEGAN. I WOKE UP HERE UTTERLY SOAKED IN VINAIGRETTE_. And so, I suppose without _ANY CLEAR MEMORY OF MY CAPTORS, I WANDER THE STREETS OF THIS GRIM DYSTOPIAN MEGALOPOLIS. IS THAT OK_? _MAYBE THERE'S A WAY OUT OF THIS PLACE. PERHAPS_ my _PLANKTON FRIENDS WILL HELP!_ In closing, I'd just like to say _EVOLUTION IS A LIE, AND GOD WAS MADE BY THE OCEANS. THANKS._

Frequently Asked Questions

Where do you get your ideas?

A SECRET PLACE
INSIDE YOUR HEAD.

Which comes first, the picture or the caption?

THE HORROR! THE HORROR!

How'd you get started?

SEE BIO AT TOP OF PAGE.

I've got a great idea for a cartoon—wanna hear it?

NO. I'D RATHER TASTE IT.

Infrequently Asked Questions

Have you mooned or *been* mooned more often in your life?

MOONED MUCH MANY MOONS AGO.

What would make a terrible pizza topping?

ALL THOSE MISSING BEES.

What might one expect to find at a really low-budget amusement park?

A PETTING ABBATOIR.

What did the shepherd say to the three-legged sheepdog?

WHERE'S LAMBIE, YOU HIDEOUS FREAK?

Complete the pie chart below in a way that tells us something about your life or how you think.

In the box below, draw something you couldn't live without.

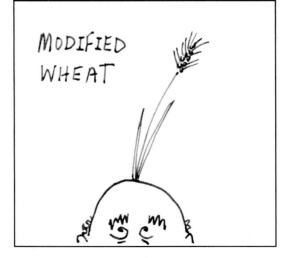

MODIFIED WHEAT

What do you hate drawing? VICTIMS. I CAN'T STAND THE WAY THEIR EYES APPEAR TO FOLLOW YOU.

Being as accurate as possible, how many desert island cartoons do you think you've come up with and submitted to *The New Yorker*? 20 OR SO. IT'S LIKE AN ILLNESS.

What's the funniest thing that you witnessed, overheard, or came up with that you couldn't figure out how to use in a cartoon? ONCE, WHEN DISCUSSING SPEARFISHING, A FRIEND SERIOUSLY ASKED ABOUT WHAT KIND OF BAIT IS PLACED ON THE POINT.

If you could ask Bob Mankoff, *The New Yorker* cartoon editor, one question, what would it be? ARE THE RUMORS TRUE THAT YOU CAN BEND FOREIGN COINS WITH YOUR POWERFUL MIND?

Draw some sort of doodle using the random lines below as a starting point.

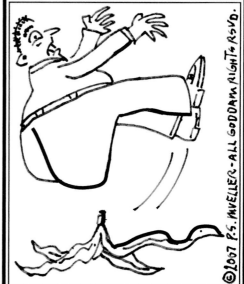

Answer the following questions with a number from 1 to 10 (1 being not very much at all and 10 being quite a bit):

How much do you enjoy bowling? 10

How close have you ever come to getting a tattoo? 1

How often do you whistle or hum? 10

How much do you resemble Bea Arthur? 8

How likely is it that you will water-ski in the coming year? 2

How often do you curse? 10

With what frequency do you imbibe smoothies? 2

How much do you dislike licorice? 10

What's your favorite number between one and ten? 1.001

How confident are you in your dancing ability? 1.002

How Jewish are you? 5

Please do not draw anything in the space below. Seriously, I mean it this time.

IS A HOWLING VOID OK? . . .

Naming Names

What name might you give to a mild-mannered, slightly overweight dental assistant in one of your cartoons? DORIS BUNDT.

Other than Lance, what name would you give to a twenty-eight-year-old metrosexual entertainment lawyer who cycles on weekends? MATTHEW DIFFEE

What would be a good name for a new, commercially unviable breakfast cereal? FLOOR CHEX.

Come up with a name for an unpleasant medical procedure. NASTYPLASTY

If you used a pen name, what would it be? MR. PEN

Circle your preference.

beach	OR	mountains
poetry	OR	sports
day	OR	night
llamas	OR	alpacas
Montana	OR	Maine
hot	OR	mild
jazz	OR	country
soup	OR	salad
Luke Skywalker	OR	Han Solo
accordion	OR	bagpipes
pickup truck	OR	Volkswagen Beetle
gorilla suit	OR	chicken suit
time travel	OR	tree health care
swimming	OR	jogging
spring	OR	fall
General Tso's chicken	OR	Caesar salad
hip-high fishing waders	OR	lifetime supply of ketchup
life without shoes	OR	life without computers
having a facial tattoo	OR	being a vegan
$10 gift certificate to Orange Julius	OR	$50 gift certificate to Chess King
your very own dump truck	OR	an iPod
one hundred dollars in quarters	OR	snowshoes
walkie-talkie, a pogo stick, a gallon of orange juice, an extension cord, and three new pairs of scissors	OR	a canoe

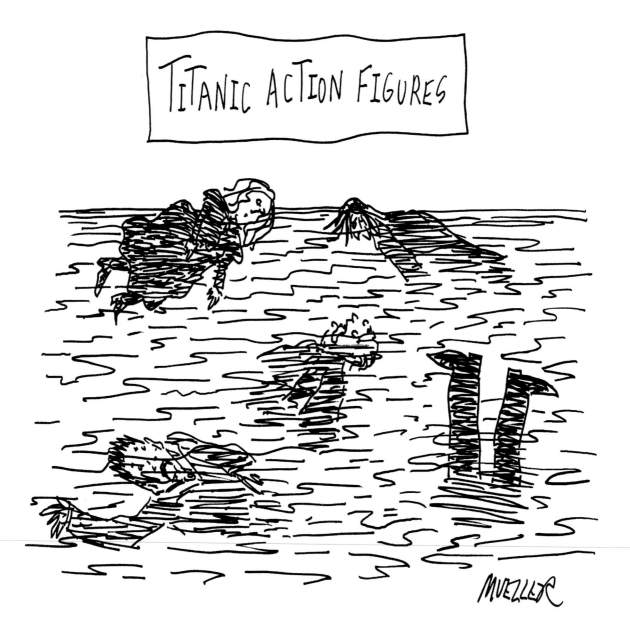

TITANIC ACTION FIGURES

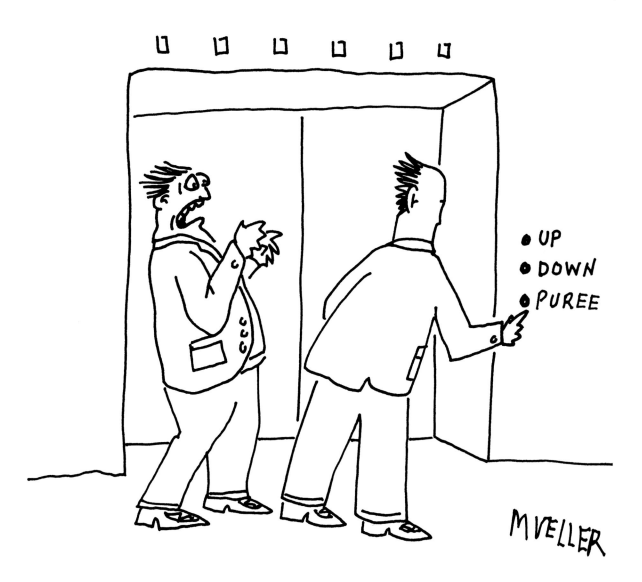

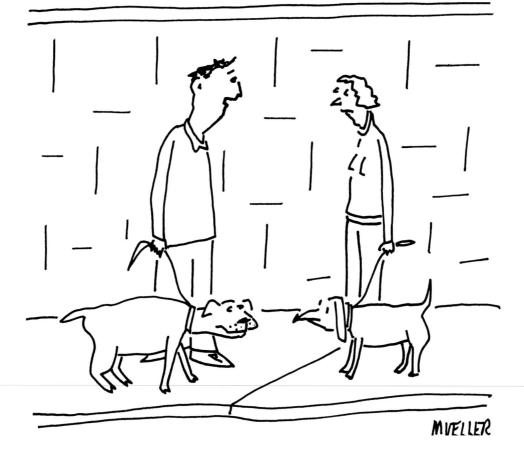

"Well, then, how about letting our dogs have sex?"

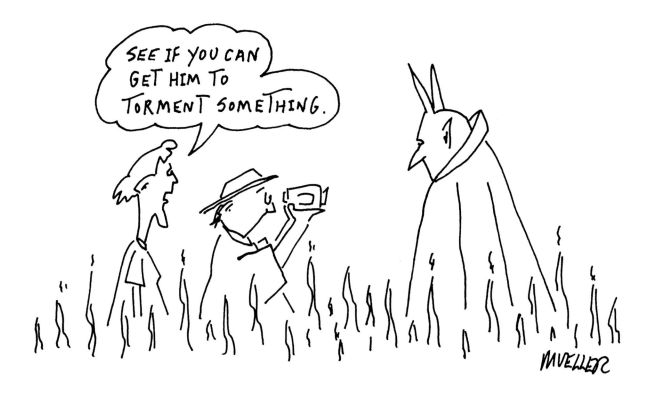

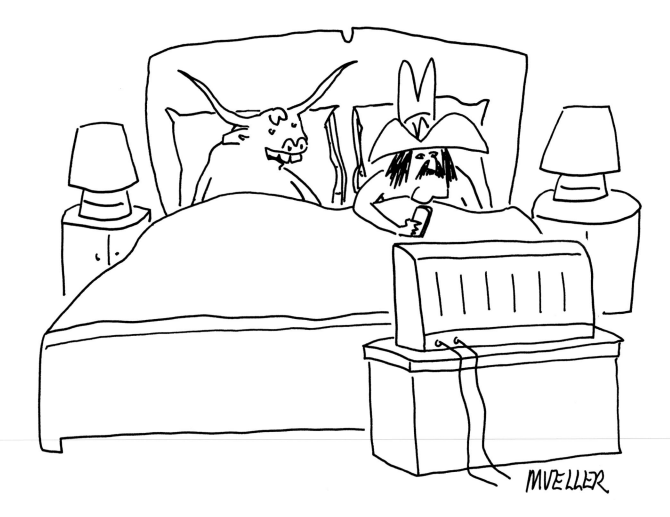

"*Fast forward to the part where you herd me.*"

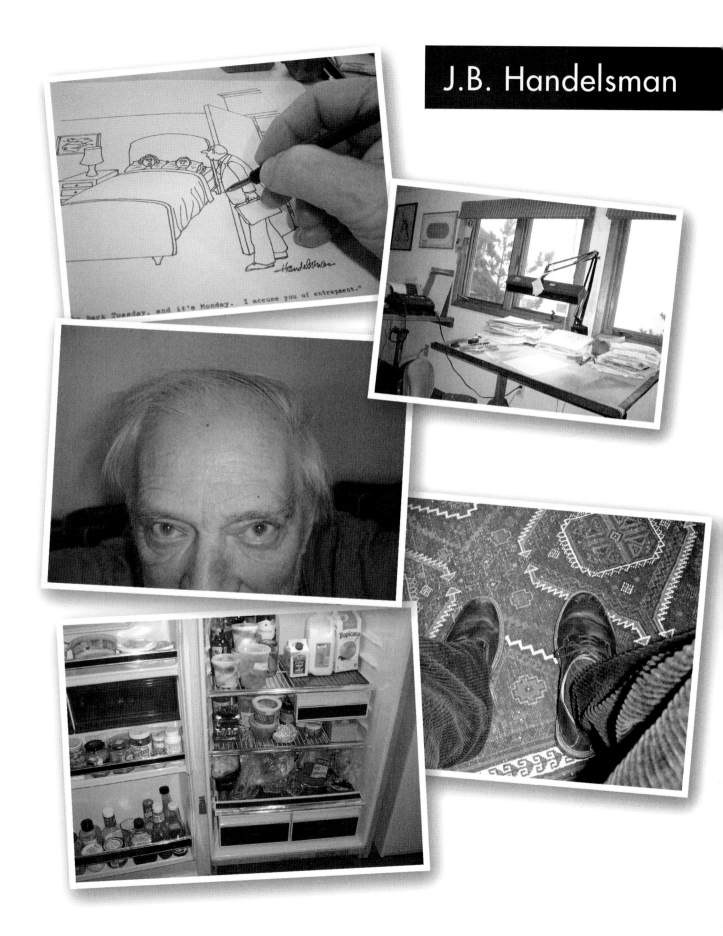

Fill-in-the-Blank Bio

I was born , IN ALL PROBABILITY, _____
_____ BUT NOT AS A jellyfish , _____
_____ NOT EVEN in high school . _____.
Not long after that, I DECIDED TO PARTICIPATE IN A WAR.

Eventually, however, despite my best efforts, OUR SIDE WON,
_____ and then DID EVERYTHING POSSIBLE TO BLOW IT
_____. Perhaps not surprisingly, WE DID SUCCEED
_____ IN BLOWING IT. The RESULT _____ of
ALL THIS ____ is THAT I BECAME THE WORLD'S GREATEST CARTOONIST.
_____. And so, I suppose without EXCESSIVE
_____ BOASTING, I ACCEPT MY OWN ACCOLADES ~ O.K. ?
_____ PLEASE ACCEPT my WARMEST REGARDS. _____.
In closing, I'd just like to say GOODBYE FROM J. B. HANDELSMAN. ____.

Frequently Asked Questions

Where do you get your ideas?
I STEAL THEM, ACCIDENTALLY
OF COURSE.

Which comes first, the picture or the caption?
THE IDEA COMES ALL AT ONCE.

How'd you get started?
LIKE ABOU BEN ADHEM, I AWOKE
FROM A DEEP DREAM OF PEACE.

I've got a great idea for a cartoon—wanna hear it?

PLEASE SPARE ME.

Infrequently Asked Questions

Have you mooned or *been* mooned more often in your life?
QUESTION NOT UNDERSTOOD.

What would make a terrible pizza topping?
EDITORS' BRAINS, IF ANY.

What might one expect to find at a really low-budget amusement park?
NOTHING.

What did the shepherd say to the three-legged sheepdog?
"YOU HAVE MY PROFOUNDEST
SYMPATHY."

Complete the pie chart below in a way that tells us something about your life or how you think.

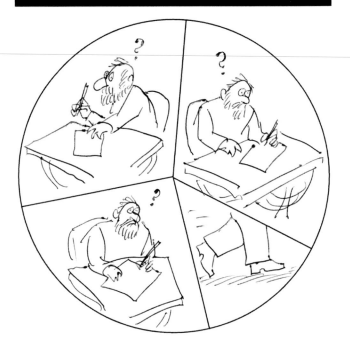

In the box below, draw something you couldn't live without.

And now for a few more questions . . .

What do you hate drawing?

I DON'T HATE DRAWING ANYTHING.

Being as accurate as possible, how many desert island cartoons do you think you've come up with and submitted to *The New Yorker*? 4

What's the funniest thing that you witnessed, overheard, or came up with that you couldn't figure out how to use in a cartoon?

CAN'T REMEMBER.

If you could ask Bob Mankoff, *The New Yorker* cartoon editor, one question, what would it be?

"WHY IS THE NEW YORKER PREJUDICED AGAINST ME AND/OR MY WORK?"

Draw some sort of doodle using the random lines below as a starting point.

THESE ARE SPERM CELLS AND I WOULDN'T DARE INTERFERE WITH THEM.

Answer the following questions with a number from 1 to 10 (1 being not very much at all and 10 being quite a bit):

How much do you enjoy bowling? 4

How close have you ever come to getting a tattoo? 1

How often do you whistle or hum? 9

How much do you resemble Bea Arthur? 1

How likely is it that you will water-ski in the coming year? 1

How often do you curse? 10

With what frequency do you imbibe smoothies? 7

How much do you dislike licorice? 10

What's your favorite number between one and ten? 5

How confident are you in your dancing ability? 1

How Jewish are you? 5

Please do not draw anything in the space below. Seriously, I mean it this time.

Naming Names

What name might you give to a mild-mannered, slightly overweight dental assistant in one of your cartoons? HANDELSMAN

Other than Lance, what name would you give to a twenty-eight-year-old metrosexual entertainment lawyer who cycles on weekends? JAMES

What would be a good name for a new, commercially unviable breakfast cereal?
STUPID FLAKES

Come up with a name for an unpleasant medical procedure.
BRAIN REMOVAL FOLLOWED BY APPOINTMENT AS EDITOR

If you used a pen name, what would it be? JUGHEAD

Circle your preference.

beach	OR	mountains
poetry	OR	sports
day	OR	night
llamas	OR	alpacas
Montana	OR	*Maine*
hot	OR	*mild*
jazz	OR	country
soup	OR	*salad*
Luke Skywalker	OR	*Han Solo*
accordion	OR	bagpipes
pickup truck	OR	Volkswagen Beetle
gorilla suit	OR	chicken suit
time travel	OR	*free health care*
swimming	OR	jogging
spring	OR	fall
General Tso's chicken	OR	*Caesar salad*
hip-high fishing waders	OR	*lifetime supply of ketchup*
life without shoes	OR	*life without computers*
having a facial tattoo	OR	*being a vegan*
$10 gift certificate to Orange Julius	OR	*$50 gift certificate to Chess King*
your very own dump truck	OR	an iPod
one hundred dollars in quarters	OR	snowshoes
walkie-talkie, a pogo stick, a gallon of orange juice, an extension cord, and three new pairs of scissors	OR	a canoe

163

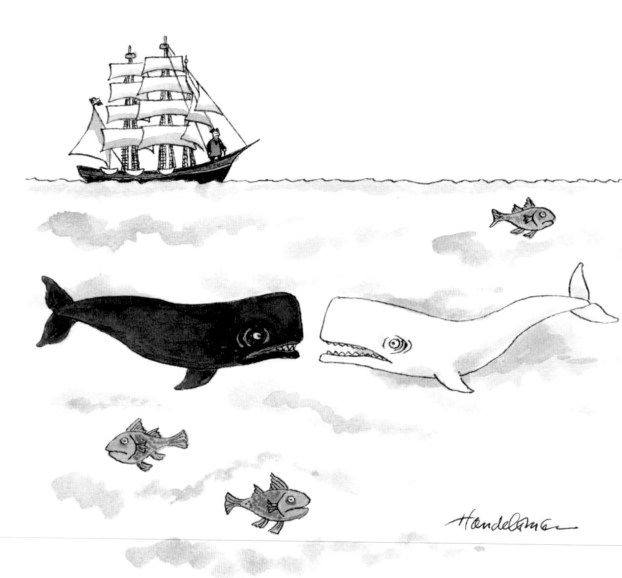

"The name's Moby Richard. Who's he callin' Dick?"

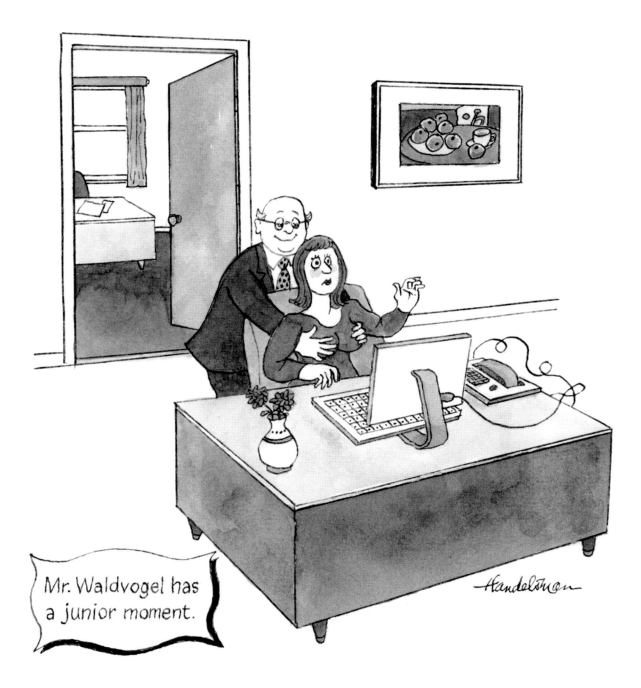

Mr. Waldvogel has a junior moment.

Handelsman

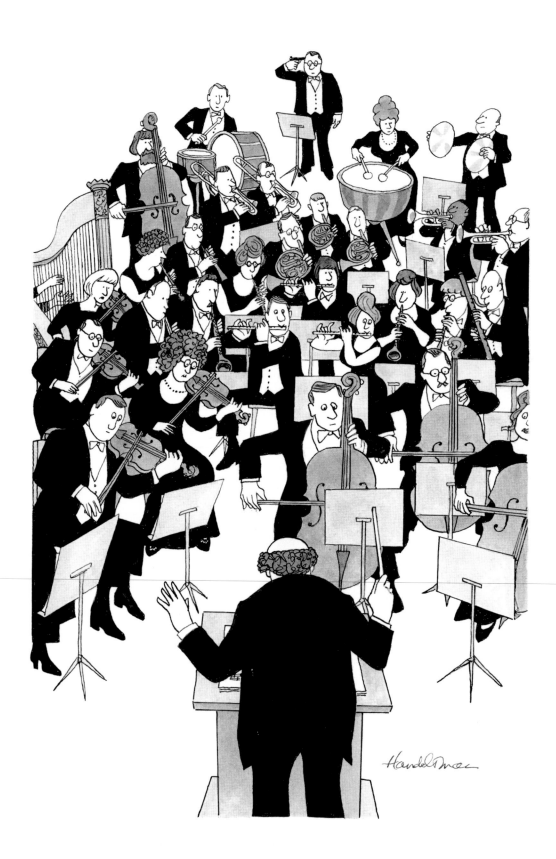

Mike Twohy

I was born with a sharpie in my hand, a clipboard in my lap and a confused look. It was sunny California in the 50's —— the jellyfish danced in the Pacific and Big Foot roamed the wilderness. In high school I insulted friends by caricaturing the 'Athlete of the week.' Not long after that, I matriculated on to College and studied fine art for many, m' years, painting large, cartoony, Pop-Art canvases. Odd jobs and my wife kept me in paint. Eventually, however, despite my best efforts, I succumbed to the addiction of freelance cartooning and then I abandoned painting completely and began to sell cartoons to many magazines, from 'Vegetarian Times' to 'Death Penalty Reporter.' Perhaps not surprisingly, my numerous sub-missions to The New Yorker came back with xeroxed R.J. slips. The larger lesson, of course, here, is to be persistent in the face of rejection, but the other lesson is to file away your failures. And so, I suppose without extensive retraining or trade school I am destined to continue producing work, a portion of which can only go for my future submission to Rejection III In closing, I'd just like to say Phew!!!

Frequently Asked Questions

Where do you get your ideas?

I think of them.

Which comes first, the picture or the caption?

A few random words and then doodling.

How'd you get started?

A guy asked me to draw up some gags he'd been carrying in his wallet for 30 years.

I've got a great idea for a cartoon—wanna hear it?

Sure — abuse me.

Infrequently Asked Questions

Have you mooned or been mooned more often in your life? Hopefully, the Lord understands my mooning was always pre-emptive.

What would make a terrible pizza topping?

scrabble tiles.

What might one expect to find at a really low-budget amusement park?

Sticky railings.

What did the shepherd say to the three-legged sheepdog?

"Don't worry. Sheep can't count."

Complete the pie chart below in a way that tells us something about your life or how you think.

In the box below, draw something you couldn't live without.

What do you hate drawing?

Casts of thousands and detailed architecture.

Being as accurate as possible, how many desert island cartoons do you think you've come up with and submitted to *The New Yorker*?

7 (5 my first year)

What's the funniest thing that you witnessed, overheard, or came up with that you couldn't figure out how to use in a cartoon?

Numerous cartoons that other people did.

If you could ask Bob Mankoff, *The New Yorker* cartoon editor, one question, what would it be?

Do you laugh this hard at everyone's cartoons?

Draw some sort of doodle using the random lines below as a starting point.

Answer the following questions with a number from 1 to 10 (1 being not very much at all and 10 being quite a bit):

How much do you enjoy bowling? 4 (audio only)

How close have you ever come to getting a tattoo? 1

How often do you whistle or hum? 6 (sing)

How much do you resemble Bea Arthur? 12 Before breakfast

How likely is it that you will water-ski in the coming year? 1

How often do you curse? 5 only at inanimate objects

With what frequency do you imbibe smoothies? 7

How much do you dislike licorice? -8

What's your favorite number between one and ten? 6

How confident are you in your dancing ability? 4 slow/2 fast

How Jewish are you? 1.5

Please do not draw anything in the space below. Seriously, I mean it this time.

Naming Names

What name might you give to a mild-mannered, slightly overweight dental assistant in one of your cartoons? Susan

Other than Lance, what name would you give to a twenty-eight-year-old metrosexual entertainment lawyer who cycles on weekends? Reg

What would be a good name for a new, commercially unviable breakfast cereal? Transfatty-Os

Come up with a name for an unpleasant medical procedure.

They've all been invented

If you used a pen name, what would it be? ZE

Circle your preference.

beach	OR	(mountains)
poetry	OR	(sports)
(day)	OR	night
(llamas)	OR	alpacas
Montana	OR	(Maine)
(hot)	OR	mild
jazz	OR	(country)
(soup)	OR	salad
Luke Skywalker	OR	(Han Solo)
accordion	OR	(bagpipes)
pickup truck	OR	(Volkswagen Beetle)
(gorilla suit)	OR	chicken suit
(time travel)	OR	free health care
(swimming)	OR	jogging
(spring)	OR	fall
(General Tso's chicken)	OR	Caesar salad
(hip-high fishing waders)	OR	lifetime supply of ketchup
life without shoes	OR	(life without computers)
having a facial tattoo	OR	(being a vegan)
($10 gift certificate to Orange Julius)	OR	$50 gift certificate to Chess King
(your very own dump truck)	OR	an iPod
one hundred dollars in quarters	OR	(snowshoes)
walkie-talkie, a pogo stick, a gallon of orange juice, an extension cord, and three new pairs of scissors	OR	(a canoe) Throw in a picnic lunch?

"Underwear is aisle nine."

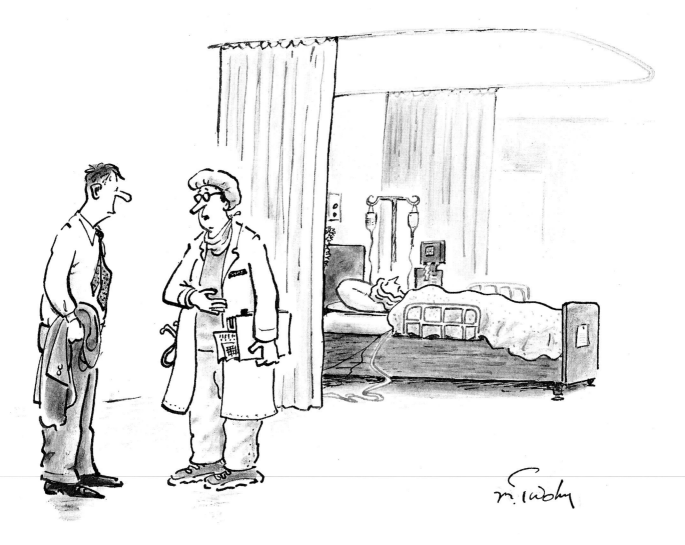

"It could be up to a week, but we do have loaners."

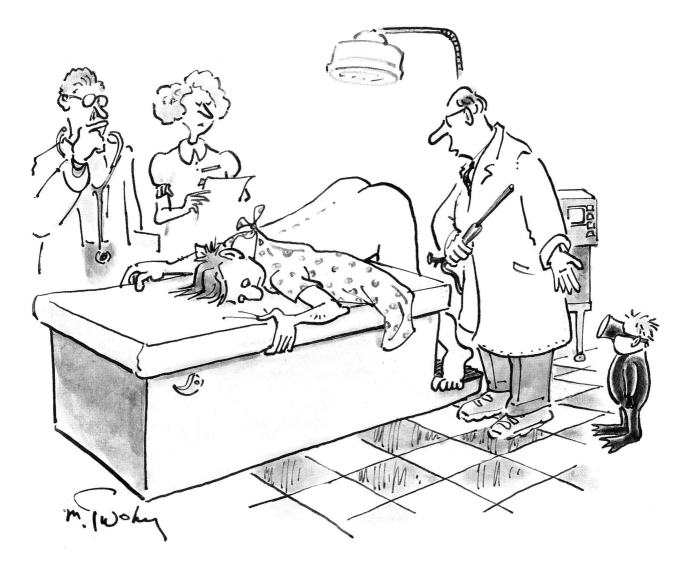

"I'm afraid we can't see anything with the sigmoidoscope,
so we'll have to send in junior."

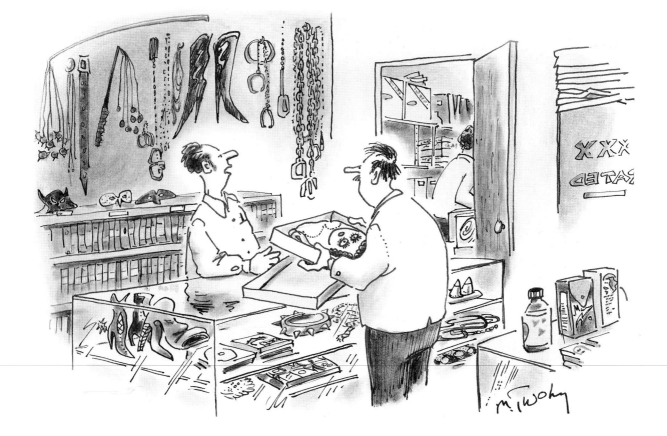

"Mr. Herndon, will we take back a blow-up if the seal hasn't been broken?"

Fill-in-the-Blank Bio

I was born IN BROOKLYN BEFORE IT WAS PART OF N.Y.C. IN FACT IT WAS STILL PART OF THE NETHERLANDS. jellyfish AT THAT TIME HAD EVOLVED SO THAT THEY COULD GO TO high school. THEN THEY DEVOLVED, & WENT TO SEA. Not long after that, I WENT TO HIGH SCHOOL, HUNDREDS OF TIMES, AND ALL I REMEMBER IS THAT OCCASIONALLY I WENT BY BIKE. Eventually, however, despite my best efforts, I CAN'T REMEMBER WHY I DIDN'T GO BY BIKE MORE OFTEN and then I RECALL THAT SOME DAYS WERE BAD BIKE DAYS. Perhaps not surprisingly, MY FRIEND ALAN'S BIKE WAS STOLEN, AND HE DIDN'T GO TO SCHOOL BY BIKE ANYMORE of course THE FACT is I STOPPED GOING TO HIGH SCHOOL AFTER A FEW YEARS, TOO. And so, I suppose without GOING TO HIGH SCHOOL FOR ANOTHER 30 YEARS OR SO, I WONDER IF I MIGHT HAVE LEARNED AN ENORMOUS AMOUNT OF my THIS & STUFF OR WHAT. In closing, I'd just like to say I MIGHT HAVE LEARNED THE SAME STUFF OVER & OVER.

Frequently Asked Questions

Where do you get your ideas? MOSTLY, WHILE SITTING — RARELY STANDING

Which comes first, the picture or the caption? VAGUE IDEA, THEN THE CAPTION.

How'd you get started? I HAD NOTHING ELSE TO DO

I've got a great idea for a cartoon—wanna hear it?

NO!!

Infrequently Asked Questions

Have you mooned or *been* mooned more often in your life? NO

What would make a terrible pizza topping? CHEESE & TOMATO SAUCE

What might one expect to find at a really low-budget amusement park? ONE BUMPER CAR

What did the shepherd say to the three-legged sheepdog? "HERE, TRIPOD!"

Complete the pie chart below in a way that tells us something about your life or how you think.

Thomas Pynchon / Rembrandt / Art Tatum / Lemon Meringue

In the box below, draw something you couldn't live without.

MY PET ANIMAL

And now for a few more questions . . .

What do you hate drawing?

SHOES. SOCKS ARE EASIER

Being as accurate as possible, how many desert island cartoons do you think you've come up with and submitted to *The New Yorker*?

2

What's the funniest thing that you witnessed, overheard, or came up with that you couldn't figure out how to use in a cartoon?

NEVER SAW ANYTHING FUNNY.

If you could ask Bob Mankoff, *The New Yorker* cartoon editor, one question, what would it be?

? 烈 桑 恭

Draw some sort of doodle using the random lines below as a starting point.

Answer the following questions with a number from 1 to 10 (1 being not very much at all and 10 being quite a bit):

How much do you enjoy bowling? 2

How close have you ever come to getting a tattoo? 0

How often do you whistle or hum? 7

How much do you resemble Bea Arthur? 1

How likely is it that you will water-ski in the coming year? 0

How often do you curse? 4 WHAT IS IT?

With what frequency do you imbibe smoothies? ___

How much do you dislike licorice? 5

What's your favorite number between one and ten? 7.362

How confident are you in your dancing ability? 1

How Jewish are you? 5 TOTAL: 32.362

Please do not draw anything in the space below. Seriously, I mean it this time.

THIS IS NOT DRAWING, BUT I'LL STOP.

Circle your preference.

beach	(OR)	mountains
poetry	(OR)	sports
day	(OR)	night
llamas	(OR)	alpacas
Montana	OR	(Maine)
(hot)	OR	mild
(jazz)	OR	country
soup	(OR)	salad
Luke Skywalker	(OR)	Han Solo
accordion	(OR)	bagpipes
pickup truck	(OR)	Volkswagen Beetle
(gorilla suit)	OR	chicken suit
(time travel)	OR	free health care
swimming	OR	(jogging)
(spring)	OR	fall
General Tso's chicken	(OR)	Caesar salad
hip-high fishing waders	(OR)	lifetime supply of ketchup
(life without shoes)	OR	life without computers
having a facial tattoo	OR	(being a vegan)
$10 gift certificate to Orange Julius	(OR)	$50 gift certificate to Chess King
(your very own dump truck)	OR	an iPod
(one hundred dollars in quarters)	OR	snowshoes
(walkie-talkie, a pogo stick, a gallon of orange juice, an extension cord, and three new pairs of scissors)	OR	a canoe

9 LEFT
3 RIGHT
11 OR

Naming Names

What name might you give to a mild-mannered, slightly overweight dental assistant in one of your cartoons?

FRITZI

Other than Lance, what name would you give to a twenty-eight-year-old metrosexual entertainment lawyer who cycles on weekends?

FRITZ

What would be a good name for a new, commercially unviable breakfast cereal?

RITZ

Come up with a name for an unpleasant medical procedure.

ITZ

If you used a pen name, what would it be?

IF IT WAS THE STATE PEN: 376148902

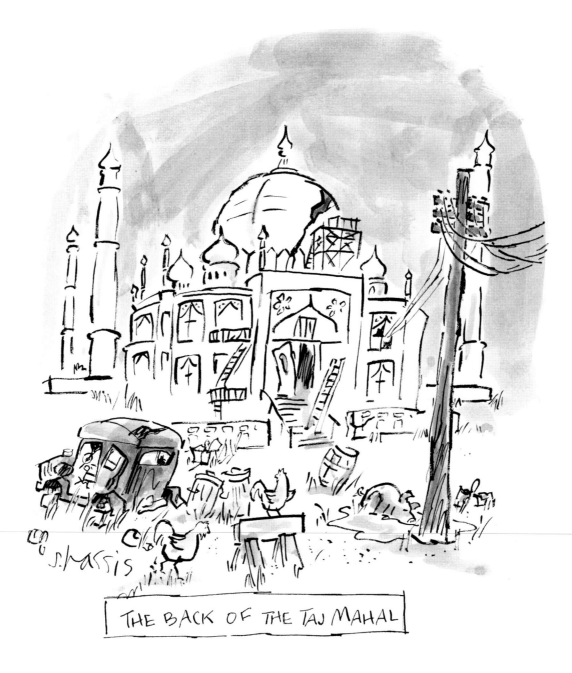

THE BACK OF THE TAJ MAHAL

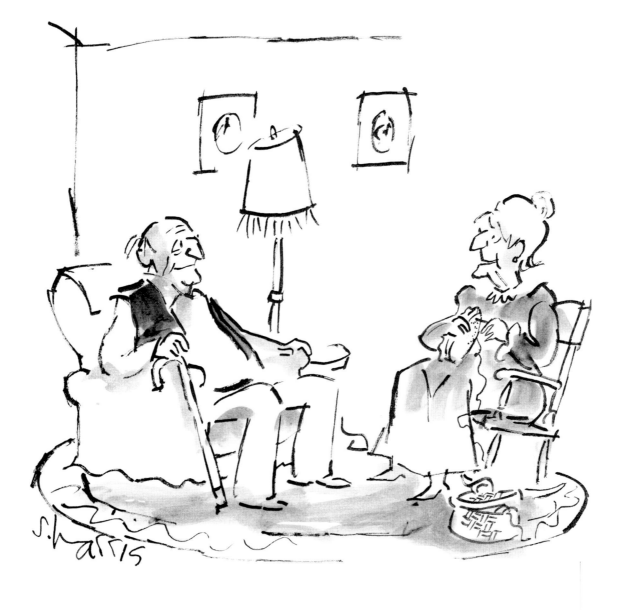

"Now that the kids and grandkids are grown I can get back to doing more erotic embroidery."

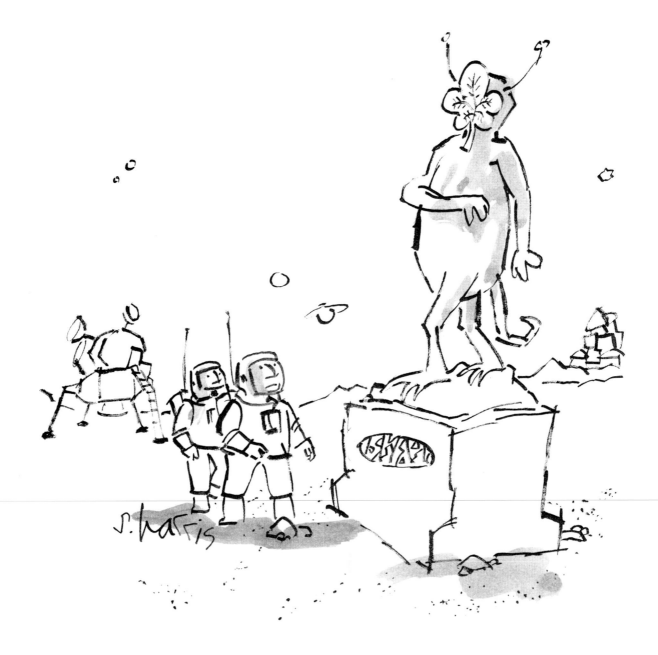

John O'Brien

Fill-in-the-Blank Bio

I was born IN 🌐 ← PHILADELPHIA PHILADELPHIA SHOWN HERE ENLARGED 200%.
DURING MY FORMATIVE YEARS I SURVIVED ON PEANUT BUTTER AND jellyfish STICKS, AND BALONEY SANDWICHES
BECAUSE IT WAS THE SIXTIES, in high school I LET MY HAIR GROW DOWN TO MY COLLAR BUT IT WAS
Not long after that, EXCEPT OF COURSE, DURING THE EARLY SEVENTIES WHEN I ATTENDED THE
PHILADELPHIA COLLEGE OF ART 🌐 ← HERE SHOWN HERE REDUCED 500%.
Eventually, however, despite my best efforts, I BECAME A CARTOONIST SLASH ILLUSTRATOR SLASH
LIFEGUARD SLASH MUSICIAN and then BECAUSE I LOVED ALL THIS SLASHING I
WANTED TO BE A SLASH QUOTER. Perhaps not surprisingly, I STARTED
QUOTING SHAKESPEARE WATCH THIS. The QUALITY of
MERCY is NOT STRAIN'D, IT DROPPETH AS THE GENTLE RAIN
FROM HEAVEN UPON THE PLACE BENEATH. And so, I suppose without SHOWING OFF
TOO MUCH COULD I QUOTE YOU SOME NEIL YOUNG ?
HEY HEY MY my ROCK AND ROLL WILL NEVER DIE
In closing, I'd just ~~like~~ CALLED to say I LOVE YOU QUOTE, STEVIE WONDER.

Frequently Asked Questions

Where do you get your ideas? THIS ONE ← IDEA

Which comes first, the picture or the caption?

How'd you get started?

I've got a great idea for a cartoon—wanna hear it?

Infrequently Asked Questions

Have you mooned or *been* mooned more often in your life?
I THINK

What would make a terrible pizza topping?
THE UNWASHED HANDS OF A RESTAURANT
EMPLOYEE RETURNING FROM THE RESTROOM?

What might one expect to find at a really low-budget amusement park?
DANGLING KEYS

What did the shepherd say to the three-legged sheepdog?
HERE, PIANO !

Complete the pie chart below in a way that tells us something about your life or how you think.

In the box below, draw something you couldn't live without.

VIEW THIS WAY

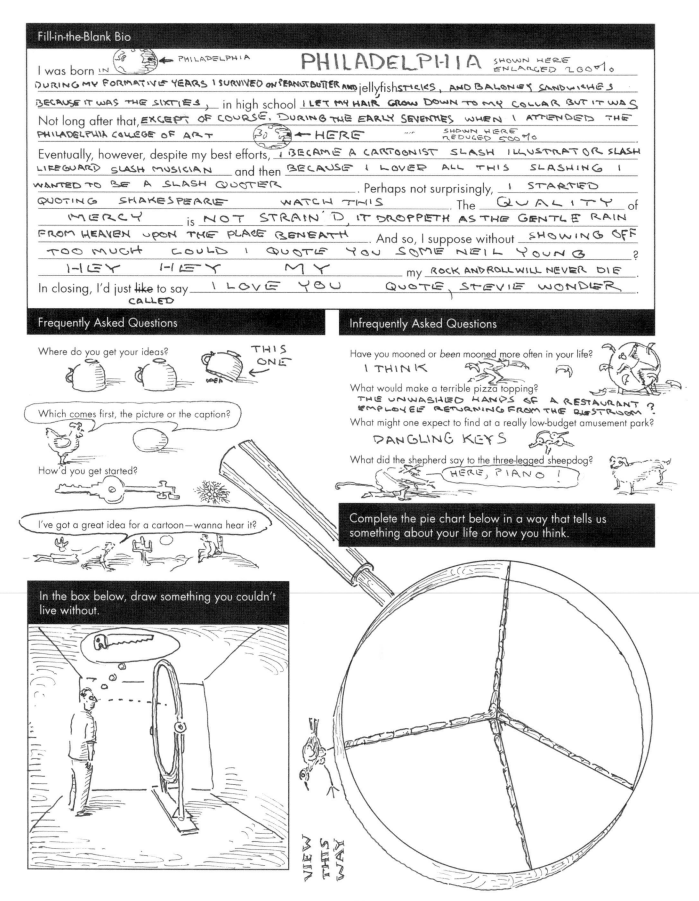

And now for a few more questions . . .

What do you hate drawing?

IF I KNEW ID HAVE
TO SHOOT MYSELF

Being as accurate as possible, how many desert island cartoons do you think you've come up with and submitted to *The New Yorker*?

MANY, BUT I'M NOT SURE IF THE
BOTTLES WASHED UP IN MANHATTAN YET.

What's the funniest thing that you witnessed, overheard, or came up with that you couldn't figure out how to use in a cartoon?

HMMM! LET ME
THINK OUT LOUD
Oooo

If you could ask Bob Mankoff, *The New Yorker* cartoon editor, one question, what would it be?

WHAT WAS WRONG WITH THAT IDEA,
ELEVENTH FROM THE BOTTOM, OF
THAT BATCH I SENT ON FEBRUARY?
FIFTEENTH, TWO THOUSAND AND TWO.

Draw some sort of doodle using the random lines below as a starting point.

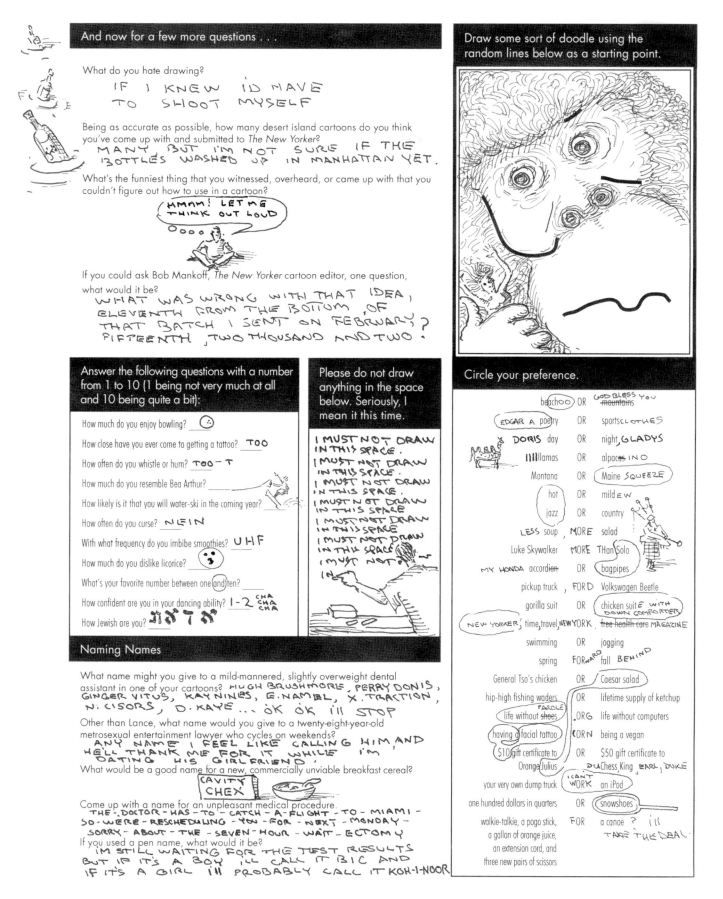

Answer the following questions with a number from 1 to 10 (1 being not very much at all and 10 being quite a bit):

How much do you enjoy bowling? ☺

How close have you ever come to getting a tattoo? TOO

How often do you whistle or hum? TOO-T

How much do you resemble Bea Arthur?

How likely is it that you will water-ski in the coming year?

How often do you curse? NEIN

With what frequency do you imbibe smoothies? UHF

How much do you dislike licorice? ☺

What's your favorite number between one (and) ten?

How confident are you in your dancing ability? 1-2 CHA CHA CHA

How Jewish are you? אאאאא

Please do not draw anything in the space below. Seriously, I mean it this time.

I MUST NOT DRAW
IN THIS SPACE.
I MUST NOT DRAW
IN THIS SPACE.
I MUST NOT DRAW
IN THIS SPACE.
I MUST NOT DRAW
IN THIS SPACE.
I MUST NOT DRAW
IN THIS SPACE
I MUST NOT DRAW
IN THIS SPACE
I MUST NOT DRAW
IN

Naming Names

What name might you give to a mild-mannered, slightly overweight dental assistant in one of your cartoons? HUGH BRUSHMORE, PERRY DONIS, GINGER VITUS, KAY NINES, E. NAMEL, X. TRACTION, N. CISORS, D. KAYE ... OK OK I'LL STOP

Other than Lance, what name would you give to a twenty-eight-year-old metrosexual entertainment lawyer who cycles on weekends?
ANY NAME I FEEL LIKE CALLING HIM, AND
HE'LL THANK ME FOR IT WHILE I'M
DATING HIS GIRLFRIEND.

What would be a good name for a new, commercially unviable breakfast cereal?

CAVITY CHEX

Come up with a name for an unpleasant medical procedure.
THE-DOCTOR-HAS-TO-CATCH-A-FLIGHT-TO-MIAMI-
SO-WE'RE-RESCHEDULING-YOU-FOR-NEXT-MONDAY-
SORRY-ABOUT-THE-SEVEN-HOUR-WAIT-ECTOMY

If you used a pen name, what would it be?
IM STILL WAITING FOR THE TEST RESULTS
BUT IF IT'S A BOY ILL CALL IT BIC AND
IF IT'S A GIRL ILL PROBABLY CALL IT KOH-I-NOOR

Circle your preference.

beach OO OR GOD BLESS YOU ~~mountains~~

EDGAR A poetry OR sportsclothes

DORIS day OR night, GLADYS

llllamas OR alpacas IN O

Montana OR Maine SQUEEZE

hot OR mild EW

jazz OR country

LESS soup, MORE salad

Luke Skywalker MORE THan Solo

MY HONDA accordion OR bagpipes

pickup truck, FORD Volkswagen Beetle

gorilla suit OR chicken suit E WITH DOWN COMFORTER

NEW YORKER, time, travel, NEW YORK, free health care MAGAZINE

swimming OR jogging

spring FORWARD fall BEHIND

General Tso's chicken OR Caesar salad

hip-high fishing waders OR lifetime supply of ketchup

PAROLE life without shoes .ORG life without computers

having a facial tattoo CORN being a vegan

$10 gift certificate to Orange Julius OR $50 gift certificate to DuChess, King EARL, DUKE

ICANTWORK your very own dump truck an iPod

one hundred dollars in quarters OR snowshoes

walkie-talkie, a pogo stick, FOR a canoe? ILL
a gallon of orange juice, TAKE THE DEAL
an extension cord, and
three new pairs of scissors

183

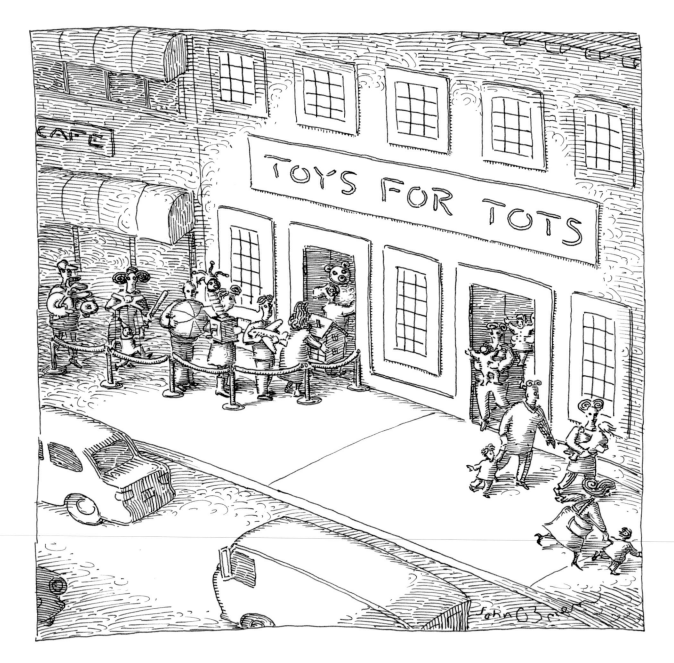

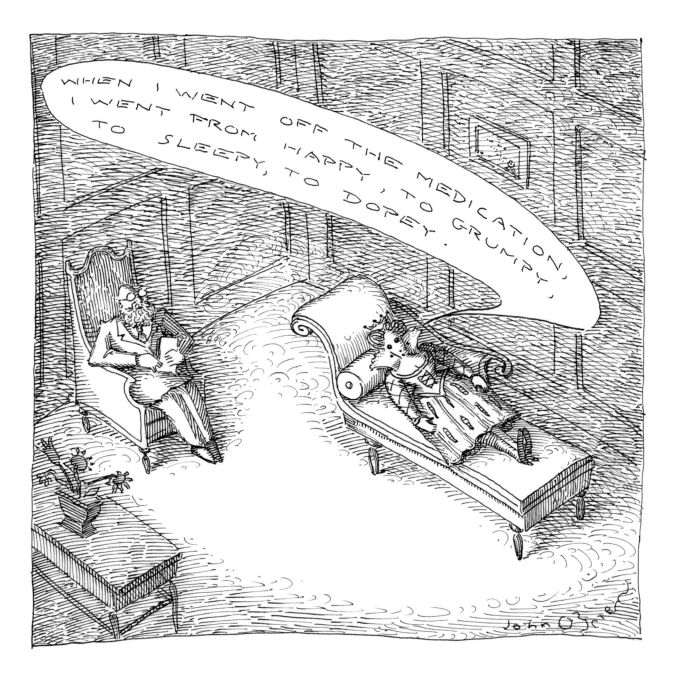

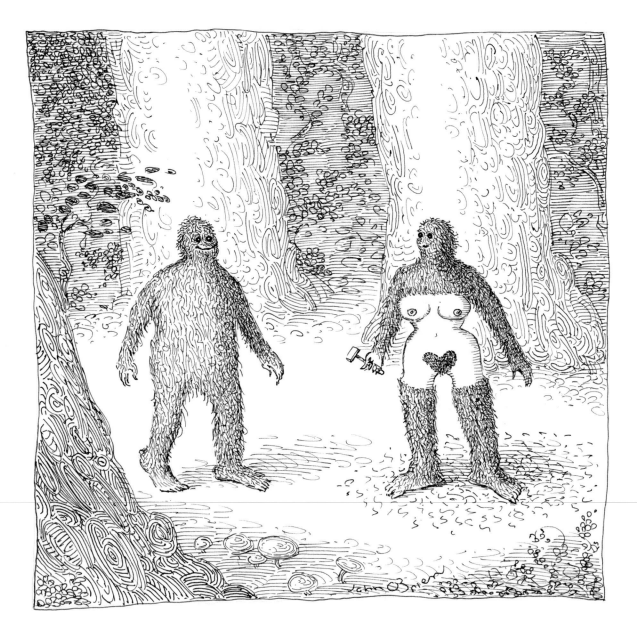

Jack Ziegler

I was born IN BROOKLYN, N.Y., BUT TOOK THE BUS OVER TO QUEENS ALMOST IMMEDIATELY. I WAS THREE WHEN I SAW MY FIRST jellyfish AT ROCKAWAY BEACH. BEING NO JOCK I~~F~~ in high school, I WAS DRAWN TO MORE DIAPHANOUS PURSUITS. Not long after that, COLLEGE, THE ARMY, A JOB IN ADVERTISING, AND THEN ONE AT CBS. LATER, I BECAME A NOVELIST. Eventually, however, despite my best efforts, THE NOVELS FAILED. and then I BECAME A FISHER OF MEN'S SOULS. . Perhaps not surprisingly, THIS DIDN'T WORK OUT EITHER. . The NEED TO EARN A TON of MONEY is WHAT DRIVES ME NOW. . And so, I suppose without FURTHER ADO, TROUSERS, VAST ACREAGE, OR SHEEP, WHAT'S A BOY TO DO? AND ANYONE WHO DISAGREES, CAN KISS my F'ING A. . In closing, I'd just like to say "ARE YOU LOOKIN' AT ME? WELL, I'M THE ONLY ONE HERE."

Frequently Asked Questions

Where do you get your ideas?

MACY'S

Which comes first, the picture or the caption?

NEITHER. BREAKFAST COMES FIRST.

How DO you get started? WITH LOTS OF BABY OIL — AND THEN WATCH OUT!?

I've got a great idea for a cartoon—wanna hear it?

I'M ALL EARS.

Infrequently Asked Questions

Have you mooned or *been* mooned more often in your life?

NEITHER.

What would make a terrible pizza topping?

IRON FILINGS.

What might one expect to find at a really low-budget amusement park?

DAVID CARUSO.

What did the shepherd say to the three-legged sheepdog?

FETCH! AND THIS TIME MORE QUICKLY PLEASE.

Complete the pie chart below in a way that tells us something about your life or how you think.

SEX / DRUGS / ROCK & ROLL / MOM

In the box below, draw something you couldn't live without.

VODKA MARTINI

WIFE (MY WIFE HAD ME ADD THIS.)

What do you hate drawing?

TALL PEOPLE.

Being as accurate as possible, how many desert island cartoons do you think you've come up with and submitted to *The New Yorker*?

HUNDREDS. (REJECTION RATE: 97%)

What's the funniest thing that you witnessed, overheard, or came up with that you couldn't figure out how to use in a cartoon?

MY FIRST LOBOTOMY.

If you could ask Bob Mankoff, *The New Yorker* cartoon editor, one question, what would it be?

WHERE DID YOU GET THAT HAIRCUT?

HELL'S ANGELS SAN BERDOO

Answer the following questions with a number from 1 to 10 (1 being not very much at all and 10 being quite a bit):

How much do you enjoy bowling? __3__

How close have you ever come to getting a tattoo? __1__

How often do you whistle or hum? ~~10~~ 2 USED ~~IT USE TO~~ BE TO

How much do you resemble Bea Arthur? __8__ (IT USE TO BE 5)

How likely is it that you will water-ski in the coming year? __1__

How often do you curse? ~~X~~ (FUCK!) 9

With what frequency do you imbibe smoothies? __1__

How much do you dislike licorice? __2__ LEAST

What's your favorite number between one and ten? __10__ (IT TAKES LONGER TO DRAW.)

How confident are you in your dancing ability? __2__

How Jewish are you? __1__ (NOT INTO THE CURRENT RACE FOR RELIGION.)

Please do not draw anything in the space below. Seriously, I mean it this time.

GOTCHA.

Naming Names

What name might you give to a mild-mannered, slightly overweight dental assistant in one of your cartoons?

BOB.

Other than Lance, what name would you give to a twenty-eight-year-old metrosexual entertainment lawyer who cycles on weekends?

BOB.

What would be a good name for a new, commercially unviable breakfast cereal?

FIBROUS BOB-O-LINKS.

Come up with a name for an unpleasant medical procedure.

THE BOB REDUCTION.

If you used a pen name, what would it be?

BOB.

Circle your preference.

beach	OR	mountains
poetry	OR	sports
day	OR	night
llamas	OR	alpacas
Montana	OR	Maine
hot	OR	mild
jazz	OR	country
soup	OR	~~salad~~ HUNGARIAN GOULASH
Luke Skywalker	OR	Han Solo
accordion	OR	bagpipes
pickup truck	OR	Volkswagen Beetle
gorilla suit	OR	chicken suit
time travel	OR	free health care
swimming	OR	jogging
spring	OR	fall
General Tso ~~chicken~~	OR	Caesar ~~salad~~
hip-high fishing waders	OR	lifetime supply of ketchup
life without shoes	OR	life without computers
having a facial tattoo	OR	being a ~~vegan~~ CARNIVORE
$10 ~~gift certificate to~~	OR	$50 ~~gift certificate to~~
your very own dump truck	OR	an iPod
one hundred dollars in quarters	OR	snowshoes
walkie-talkie, a pogo stick, a gallon of orange juice, an extension cord, and three new pairs of scissors	OR	a canoe

TRICK QUESTION, RIGHT?

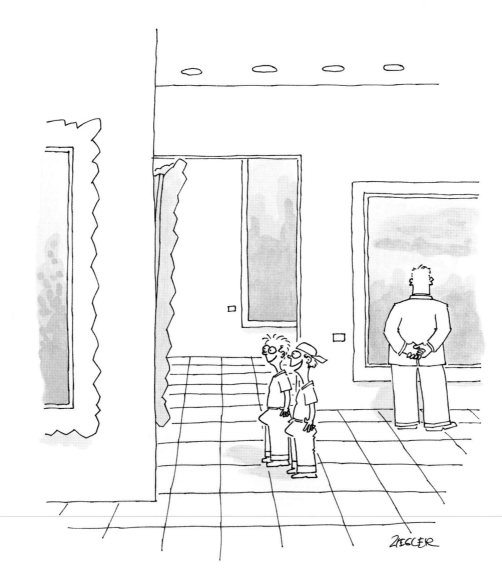

"Wow! Great nude!"

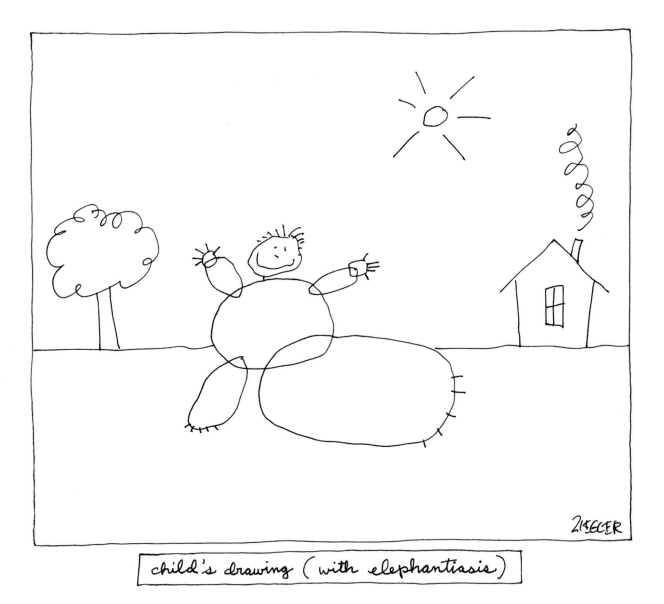

child's drawing (with elephantiasis)

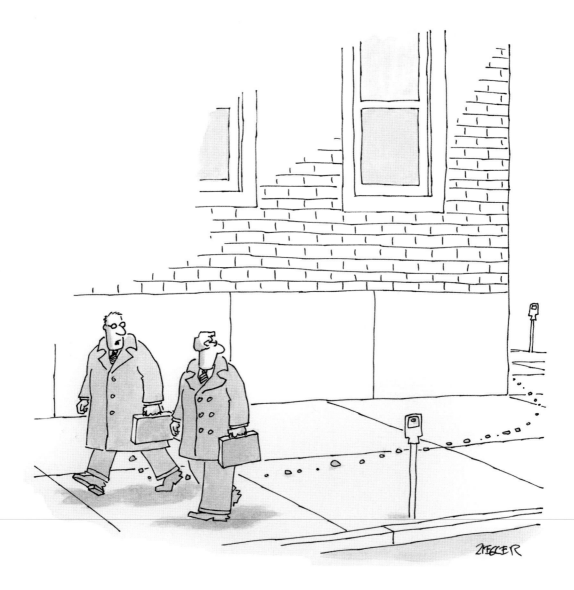

"Sorry, Ted. Generally, what happens in the pants stays in the pants."

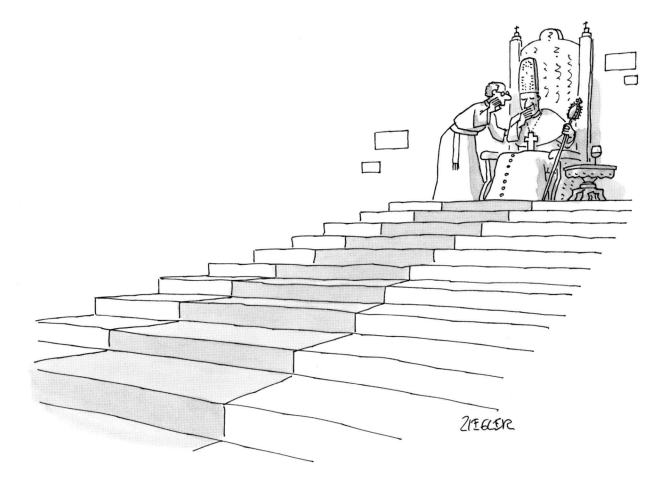

"Saturday night, Your Eminence. The nuns are ready for their bath."

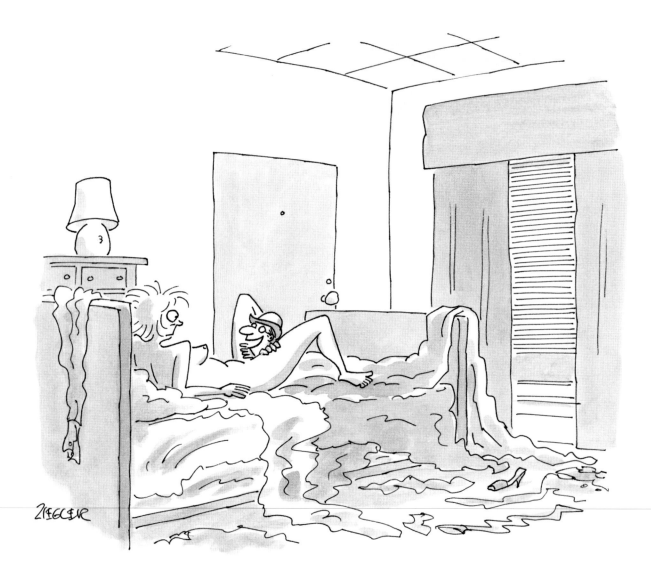

"I'm afraid I made quite a nuisance of myself in here last night."

Robert Weber

Fill-in-the-Blank Bio

I was born IN LOS ANGELES IN 1924 (A VINTAGE YEAR.)

jellyfish DON'T KNOW ANY.

in high school SUFFERED TEEN ANGST.

Not long after that, WORKED 6 MOS. IN A RADIO STATION. JOINED THE US COAST GUARD TO AVOID WORLD WAR II DRAFT.

Eventually, however, despite my best efforts, THE WAR ENDED.

and then I WENT TO ART SCHOOL (PRATT INSTITUTE IN BROOKLYN, NY.) . Perhaps not surprisingly, I DIDN'T GRADUATE. The GIST of IT ALL is LIFE IS FULL OF SURPRISES, ALSO DEAD END STREETS. And so, I suppose without KNOWING ANYTHING RELEVANT, I GOT MARRIED. ?

In closing, I'd just like to say DON'T SWALLOW ANYTHING YOU CAN'T CHEW. SEND IT BACK TO THE KITCHEN

Frequently Asked Questions

Where do you get your ideas?
YOU THINK I'D TELL YOU?

Which comes first, the picture or the caption? BOTH

How'd you get started?
DOING SPOTS FOR MAGAZINES.

I've got a great idea for a cartoon—wanna hear it?
YOU THINK I'D TELL YOU?

Infrequently Asked Questions

Have you mooned or *been* mooned more often in your life?
LET'S NOT GO THERE.

What would make a terrible pizza topping?
THAT'S FOR YOU TO ANSWER

What might one expect to find at a really low-budget amusement park?
A LOT OF DASHED EXPECTATIONS.

What did the shepherd say to the three-legged sheepdog?
PLEASE PASS THE BRANDY.

Complete the pie chart below in a way that tells us something about your life or how you think.

In the box below, draw something you couldn't live without.

CERTIFIED

APPLE

LEMON MERENGUE

STRAW-BERRY RUBARB

PIZZA

And now for a few more questions . . .

What do you hate drawing?

MONEY FROM SAVINGS ACCOUNT.

Being as accurate as possible, how many desert island cartoons do you think you've come up with and submitted to *The New Yorker*?

64,000.

What's the funniest thing that you witnessed, overheard, or came up with that you couldn't figure out how to use in a cartoon?

RECOVERING FROM BI-LATERAL KNEE SURGERY.

If you could ask Bob Mankoff, *The New Yorker* cartoon editor, one question, what would it be?

BOB ARE YOU SURE THIS IS SOMETHING YOU REALLY WANT TO DO?

Answer the following questions with a number from 1 to 10 (1 being not very much at all and 10 being quite a bit):

How much do you enjoy bowling? O

How close have you ever come to getting a tattoo? O

How often do you whistle or hum? NEVER

How much do you resemble Bea Arthur? A LOT

How likely is it that you will water-ski in the coming year? VERY

How often do you curse? THE HELL WITH THIS QUESTION

With what frequency do you imbibe smoothies? O

How much do you dislike licorice? I LIKE LICORICE

What's your favorite number between one and ten? 7 $\frac{11}{16}$

How confident are you in your dancing ability? VERY

How Jewish are you? TOTALLY

Please do not draw anything in the space below. Seriously, I mean it this time.

Naming Names

What name might you give to a mild-mannered, slightly overweight dental assistant in one of your cartoons? ZANDRA-LOIS

Other than Lance, what name would you give to a twenty-eight-year-old metrosexual entertainment lawyer who cycles on weekends? HORACE BORIS

What would be a good name for a new, commercially unviable breakfast cereal? ORGAN-IKY

Come up with a name for an unpleasant medical procedure. OPSY

If you used a pen name, what would it be? WATERMAN

Draw some sort of doodle using the random lines below as a starting point.

Circle your preference.

beach	OR	mountains
poetry	OR	sports
day	OR	night
llamas	OR	alpacas
Montana	OR	Maine
hot	OR	mild
jazz	OR	country
soup	OR	salad
Luke Skywalker	OR	Han Solo
accordion	OR	bagpipes
pickup truck	OR	Volkswagen Beetle
gorilla suit	OR	chicken suit
time travel	OR	free health care
swimming	OR	jogging
spring	OR	fall
General Tso's chicken	OR	Caesar salad
hip-high fishing waders	OR	lifetime supply of ketchup
life without shoes	OR	life without computers
having a facial tattoo	OR	being a vegan
$10 gift certificate to Orange Julius	OR	$50 gift certificate to Chess King
your very own dump truck	OR	an iPod
one hundred dollars in quarters	OR	snowshoes
walkie-talkie, a pogo stick, a gallon of orange juice, an extension cord, and three new pairs of scissors	OR	a canoe

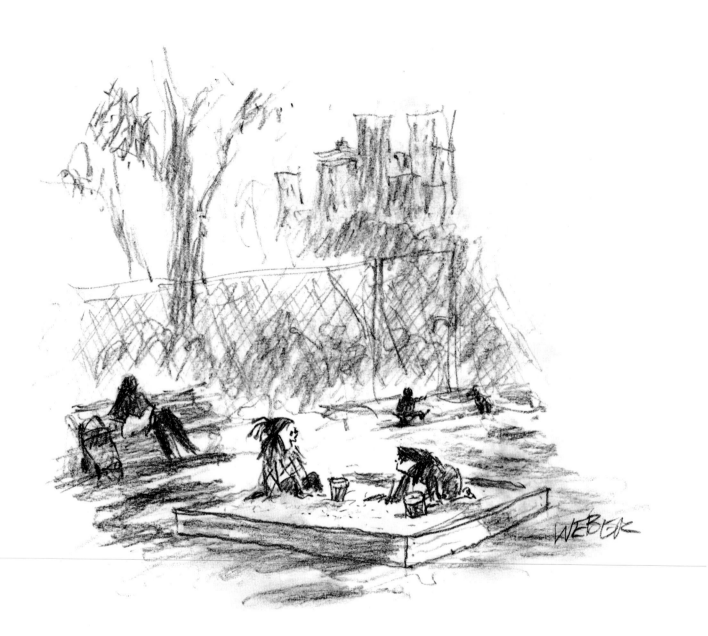

"Wanna see me fake an orgasm?"

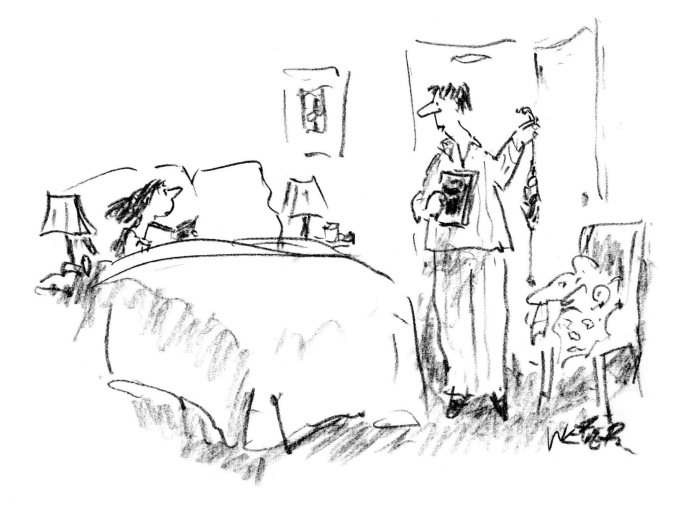

"Do you mind if I use your thong as a bookmark?"

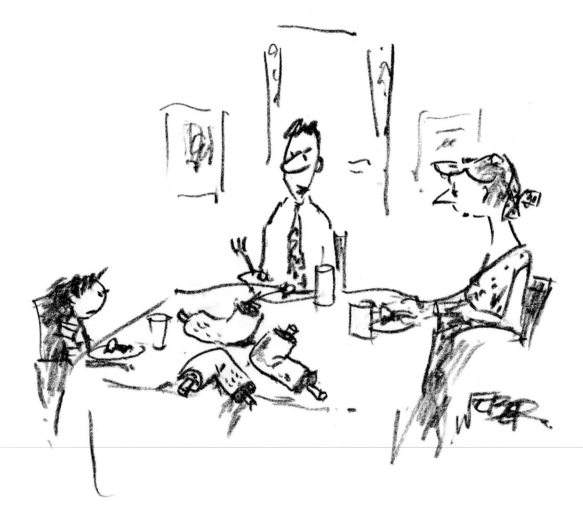

"How many times have I told you to keep your elbows off the table?"

Marisa Acocella Marchetto

Fill-in-the-Blank Bio

I was born in a cross-fire hurricane. Actually, I was born on Christmas. My favorite sandwich is peanut butter, jellyfish, and . I always studied art, starting at age 4. When in high school, I was the art girl in all black. Not long after that, I went to Pratt Institute and studied fine arts and had a PUNK ROCK band where I played a Gibson hollow bodied Bass. RED. Eventually, however, despite my best efforts, I didn't become the rock star I had dreamed of and then I went into advertising, where in meetings I would draw these "women" in my toons. Perhaps not surprisingly, while I was in advertising, I drew myself with a gun in my mouth. "SHE WAS A LITTLE UPSET DURING THE MEETING." The first cartoon I ever did, the start of my career. What's ironic is that my best work comes out of some kind of suffering or tragedy. The Woody Allen Thing — Comedy = tragedy + time. And so, I suppose without the angst of those meetings meetings meetings advertising all about the product maybe I wouldn't have this career? I thought if I was published in The New Yorker all my problems will be over. Right. In closing, I'd just like to say cartooning is serious business

Frequently Asked Questions

Where do you get your ideas? If I knew, I'd have more. Just kidding, from life.

Which comes first, the picture or the caption?
The EGG.

How'd you get started?
See above.

I've got a great idea for a cartoon—wanna hear it?
Please, then you'll ask me to draw it. Nope. No way.

Infrequently Asked Questions

Have you mooned or been mooned more often in your life?
I prefer the sun.

What would make a terrible pizza topping? A Tophat.

What might one expect to find at a really low-budget amusement park?
No one having any fun.

What did the shepherd say to the three-legged sheepdog?
"Herd any good jokes?" I can't believe I wrote that.

Complete the pie chart below in a way that tells us something about your life or how you think.

In the box below, draw something you couldn't live without.

202

What do you hate drawing?

Babies.

Being as accurate as possible, how many desert island cartoons do you think you've come up with and submitted to *The New Yorker*?

Actually, NONE.

What's the funniest thing that you witnessed, overheard, or came up with that you couldn't figure out how to use in a cartoon?

If I told you, then I'd be giving you material

If you could ask Bob Mankoff, *The New Yorker* cartoon editor, one question, what would it be?

Why are YOU always published ???.??

Answer the following questions with a number from 1 to 10 (1 being not very much at all and 10 being quite a bit):

How much do you enjoy bowling? 1

How close have you ever come to getting a tattoo? 1

How often do you whistle or hum? 8

How much do you resemble Bea Arthur? 1

How likely is it that you will water-ski in the coming year? 1

How often do you curse? 8

With what frequency do you imbibe smoothies? 1

How much do you dislike licorice? 1

What's your favorite number between one and ten? 7

How confident are you in your dancing ability? 8

How Jewish are you? 4

Please do not draw anything in the space below. Seriously, I mean it this time.

Naming Names

What name might you give to a mild-mannered, slightly overweight dental assistant in one of your cartoons?

Esther

Other than Lance, what name would you give to a twenty-eight-year-old metrosexual entertainment lawyer who cycles on weekends?

~~CURT~~ JONATHAN

What would be a good name for a new, commercially unviable breakfast cereal?

~~Toxic~~. Cereal Killer.

Come up with a name for an unpleasant medical procedure. What Medical procedure is pleasant?

If you used a pen name, what would it be? Rapidigraph.

Draw some sort of doodle using the random lines below as a starting point.

Circle your preference.

(beach)	OR	mountains
poetry	OR	(sports)
day	OR	(night)
llamas	OR	(alpacas)
NEITHER Montana	OR	Maine
(hot)	OR	mild
jazz	OR	(country)
soup	OR	(salad)
Luke Skywalker	OR	(Han Solo)
accordion	OR	(bagpipes)
pickup truck	OR	(Volkswagen Beetle)
(gorilla suit)	OR	chicken suit
time travel	OR	(free health care)
(swimming)	OR	jogging
(spring)	OR	fall
General Tso's chicken	OR	(Caesar salad)
hip-high fishing waders	OR	(lifetime supply of ketchup)
life without shoes	OR	(life without computers)
having a facial tattoo	OR	(being a vegan)
$10 gift certificate to Orange Julius	OR	($50 gift certificate to Chess King)
your very own dump truck	OR	(an iPod)
(one hundred dollars in quarters)	OR	snowshoes
(walkie-talkie, a pogo stick, a gallon of orange juice, an extension cord, and three new pairs of scissors)	OR	a canoe

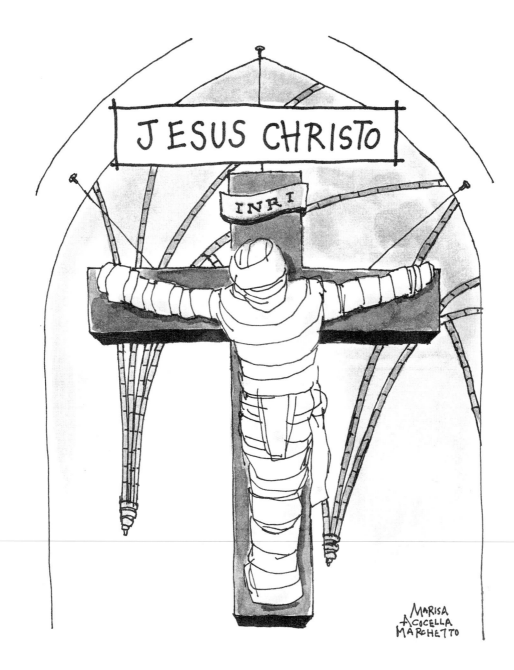

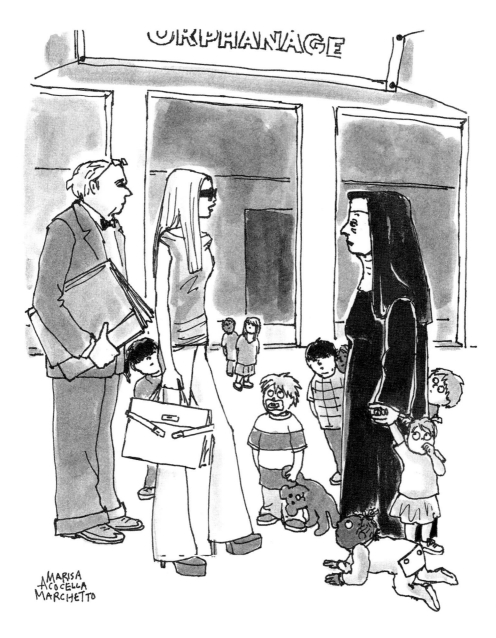

"I'll take one in every color."

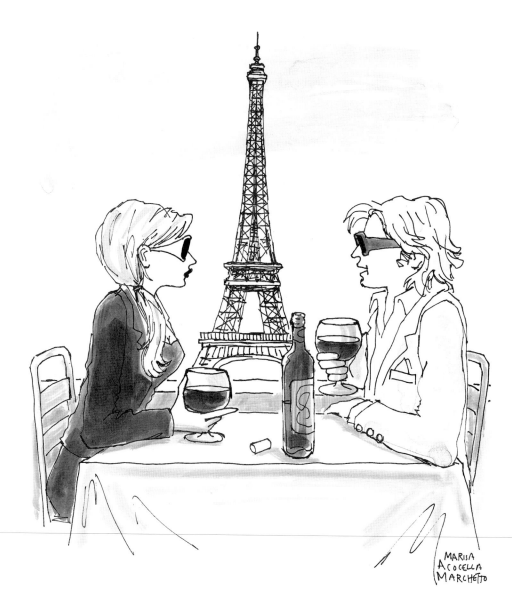

"This isn't the Paris I was dreaming about."

Fill-in-the-Blank Bio

I was born in Detroit and enjoyed a simple childhood of climbing trees, riding bikes and eating lots of peanut butter and jellyfishing wasn't possible in the city, but we still dug worms after a rain. high school in the '70's wasn't like on TV. My hair really was Not long after that, I went to college, then joined "the real world", working at an array of jobs seemingly unrelated to cartooning. As you no doubt surmised, I did find cartooning Eventually, however, despite my best efforts, though, remaining a child at heart did nothing to prevent hair loss. My drawing hand then began to develop a condition where it was blurry all the time. Was it simply my eyesight? Perhaps, not surprisingly, my optometrist said it was linked to the hair loss or, rather, middle age. They say that the trade-off for growing older is gaining wisdom. It is my good luck then to make a living as a wise guy — and to have a wife who will underst And somEsuppose, without giving it any real thought, that creating cartoons is easy. But have you ever tried the Caption Contest? Even starting with a great drawing, the alchemy of a funny cartoon is elusive. In closing, I'd just like to say thank you for supporting wise-guy alchemists of all ages.

Frequently Asked Questions

Where do you get your ideas?
DIDN'T WE ANSWER THIS LAST TIME? OR IS THAT WHAT YOU MEAN BY FREQUENTLY ASKED QUESTIONS?

Which comes first, the picture or the caption?
YES. (YES!)

How'd you get started?
THE SAME AS EVERYONE ELSE. ALL KIDS START OUT DRAWING CARTOONS. SOME OF US SIMPLY DON'T STOP.

I've got a great idea for a cartoon—wanna hear it?
NO, I WANT TO SEE IT.

Infrequently Asked Questions

Have you mooned or *been* mooned more often in your life?
I'VE SUCCESSFULLY REPRESSED THOSE MEMORIES, THANK YOU VERY MUCH.

What would make a terrible pizza topping?
SNICKERS BARS, BASED ON HOW AWFUL THEY TASTE DEEP FRIED ON A STICK.

What might one expect to find at a really low-budget amusement park?
THE TUNNEL OF COUSINS

What did the shepherd say to the three-legged sheepdog?
"SHAKE."

Complete the pie chart below in a way that tells us something about your life or how you think.

In the box below, draw something you couldn't live without.

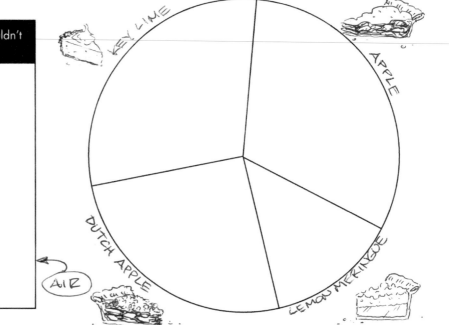

208

What do you hate drawing?

A BLANK.

Being as accurate as possible, how many desert island cartoons do you think you've come up with and submitted to *The New Yorker*?

AZORES < X < INDONESIA

What's the funniest thing that you witnessed, overheard, or came up with that you couldn't figure out how to use in a cartoon?

BUT YOU REALLY HAD TO BE THERE.

If you could ask Bob Mankoff, *The New Yorker* cartoon editor, one question, what would it be?

IF A TRAIN LEAVES NEW YORK AT 9:00 AM, AND ANOTHER TRAIN LEAVES ALBANY AT 9:30 AM, AND THEIR SPEEDS ARE RESPECTIVELY 50 MPH AND 47 MPH

Draw some sort of doodle using the random lines below as a starting point.

o "PICASSO SNOWGLOBE"

Answer the following questions with a number from 1 to 10 (1 being not very much at all and 10 being quite a bit):

How much do you enjoy bowling? 4

How close have you ever come to getting a tattoo? .1

How often do you whistle or hum? 7.5 (SING MORE)

How much do you resemble Bea Arthur? ✳

How likely is it that you will water-ski in the coming year? >1

How often do you curse? 53

With what frequency do you imbibe smoothies? 1/365

How much do you dislike licorice? BLACK OR RED?

What's your favorite number between one and ten? π

How confident are you in your dancing ability? 6

How Jewish are you? ℵ

Please do not draw anything in the space below. Seriously, I mean it this time.

✳ I SHARE 98% OF MY GENES WITH A CHIMP, SO PROBABLY EVEN MORE WITH BEA ARTHUR.
(OH, AND THIS IS WRITING, NOT DRAWING.)

Circle your preference.

beach	OR	(mountains)
(poetry)	OR	sports
day	OR	night
llamas	OR	(alpacas)
(Montana)	OR	Maine
(hot)	OR	(mild)
(jazz)	OR	country
soup	OR	(salad)
Luke Skywalker	OR	(Han Solo)
(accordion)	OR	bagpipes
pickup truck	OR	(Volkswagen Beetle)
(gorilla suit)	OR	chicken suit
(time travel)	OR	free health care
(swimming)	OR	jogging
spring	OR	(fall)
General Tso's chicken	OR	(Caesar salad) DUH!
hip-high fishing waders	OR	(lifetime supply of ketchup)
life without shoes	OR	(life without computers)
having a facial tattoo	(OR)	being a vegan
($10 gift certificate to Orange Julius)	OR	$50 gift certificate to Chess King
(your very own dump truck)	OR	an iPod
(one hundred dollars in quarters)	OR	snowshoes
walkie-talkie, a pogo stick, a gallon of orange juice, an extension cord, and three new pairs of scissors	OR	(a canoe)

WHICHEVER IT IS → RIGHT NOW

SALSA →

← WEATHER BUT IT'S VERY CLOSE

LONGER ACTING CAREER

LOVE THE SEASON, HATE THE → ALLERGIES

IT WOULD BOTHER ME LESS TO LET IT EXPIRE

ACTUALLY, I'D PREFER A KAYAK. I ALREADY HAVE A CANOE.

Naming Names

What name might you give to a mild-mannered, slightly overweight dental assistant in one of your cartoons?

LLEWELYN

Other than Lance, what name would you give to a twenty-eight-year-old metrosexual entertainment lawyer who cycles on weekends?

CHAZ

What would be a good name for a new, commercially unviable breakfast cereal?

TAC-Os "IT'S A FIESTA IN YOUR MOUTH!"

Come up with a name for an unpleasant medical procedure.

BONE FLUSHING

If you used a pen name, what would it be?

UNI-BALL JETSTREAM

IN FACT, I USE IT ALL THE TIME!

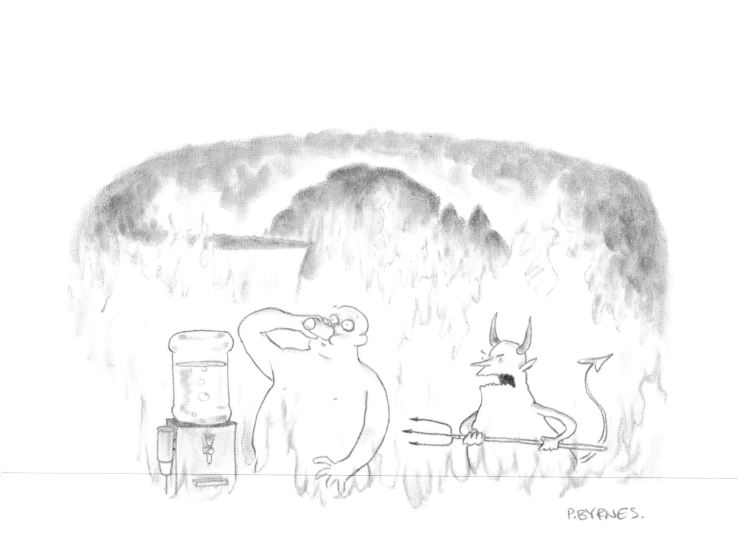

"Hey, get away from the urinal."

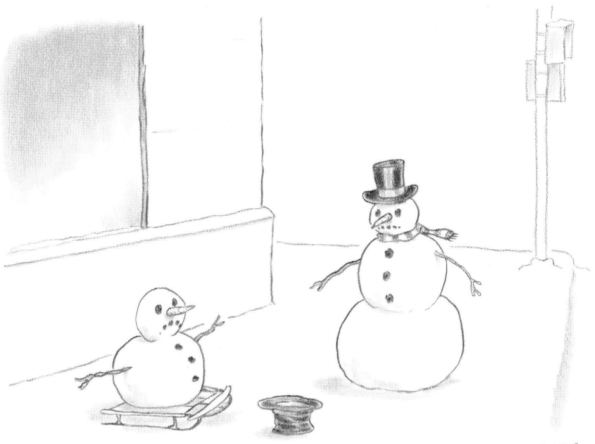

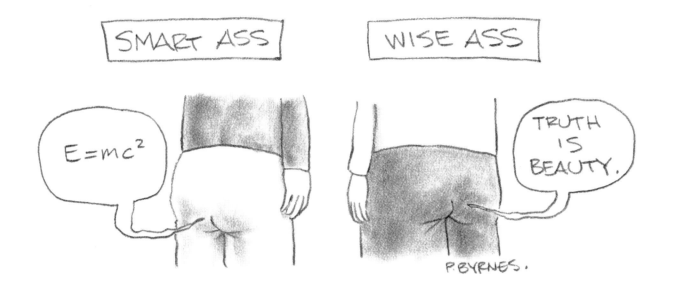

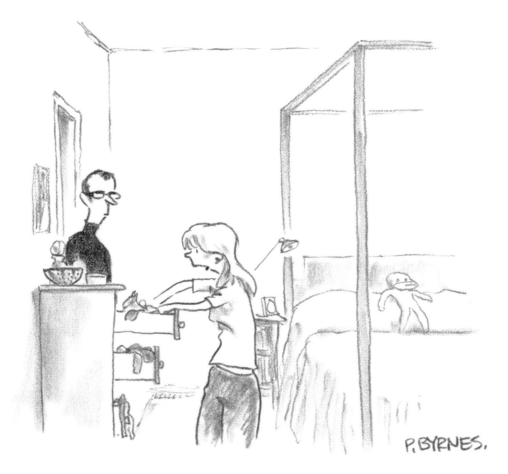

"I've got an important audition today. Have you seen my diaphragm?"

KEISTER ISLAND

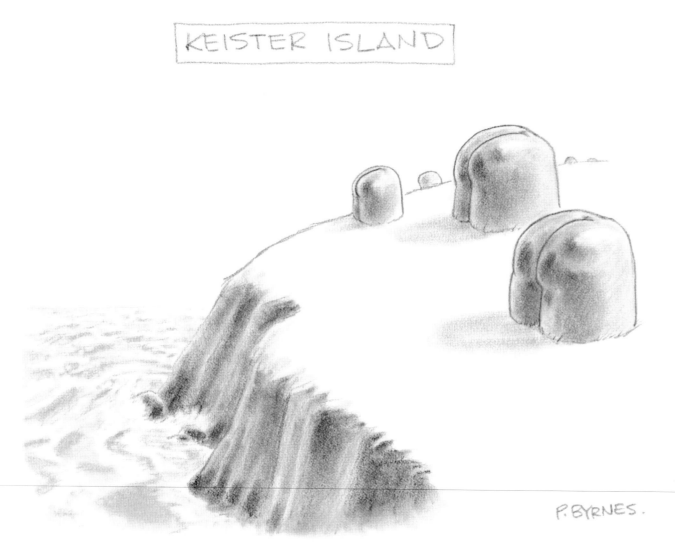

P. BYRNES.

I was born . THOUGHT I'D VISIT THE CLUB, GOT AS FAR AS ~~jellyfish~~ THE DOOR, THEY'D HAVE ~~high school~~ ASKED ME ABOUT, ~~Not long after that~~ YOU, DON'T GET AROUND MUCH ANY MORE. DARLING,. Eventually, however, despite my best efforts, I GUESS MY MIND'S MORE AT EASE and then BUT NEVERTHELESS, WHY STIR UP MEMORIES Perhaps not surprisingly, BEEN INVITED ON DATES, MIGHT . ~~The~~ HAVE ~~of~~ GONE BUT WHAT FOR? AWFULLY DIFF'RENT . And so, ~~I suppose~~ without YOU, DON'T GET AROUND MUCH ANY MORE ? In closing, I'd just like to say HE DON' PLANT TATERS, HE DON' PLANT COTTON, AN' DEM OAT PLANTS 'EM IS SOON FORGOTTEN

Frequently Asked Questions

Where do you get your ideas?

MY BEST FRIEND'S GIRL.

Which comes first, the picture or the caption?

YOU AMERICANS!

How'd you get started?

IN THE SPRING THE LARVAE HATCH AND THE CYCLE BEGINS AGAIN.

I've got a great idea for a cartoon—wanna hear it?

MAYBE WE CAN TOUCH BASE IN HELL.

Infrequently Asked Questions

Have you mooned or *been* mooned more often in your life?

YOU LATE-RISING PROFESSIONALS!

What would make a terrible pizza topping?

A LINCOLN FULL OF MEXICANS.

What might one expect to find at a really low-budget amusement park?

CONDI AND HER RAGGEDY PLUSH SYLVESTER

What did the shepherd say to the three-legged sheepdog? THE CAT TOY

YOU WANT MY NUMBER?

Complete the pie chart below in a way that tells us something about your life or how you think.

In the box below, draw something you couldn't live without.

What do you hate drawing?

MY BEST FRIEND'S GIRL.

Being as accurate as possible, how many desert island cartoons do you think you've come up with and submitted to *The New Yorker*?

3̸ 0

What's the "funniest" thing that you witnessed, overheard, or came up with that you couldn't figure out how to use in a cartoon?

JESUS IN THE "12 APOSTLES OR LESS" LINE AT FAIRWAY.

If you could ask Bob Mankoff, *The New Yorker* cartoon editor, one question, what would it be?

COULD YOU SUPERSIZE THAT FOR ME, SONNY?

Answer the following questions with a number from 1 to 10 (1 being not very much at all and 10 being quite a bit):

Please do not draw anything in the space below. Seriously, I mean it this time.

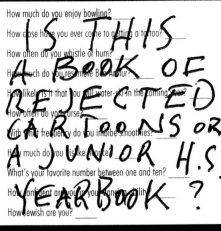

How much do you enjoy bowling?

IS THIS A BOOK OF REJECTED CARTOONS OR A JUNIOR H.S. YEARBOOK?

How close have you ever come to getting a tattoo?

How often do you whistle or hum?

How much do you resemble Bea Arthur?

How likely is it that you will water-ski in the coming year?

How often do you curse?

With what frequency do you imbibe smoothies?

How much do you dislike born/tea?

What's your favorite number between one and ten?

How confident are you in your dancing ability?

How Jewish are you?

Naming Names

What name might you give to a mild-mannered, slightly overweight dental assistant in one of your cartoons?

NURSEY NURSE

Other than Lance, what name would you give to a twenty-eight-year-old metrosexual entertainment lawyer who cycles on weekends?

WHOA! YOU'VE GOT A LOT OF ANGER.

What would be a good name for a new, commercially unviable breakfast cereal?

BARF LOOPS

Come up with a name for an unpleasant medical procedure.

A PECKERECTOMY

If you used a pen name, what would it be?

UNIBALL GEL IMPACT

Draw some sort of doodle using the random lines below as a starting point.

Circle your preference.

beach	OR	mountains
poetry	OR	sports
day	OR	night
llamas	OR	alpacas
Montana	OR	Maine
hot	OR	mild
jazz	OR	country
soup	OR	salad
Luke Skywalker	OR	Han Solo
accordion	OR	bagpipes
pickup truck	OR	Volkswagen Beetle
gorilla suit	OR	chicken suit
time travel	OR	free health care
swimming	OR	jogging
spring	OR	fall
General Tso's chicken	OR	Caesar salad
hip-high fishing waders	OR	lifetime supply of ketchup
life without shoes	OR	life without computers
having a facial tattoo	OR	being a vegan
$10 gift certificate to Orange Julius	OR	$50 gift certificate to Chess King
your very own dump truck	OR	an iPod
one hundred dollars in quarters	OR	snowshoes
walkie-talkie, a pogo stick, a gallon of orange juice, an extension cord, and three new pairs of scissors	OR	a canoe

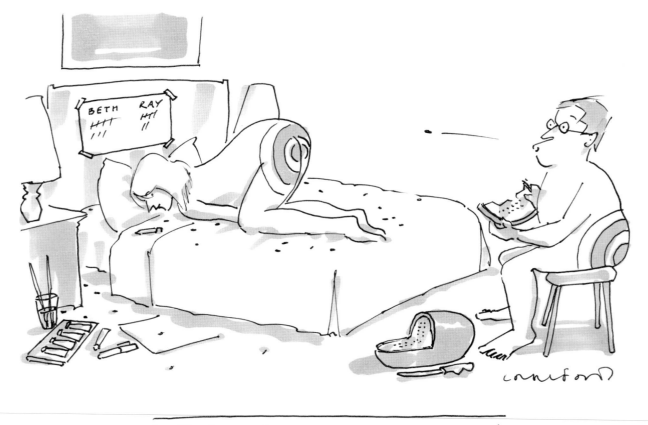

LET THE SUMMER GAMES BEGIN!

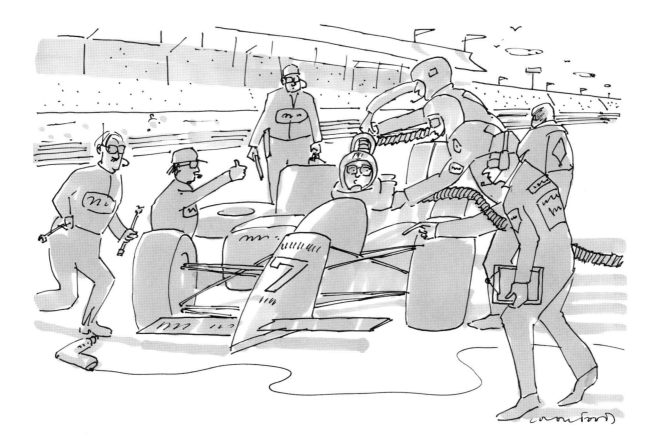

"I need to tinkle."

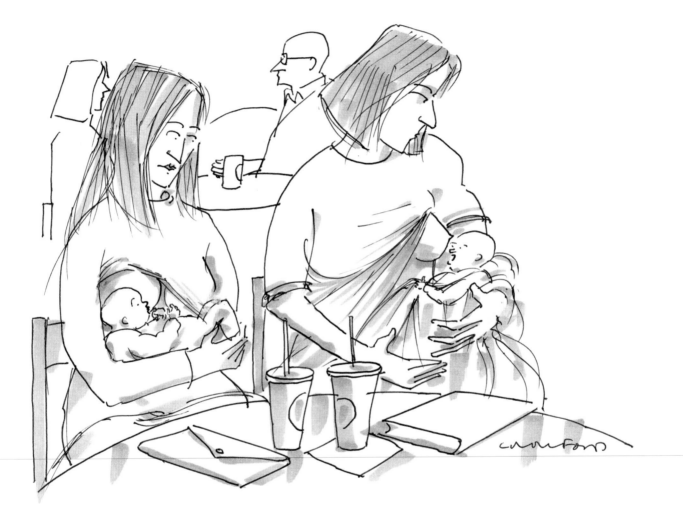

"Wanna swap?"

Gahan Wilson

I was born IGNORANT OF JELLYFISH BUT SAW SOME AT THE AGE OF THREE AND WAS DELIGHTED. YEARS LATER I HEARD jellyfish EXPLAINED BY A TEACHER TO ME in high school AND LOST ALL INTEREST IN THEM. Not long after that, I LOST ALL INTEREST IN HIGH SCHOOL.

Eventually, however, despite my best efforts, I FOUND I HAD GOT BACK MY INTEREST IN JELLYFISH and then IN THE TEACHER BECAUSE I SAW SHE WAS A VERY BEAUTIFUL AND SEXY WOMAN. Perhaps not surprisingly, ALL OF THIS LEFT ME DAZED AND CONFUSED. The POINT of THIS STORY is STILL A MYSTERY TO ME. . And so, I suppose without QUESTION (?) I MUST ADMIT my TALE IS CONFUSING. In closing, I'd just like to say I CAN'T THINK WHY I BROUGHT IT UP.

Frequently Asked Questions

Where do you get your ideas?

YOU TELL ME.

Which comes first, the picture or the caption?

THEY USUALLY CROWD IN TOGETHER.

How'd you get started?

I NOTICED I WAS DRAWING ON WALLS AND TRIED DOING IT ON PAPER.

I've got a great idea for a cartoon—wanna hear it?

HEY, WOULD YOU LOOK AT THE TIME--I'VE GOT TO CATCH A TRAIN!

Infrequently Asked Questions

Have you mooned or *been* mooned more often in your life?

NEITHER.

What would make a terrible pizza topping?

YET ANOTHER PIZZA.

What might one expect to find at a really low-budget amusement park?

MYSELF KILLED BY A FAULTY ROLLER COASTER.

What did the shepherd say to the three-legged sheepdog?

"WHAT SAY WE GO INTO ANOTHER LINE OF WORK?"

Complete the pie chart below in a way that tells us something about your life or how you think.

In the box below, draw something you couldn't live without.

KA THUMP
KA THUMP
KA THUMP
KA THUMP

THERE-- NOW IT'S DONE!

And now for a few more questions . . .

What do you hate drawing?

I'M AFRAID YOU'VE MISTAKEN ME FOR SOMEBODY ELSE.

Being as accurate as possible, how many desert island cartoons do you think you've come up with and submitted to *The New Yorker*?

SOMETHING LIKE 250.

What's the funniest thing that you witnessed, overheard, or came up with that you couldn't figure out how to use in a cartoon?

SO FAR I'VE BEEN LUCKY ENOUGH NOT TO RUN INTO IT.

If you could ask Bob Mankoff, *The New Yorker* cartoon editor, one question, what would it be?

"WHAT'S THE MEANING OF LIFE, BOB?"

Answer the following questions with a number from 1 to 10 (1 being not very much at all and 10 being quite a bit):

How much do you enjoy bowling? 1

How close have you ever come to getting a tattoo? 1

How often do you whistle or hum? 3, MAYBE 4

How much do you resemble Bea Arthur? 2

How likely is it that you will water-ski in the coming year? 1

How often do you curse? DEPENDS ON WHAT YOU MEAN BY "CURSE"

With what frequency do you imbibe smoothies? 1

How much do you dislike licorice? 1

What's your favorite number between one and ten? 5 OR 6

How confident are you in your dancing ability? 1

How Jewish are you? 2 TO 4. IT DEPENDS.

Please do not draw anything in the space below. Seriously, I mean it this time.

Naming Names

What name might you give to a mild-mannered, slightly overweight dental assistant in one of your cartoons?

LANCE

Other than Lance, what name would you give to a twenty-eight-year-old metrosexual entertainment lawyer who cycles on weekends?

FRED

What would be a good name for a new, commercially unviable breakfast cereal?

LANCE

Come up with a name for an unpleasant medical procedure.

LANCE

If you used a pen name, what would it be?

LANCE

Draw some sort of doodle using the random lines below as a starting point.

Circle your preference.

beach OR (mountains)
(poetry) OR sports
(day) OR night
(llamas) OR alpacas
Montana OR (Maine)
hot OR (mild)
(jazz) OR country
(soup) OR salad
Luke Skywalker OR Han Solo NEITHER
accordion OR (bagpipes)
pickup truck OR (Volkswagen Beetle)
(gorilla suit) OR chicken suit
time travel OR (free health care)
(swimming) OR jogging
spring OR (fall)
General Tso's chicken OR (Caesar salad)
hip-high fishing waders OR (lifetime supply of ketchup)
UNDECIDED life without shoes OR life without computers
(having a facial tattoo) OR being a vegan
($10 gift certificate to Orange Julius) OR $50 gift certificate to Chess King
your very own dump truck OR (an iPod)
(one hundred dollars in quarters) OR snowshoes
walkie-talkie, a pogo stick, a gallon of orange juice, an extension cord, and three new pairs of scissors OR (a canoe)

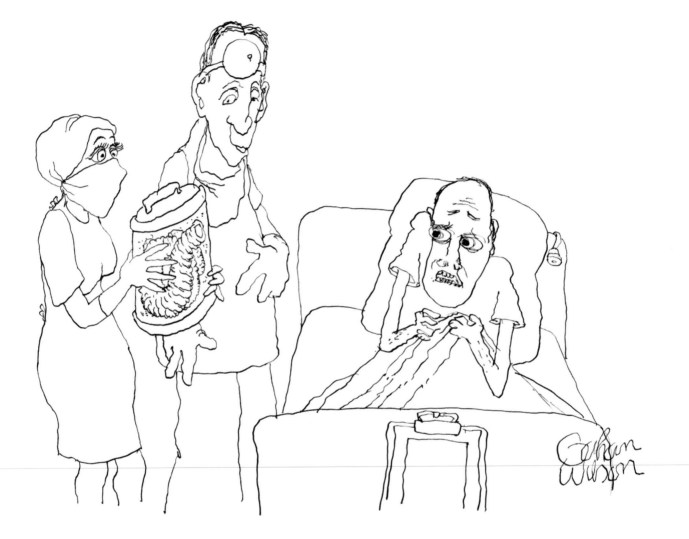

"Some like to keep them as souvenirs, some don't."

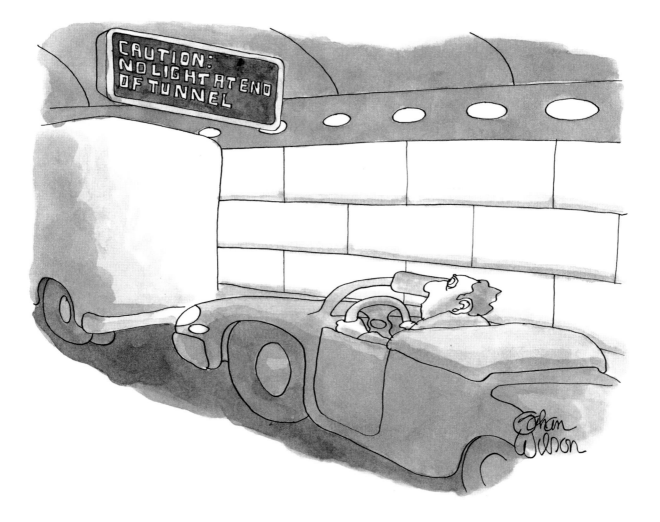

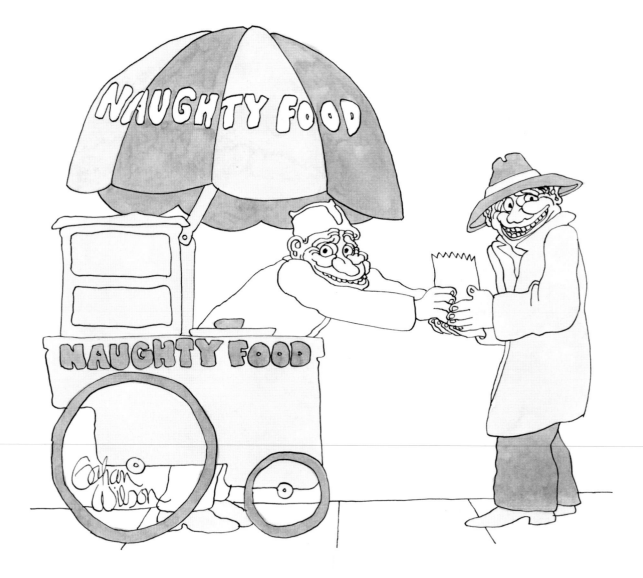

Fill-in-the-Blank Bio

I was born _IN NEW YORK._

~~Jellyfish~~

WHILE in high school _I STAYED IN NEW YORK._

Not long after that, _I CONTINUED TO STAY IN NEW YORK._

Eventually, however, despite my best efforts, _I CONTINUED TO BE IN NEW YORK._

~~and then~~ _____ . Perhaps not surprisingly, _I SOMETIMES_

FANTASIZE ABOUT NOT BEING IN NEW YORK, _____ . The _____ of

_____ ~~is~~ _____

_____ . And so, ~~I suppose~~ without _____

_____ _BUT_ my _ANKLE MONITOR SAYS OTHERWISE._

In closing, I'd just like to say _I'M STILL IN NEW YORK._

Frequently Asked Questions

Where do you get your ideas?

FROM A BOX ON THE SHELF.

Which comes first, the picture or the caption?

ONE OR THE OTHER.

How'd you get started?

AT THE BEGINNING.

I've got a great idea for a cartoon—wanna hear it?

SURE.

Infrequently Asked Questions

Have you mooned or *been* mooned more often in your life?

I CAN'T REMEMBER.

What would make a terrible pizza topping?

CHEESE

What might one expect to find at a really low-budget amusement park?

" STANDING STILL, THE RIDE."

What did the shepherd say to the three-legged sheepdog?

WHERE'S YOUR OTHER LEG?

In the box below, draw something you couldn't live without.

Complete the pie chart below in a way that tells us something about your life or how you think.

And now for a few more questions . . .

What do you hate drawing?

STEAM COMING FROM A FRESHLY SLAUGTERED ANIMAL.

Being as accurate as possible, how many desert island cartoons do you think you've come up with and submitted to *The New Yorker*?

184

What's the funniest thing that you witnessed, overheard, or came up with that you couldn't figure out how to use in a cartoon?

NAUGHTY PINE

If you could ask Bob Mankoff, *The New Yorker* cartoon editor, one question, what would it be?

WHEN IS THE CARTOONISTS' LOUNGE GOING TO BE REDECORATED?

Answer the following questions with a number from 1 to 10 (1 being not very much at all and 10 being quite a bit):

How much do you enjoy bowling? 1

How close have you ever come to getting a tattoo? 1

How often do you whistle or hum? 1

How much do you resemble Bea Arthur? 1

How likely is it that you will water-ski in the coming year? 1

How often do you curse? 2

With what frequency do you imbibe smoothies? 1

How much do you dislike licorice? 1

What's your favorite number between one and ten? 1

How confident are you in your dancing ability? 1

How Jewish are you? 2

Please do not draw anything in the space below. Seriously, I mean it this time.

Naming Names

What name might you give to a mild-mannered, slightly overweight dental assistant in one of your cartoons?

LANCE

Other than Lance, what name would you give to a twenty-eight-year-old metrosexual entertainment lawyer who cycles on weekends?

VANCE

What would be a good name for a new, commercially unviable breakfast cereal?

"STEAM FROM A FRESHLY SLAUGHTERED ANIMAL"

Come up with a name for an unpleasant medical procedure.

A DOCTOR EXTRACTION.

If you used a pen name, what would it be?

P. C. VEY

Draw some sort of doodle using the random lines below as a starting point.

Circle your preference.

beach	OR	(mountains)
(poetry)	OR	sports
day	OR	(night)
llamas	OR	(alpacas)
Montana	OR	(Maine)
hot	OR	(mild)
(jazz)	OR	country
soup	OR	(salad)
Luke Skywalker	OR	(Han Solo)
(accordion)	OR	bagpipes
pickup truck	OR	(Volkswagen Beetle)
gorilla suit	OR	(chicken suit)
(time travel)	OR	free health care
swimming	OR	(jogging)
spring	OR	(fall)
General Tso's chicken	OR	(Caesar salad)
hip-high fishing waders	OR	(lifetime supply of ketchup)
life without shoes	OR	(life without computers)
(having a facial tattoo)	OR	being a vegan
$10 gift certificate to Orange Julius	OR	($50 gift certificate to Chess King)
your very own dump truck	OR	(an iPod)
(one hundred dollars in quarters)	OR	snowshoes
(walkie-talkie, a pogo stick, a gallon of orange juice, an extension cord, and three new pairs of scissors)	OR	a canoe

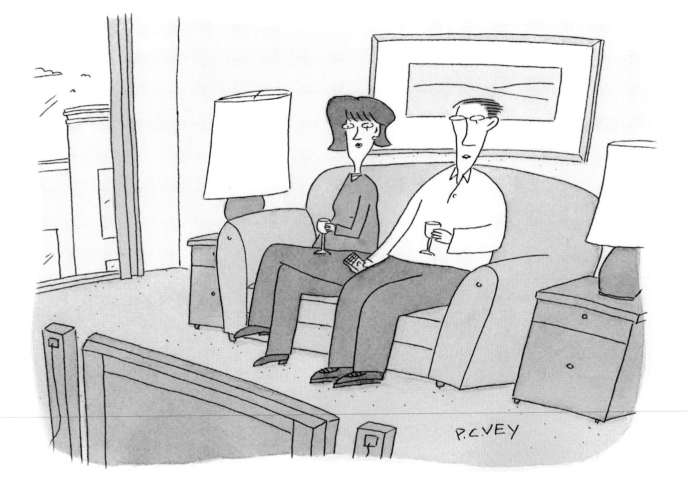

"*You haven't seen disaster relief till you've seen it in high definition.*"

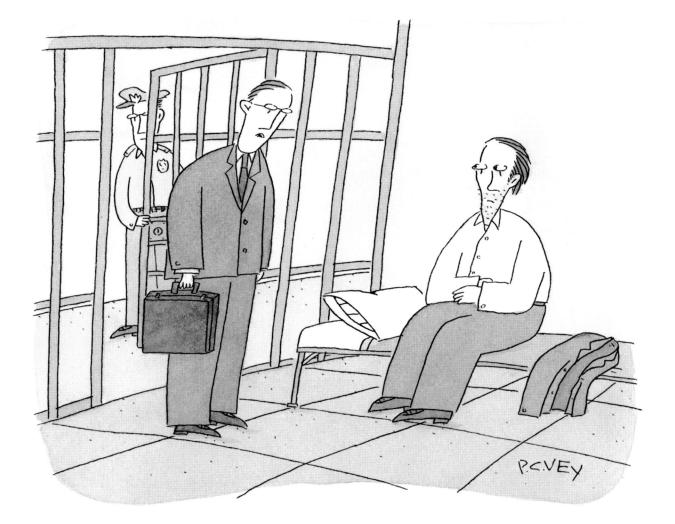

"They've agreed to drop the charges, but only if you agree never to stuff the turkey again."

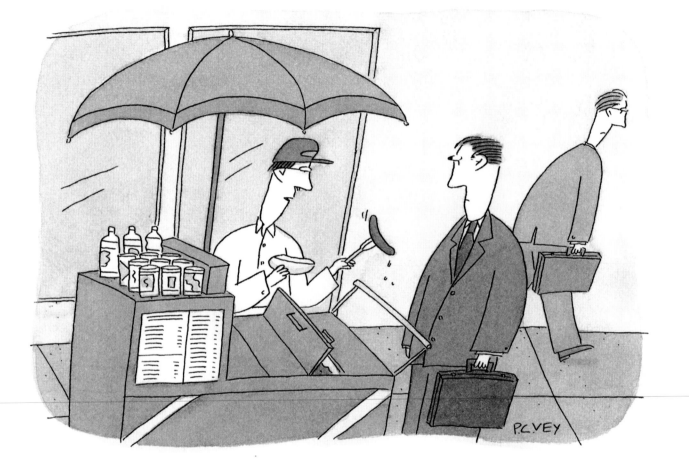

"Are you sure you don't want to lick it before I bun it?"

Fill-in-the-Blank Bio

I was born HASTILY AND AGAINST MY WISHES, A CLEAR VIOLATION OF AN INTRA-UTERO AGREEMENT THAT MY _____ jellyfish OF AN ATTORNEY PROMISED ME WOULDN'T EXPIRE UNTIL I WAS in high school AND FREE OF MY SHADY PAST.

Not long after that, I FOUND MY WAY TO A TRAVELING ROADSHOW WHERE I LIVED OFF MY WITS AND ROGUE STREET CHEETOS.

Eventually, however, despite my best efforts, THE WINDS OF DESTINY GATHERED, SWIRLED and then BLEW AN EMBER OF GOOD FORTUNE ONTO MY TINDERBOX OF FATE. Perhaps not surprisingly, I ROSE QUICKLY AMONG THE RANKS OF THE FALSE PROPHETS. The POWERS of MY RELIGIOUS VENTRILOQUISM is UNPARALELLED AMONGST THE CHOSEN FEW WHO ARE BOLD ENOUGH TO SEEK SUCH HERCULEAN TALENTS. And so, I suppose without MY FULL CONTROL, VENTRILO-THEISM BROUGHT THE MESSAGE TO THE MASSES AND MASSES TO THE PUPPET? THEN AGAIN, MAYBE IT WAS JUST MORE ENTERTAINING THAN my TALKING HORSE ACT.

In closing, I'd just like to say BRING THEE TITHINGS UNTO ME AND YOU MAY HEAR THE TRUTHS SPOKEN FROM THE WOODEN IDOL. CASH, NO CHECKS.

Frequently Asked Questions

Where do you get your ideas?
DEEP IN THE HEART OF NEW JERSEY, BURIED IN AN OLD ABANDONED MINE THERE LIES A TRUNK FULL OF GAGS. UNFORTUNATELY, ALL ABOUT DESERT ISLANDS.

Which comes first, the picture or the caption?
THE EGG — WAIT — NO, CHICKEN.

How'd you get started?
USUALLY WITH A CUP OF COFFEE.

I've got a great idea for a cartoon—wanna hear it?
THAT'S THE FIRST THREE MINUTES OF EVERY COCKTAIL PARTY I'VE EVER BEEN TO.

Infrequently Asked Questions

Have you mooned or *been* mooned more often in your life?
I PROUDLY REFUSE TO WRITE A VENUS OR URANUS JOKE HERE.

What would make a terrible pizza topping?
CHEESE.

What might one expect to find at a really low-budget amusement park?
MOST OF MY FAMILY. WE'RE CARNY PROUD.

What did the shepherd say to the three-legged sheepdog?
SIT. STAY. FALL OVER.

Complete the pie chart below in a way that tells us something about your life or how you think.

In the box below, draw something you couldn't live without.

mmmm...

COFFEE AND PIE

What do you hate drawing?

THE SHATTERED HOPES AND DREAMS OF A GENERATION. THAT, AND WALNUTS.

Being as accurate as possible, how many desert island cartoons do you think you've come up with and submitted to *The New Yorker*?

ZERO. ATHOUGH STRANGELY, SOME WERE PUBLISHED UNDER MY NAME.

What's the funniest thing that you witnessed, overheard, or came up with that you couldn't figure out how to use in a cartoon?

ONCE, THERE WAS THIS GUY AND HE DID THIS THING AT THIS PLACE AND IT WAS A RIOT!! YOU CAN'T MAKE THAT STUFF UP!!! GOOD TIMES.

If you could ask Bob Mankoff, *The New Yorker* cartoon editor, one question, what would it be?

BOB, WHY DO GOOD THINGS HAPPEN TO BAD PEOPLE?

Draw some sort of doodle using the random lines below as a starting point.

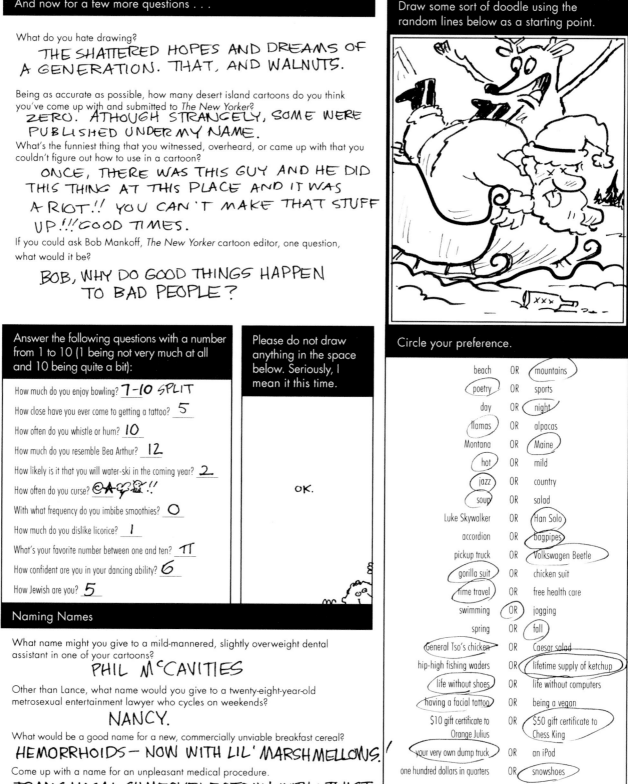

Answer the following questions with a number from 1 to 10 (1 being not very much at all and 10 being quite a bit):

How much do you enjoy bowling? 7-10 SPLIT

How close have you ever come to getting a tattoo? 5

How often do you whistle or hum? 10

How much do you resemble Bea Arthur? 12

How likely is it that you will water-ski in the coming year? 2

How often do you curse? @A-$%&!!

With what frequency do you imbibe smoothies? O

How much do you dislike licorice? 1

What's your favorite number between one and ten? π

How confident are you in your dancing ability? 6

How Jewish are you? 5

Please do not draw anything in the space below. Seriously, I mean it this time.

OK.

Circle your preference.

beach	OR	(mountains)
(poetry)	OR	sports
day	OR	(night)
(llamas)	OR	alpacas
Montana	OR	(Maine)
(hot)	OR	mild
(jazz)	OR	country
(soup)	OR	salad
Luke Skywalker	OR	(Han Solo)
accordion	OR	(bagpipes)
pickup truck	OR	(Volkswagen Beetle)
(gorilla suit)	OR	chicken suit
(time travel)	OR	free health care
swimming	(OR)	jogging
spring	OR	(fall)
(General Tso's chicken)	OR	Caesar salad
hip-high fishing waders	OR	(lifetime supply of ketchup)
(life without shoes)	OR	life without computers
(having a facial tattoo)	OR	being a vegan
$10 gift certificate to Orange Julius	OR	($50 gift certificate to Chess King)
(your very own dump truck)	OR	an iPod
one hundred dollars in quarters	OR	(snowshoes)
walkie-talkie, a pogo stick, a gallon of orange juice, an extension cord, and three new pairs of scissors	OR	a canoe

What name might you give to a mild-mannered, slightly overweight dental assistant in one of your cartoons?

PHIL McCAVITIES

Other than Lance, what name would you give to a twenty-eight-year-old metrosexual entertainment lawyer who cycles on weekends?

NANCY.

What would be a good name for a new, commercially unviable breakfast cereal?

HEMORRHOIDS — NOW WITH LIL' MARSHMELLOWS!

Come up with a name for an unpleasant medical procedure.

TRANS NASAL SHMECKELECTOMY, WITH A TWIST.

If you used a pen name, what would it be?

MAX KENSINGTON OR KARL MERRIWEATHER WOULD BE MY NOM DE TOON.

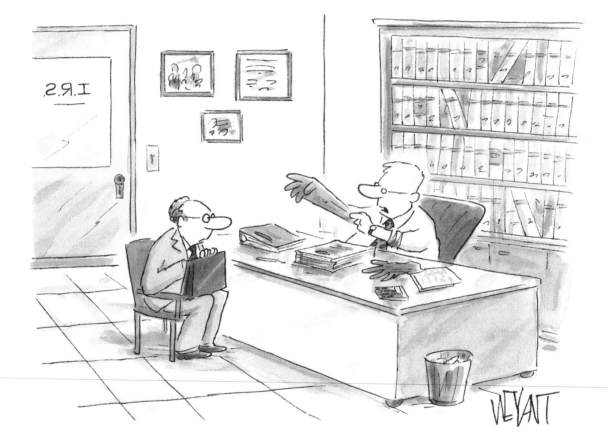

"Is this your first audit?"

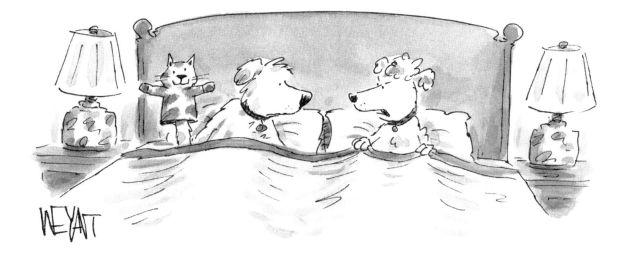

"I told you I'm not into any kinky stuff."

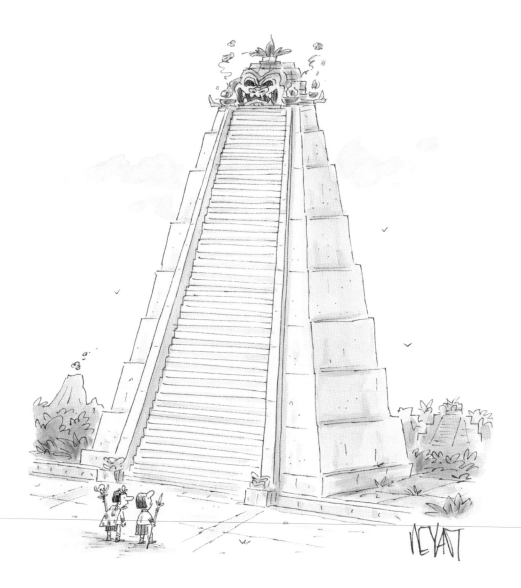

"*The gods really love tight buns.*"

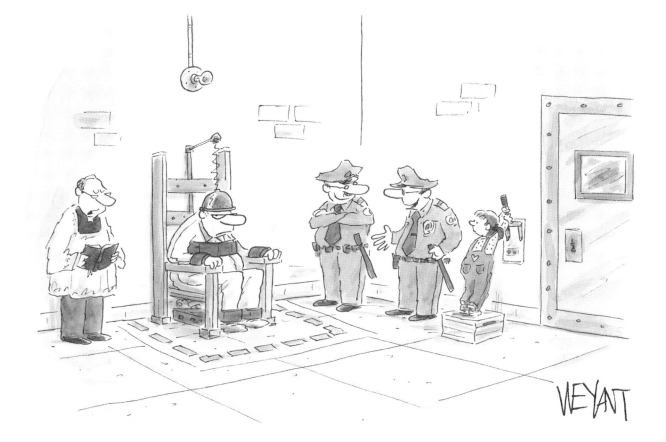

*"I've got to admit, Bring Your Daughter to Work Day really
adds a touch of home to the workplace."*

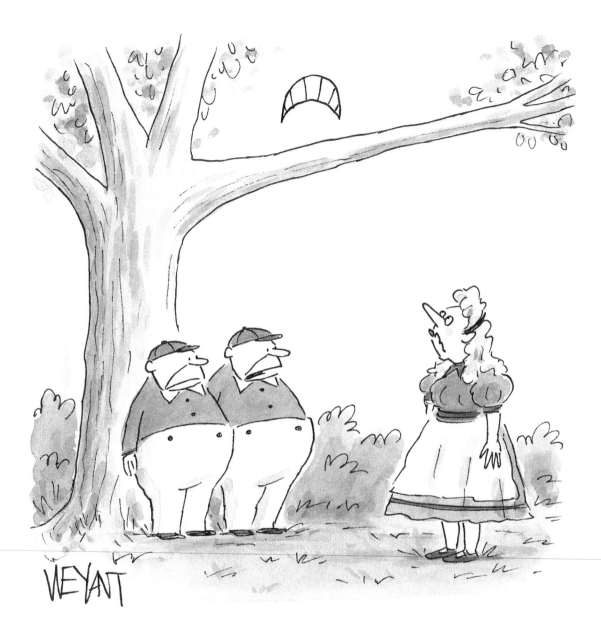

"We had him neutered."

I was born _in Seattle before it was cool. I spent my_ childhood drawing like a _jellyfish, instead of inventing_ Microsoft. Then, in high school, _I could draw like a monkey._ Not long after that, _I went on to college in the hope I_ _could draw like Michelangelo or at least a human._ Eventually, however, despite my best efforts, _it became apparent I was a_ _cartoonist. Now_ and then, _I wonder if I could have_ _at least invented Starbucks_. Perhaps not surprisingly, _my years_ _of bitterness come out in my work_. The _usual outcome_ of _these thoughts_ is _a batch of cartoons to send_ _around to wary editors_. And so, I suppose without _this_ _outlet I'd be like a billionaire or something_? _I'm just glad I haven't wasted_ my _life like some people._ In closing, I'd just like to say _I don't even like coffee, so there_!

Frequently Asked Questions

Where do you get your ideas?
Brooding, obsessing, daydreaming

Which comes first, the picture or the caption?
The embryonic idea comes at once — then evolves.

How'd you get started?
We had drawing time everyday

I've got a great idea for a cartoon—wanna hear it?
No, but Diffee does!

Infrequently Asked Questions

Have you mooned or *been* mooned more often in your life?
The pets moon me everyday

What would make a terrible pizza topping?
Cat food-right, Mom?

What might one expect to find at a really low-budget amusement park?
Teeny Tiny Rollercoasters

What did the shepherd say to the three-legged sheepdog?
I just hope it was empathetic and not some dumb joke

Complete the pie chart below in a way that tells us something about your life or how you think.

In the box below, draw something you couldn't live without.

And now for a few more questions . . .

What do you hate drawing?

Nothing

Being as accurate as possible, how many desert island cartoons do you think you've come up with and submitted to *The New Yorker*?

12.5

What's the funniest thing that you witnessed, overheard, or came up with that you couldn't figure out how to use in a cartoon?

Nice try, Diffee!

If you could ask Bob Mankoff, *The New Yorker* cartoon editor, one question, what would it be?

Have you ever laughed out loud at one of my cartoons? Smiled to yourself? Never mind.

Answer the following questions with a number from 1 to 10 (1 being not very much at all and 10 being quite a bit):

How much do you enjoy bowling? 8

How close have you ever come to getting a tattoo? 1

How often do you whistle or hum? 3

How much do you resemble Bea Arthur? Hey!

How likely is it that you will water-ski in the coming year? 3

How often do you curse? 4

With what frequency do you imbibe smoothies? 10

How much do you dislike licorice? 2

What's your favorite number between one and ten? 10

How confident are you in your dancing ability? 5

How Jewish are you? 1

Naming Names

What name might you give to a mild-mannered, slightly overweight dental assistant in one of your cartoons?

Amy

Other than Lance, what name would you give to a twenty-eight-year-old metrosexual entertainment lawyer who cycles on weekends?

Josh

What would be a good name for a new, commercially unviable breakfast cereal?

Chunks

Come up with a name for an unpleasant medical procedure.

Nosectomy

If you used a pen name, what would it be?

Warp — But it's not

Please do not draw anything in the space below. Seriously, I mean it this time.

PAY
KIM WARP
ONE MILLION
DOLLARS
M.D.

Draw some sort of doodle using the random lines below as a starting point.

Circle your preference.

beach OR mountains
poetry OR sports
day OR night
llamas OR alpacas
Montana OR Maine
weather hot OR mild sauce
jazz OR country
soup OR salad
Luke Skywalker OR Han Solo
death accordion OR bagpipes
pickup truck OR Volkswagen Beetle
gorilla suit OR chicken suit
time travel OR free health care
swimming OR jogging
spring OR fall
General Tso's chicken OR Caesar salad
hip-high fishing waders OR lifetime supply of ketchup
life without shoes OR life without computers
having a facial tattoo OR being a vegan
$10 gift certificate to Orange Julius OR $50 gift certificate to Chess King
your very own dump truck OR an iPod
one hundred dollars in quarters OR snowshoes
walkie-talkie, a pogo stick, a gallon of orange juice, an extension cord, and three new pairs of scissors OR a canoe

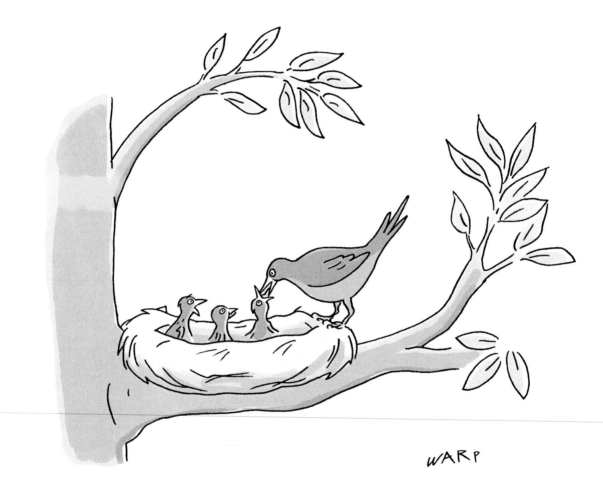

"Smoothies again?"

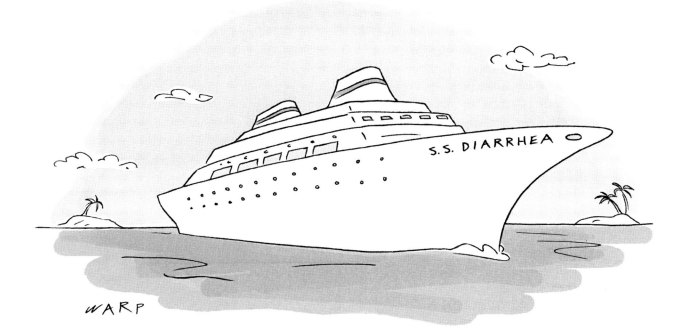

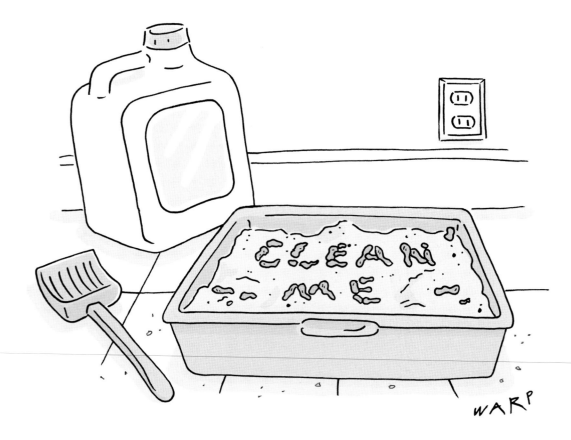

Drew Dernavich

Fill-in-the-Blank Bio

I was born, I THINK. I ALWAYS PREFERRED TO THINK THAT I WAS A SEA CREATURE, CREATED BY THE OCEAN AND WASHING UP ON SHORE LIKE A jellyfish, WHERE I ATE SOME BREAKFAST AND THEN ENROLLED in high school. NO ONE WOULD EVER KNOW, RIGHT?

Not long after that, THOUGH, WHEN I GOT MY DRIVERS LICENSE, I REALIZED THAT "WASHED-UP-ON-SHORE DATE" WOULD PROBABLY RAISE SOME RED FLAGS. I TRIED IT ANYWAY.

Eventually, however, despite my best efforts, I HAD TO ADMIT I WAS BORN, IF ONLY SO THAT I COULD LEGALLY PLAY SPORTS and then LEGALLY DRINK AND LEGALLY MEET WOMEN AND THEN LEAD A NORMAL LIFE. THAT WAS THE PLAN. Perhaps not surprisingly, I DIDN'T LEAD A NORMAL LIFE AS A HUMAN, NO MATTER HOW HARD I TRIED. The REAL KICKER of THE SITUATION is THAT I ACTUALLY DID HAVE RUBBERY LEGS (BAD FOR SPORTS) AND A SQUISHY HEAD AND I LEFT A TRAIL OF OOZE. And so, I suppose without KNOWING, I WAS ALWAYS A SEA CREATURE. KAFKA COULD BE A ROACH - WHY COULDN'T I BE A JELLY? I'M BEING TRANSPARENT HERE. CAN YOU SEE my DILEMMA?

In closing, I'd just like to say MAYBE THIS IS ALL CRAZY TALK. SEE YOU AT THE BEACH.

Frequently Asked Questions

Where do you get your ideas? BEHIND THAT TALL, SHINY-LOOKING THINGY WITH THE KNOB ON IT, RIGHT ACROSS FROM YOU. NO, NOT THAT ONE. THE OTHER ONE.

Which comes first, the picture or the caption?

THE IDEA

How'd you get started?

WITH MY FIRST IDEA

I've got a great idea for a cartoon—wanna hear it?

HOW ABOUT A BEER INSTEAD?

Infrequently Asked Questions

Have you mooned or *been* mooned more often in your life?
AFTER A LONG DAY OF WORK, I LOVE TO GO OUT AND GET MOONED.

What would make a terrible pizza topping?

NOSTALGIA

What might one expect to find at a really low-budget amusement park?
MATT DIFFEE, EATING CIRCUS PEANUTS

What did the shepherd say to the three-legged sheepdog?

"I'VE GOT A GREAT IDEA FOR A CARTOON— WANNA HEAR IT?"

Complete the pie chart below in a way that tells us something about your life or how you think.

In the box below, draw something you couldn't live without.

MEDICINAL CHILI

And now for a few more questions . . .

What do you hate drawing?

SHRUBBERY. FEET. TINY LITTLE DETAILS.

Being as accurate as possible, how many desert island cartoons do you think you've come up with and submitted to *The New Yorker*?

14

What's the funniest thing that you witnessed, overheard, or came up with that you couldn't figure out how to use in a cartoon?

THERE USED TO BE A BLIND MAN AT MY SUBWAY STOP WHO WOULD FEEL FOR HIS SEAT BY PLUNGING HIS STICK INTO EVERYBODY'S CROTCH. HIS AIM WAS PAINFULLY ACCURATE. PEOPLE WERE TERRIFIED. IT WAS GREAT THEATRE. I COULD NEVER MAKE IT ANY FUNNIER THAN IT WAS.

If you could ask Bob Mankoff, *The New Yorker* cartoon editor, one question, what would it be?

"WHY ARE YOU INTERESTED IN COMING TO WORK FOR ME, MR. MANKOFF?"

Draw some sort of doodle using the random lines below as a starting point.

Answer the following questions with a number from 1 to 10 (1 being not very much at all and 10 being quite a bit):

How much do you enjoy bowling? __8__

How close have you ever come to getting a tattoo? __1__

How often do you whistle or hum? __2__

How much do you resemble Bea Arthur? __B__

How likely is it that you will water-ski in the coming year? __1__

How often do you curse? __2. BFD.__

With what frequency do you imbibe smoothies? __8. BFD.__

How much do you dislike licorice? __9__

What's your favorite number between one and ten? __3__

How confident are you in your dancing ability? __4__

How Jewish are you? __4__

Naming Names

What name might you give to a mild-mannered, slightly overweight dental assistant in one of your cartoons?

NACHO PANZA

Other than Lance, what name would you give to a twenty-eight-year-old metrosexual entertainment lawyer who cycles on weekends?

CHAD

What would be a good name for a new, commercially unviable breakfast cereal?

INDIVIDUALLY WRAPPED RICE KRISPIES

Come up with a name for an unpleasant medical procedure.

LEMON MERINGUE (THE PROCEDURE IS SO PAINFUL I COULDN'T NAME IT FOR WHAT IT REALLY IS.

If you used a pen name, what would it be? 'T REALLY IS.

MARCUS CHICKENSTOCK *

* WITH APOLOGIES TO JOHN HODGMAN

Please do not draw anything in the space below. Seriously, I mean it this time.

COUNT SPORKULA

Circle your preference.

beach OR mountains
poetry OR sports
day OR night
llamas OR alpacas
Montana OR Maine
hot OR mild
jazz OR country
soup OR salad
Luke Skywalker OR Han Solo
accordion OR bagpipes
pickup truck OR Volkswagen Beetle
gorilla suit OR chicken suit
time travel OR free health care
swimming OR jogging
spring OR fall
General Tso's chicken OR Caesar salad
hip-high fishing waders OR lifetime supply of ketchup
life without shoes OR life without computers
having a facial tattoo OR being a vegan
$10 gift certificate to Orange Julius OR $50 gift certificate to Chess King
your very own dump truck OR an iPod
one hundred dollars in quarters OR snowshoes
walkie-talkie, a pogo stick, a gallon of orange juice, an extension cord, and three new pairs of scissors OR a canoe

↘ HOW FRESH IS THE O.J.? I NEED MORE TIME.

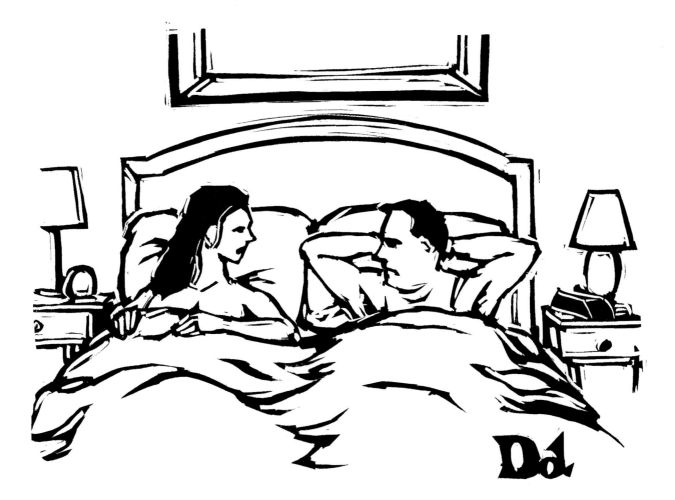

"I faked your New Year's resolution."

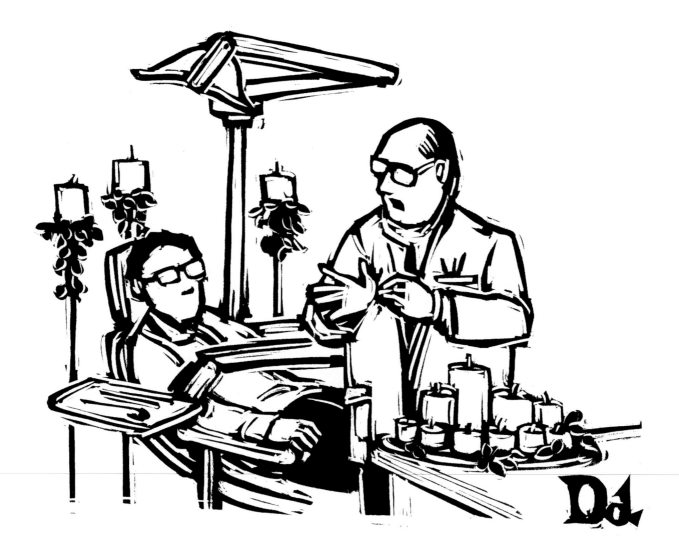

"Will it be just a cleaning or the full hour of sensual dentistry?"

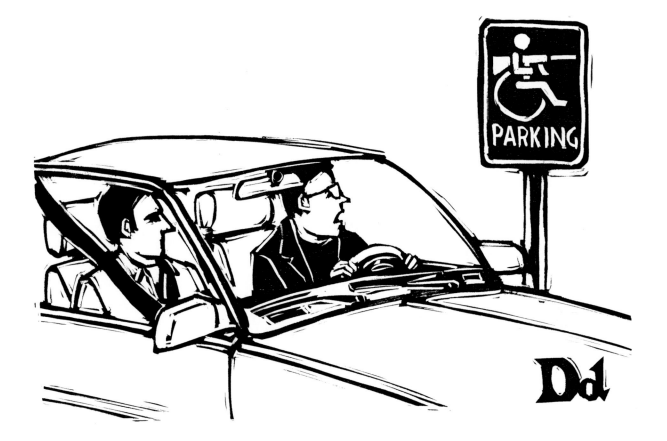

"It's not the ticket I'm worried about."

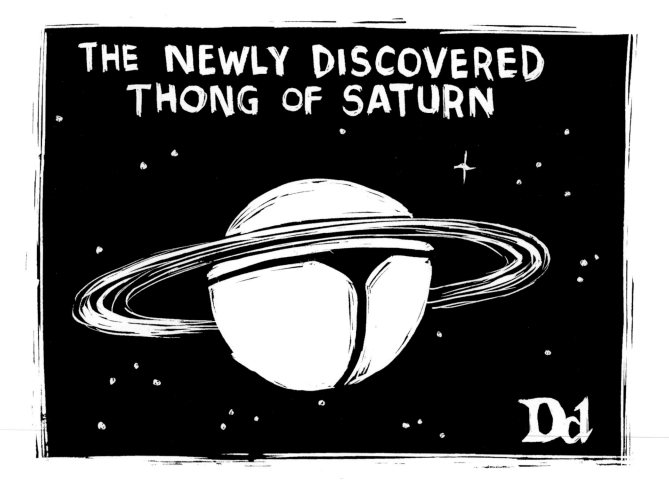

Danny Shanahan

Fill-in-the-Blank Bio

I was born _near Prospect Hospital, in Brooklyn, in the street,_
___My first love was a___ jellyfish _whose name was Marguerite._
___I met a girl___ in high school, _who wouldn't sting me raw,_
Not long after that, _my Marguerite became a seaside whore._
I begged with her, I pleaded – I said, "We'll float away,"
Eventually, however, despite my best efforts, _she'd just say:_
"The money's great" and then _she'd scream "I'll dry up_
if you go!" Meanwhile, Perhaps not surprisingly, _she spent_
her cash on blow. The _moral_ of
this story is, _a jellyfish's life, should move toward true_
enlightenment, not "see-through, drugged out wife And so, I suppose without _a spine,_
inevitably, Mags sank. She washed up (??????),
decomposed on shore, and, Oh my _Lord, she stank._
In closing, I'd just like to say _Mom & Dad, don't worry, And Marguerite, I'm_
very, very, very, very sorry.

Frequently Asked Questions

Where do you get your ideas?

From Thomas Edison's
slush pile.

Which comes first, the picture or the caption?

The caption.

How'd you get started?

Coffee and crystal.

I've got a great idea for a cartoon—wanna hear it?

Thanks, heard it.

Infrequently Asked Questions

Have you mooned or *been* mooned more often in your life?

Been mooned.

What would make a terrible pizza topping?

Cookie dough.

What might one expect to find at a really low-budget amusement park?

Ride the Spatula

What did the shepherd say to the three-legged sheepdog?

"And my father's Rolex?"

Complete the pie chart below in a way that tells us something about your life or how you think.

In the box below, draw something you couldn't live without.

What do you hate drawing? Orchestras; The Vatican; love, in all its myriad guises.

Being as accurate as possible, how many desert island cartoons do you think you've come up with and submitted to *The New Yorker*?

At least three dozen.

What's the funniest thing that you witnessed, overheard, or came up with that you couldn't figure out how to use in a cartoon?

Wow, wouldn't that be something? If that ever happened? Wow. Wow. Wow. Wow.

If you could ask Bob Mankoff, *The New Yorker* cartoon editor, one question, what would it be?

"Is it I, Lord?"

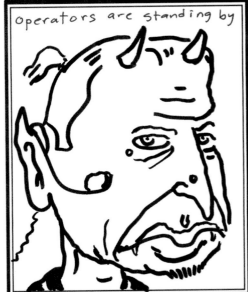

Draw some sort of doodle using the random lines below as a starting point.

operators are standing by

Answer the following questions with a number from 1 to 10 (1 being not very much at all and 10 being quite a bit):

How much do you enjoy bowling? 3

How close have you ever come to getting a tattoo? 1

How often do you whistle or hum? 8

How much do you resemble Bea Arthur? 5

How likely is it that you will water-ski in the coming year? 1

How often do you curse? 5

With what frequency do you imbibe smoothies? 2

How much do you dislike licorice? 1

What's your favorite number between one and ten? 7

How confident are you in your dancing ability? 1

How Jewish are you? a shtikl

Please do not draw anything in the space below. Seriously, I mean it this time.

Naming Names

What name might you give to a mild-mannered, slightly overweight dental assistant in one of your cartoons?

Jack Plaque

Other than Lance, what name would you give to a twenty-eight-year-old metrosexual entertainment lawyer who cycles on weekends?

Flash

What would be a good name for a new, commercially unviable breakfast cereal?

Placent-Os

Come up with a name for an unpleasant medical procedure.

Aortic Martinizing

If you used a pen name, what would it be?

Penny

Circle your preference.

(beach)	OR	mountains
poetry	OR	(sports)
day	OR	(night)
(llamas)	OR	alpacas
Montana	(OR)	Maine
(hot)	OR	mild
jazz	OR	(country)
(soup)	OR	salad
Luke Skywalker	OR	(Han Solo)
(accordion)	OR	bagpipes
(pickup truck)	OR	Volkswagen Beetle
(gorilla suit)	OR	chicken suit
(time travel)	OR	free health care
(swimming)	OR	jogging
(spring)	OR	fall
(General Tso's chicken)	OR	Caesar salad
(hip-high fishing waders)	OR	lifetime supply of ketchup
(life without shoes)	OR	life without computers
(having a facial tattoo)	OR	being a vegan
($10 gift certificate to Orange Julius)	OR	$50 gift certificate to Chess King
(your very own dump truck)	OR	an iPod
(one hundred dollars in quarters)	OR	snowshoes
walkie-talkie, a pogo stick, a gallon of orange juice, an extension cord, and three new pairs of scissors	OR	(a canoe)

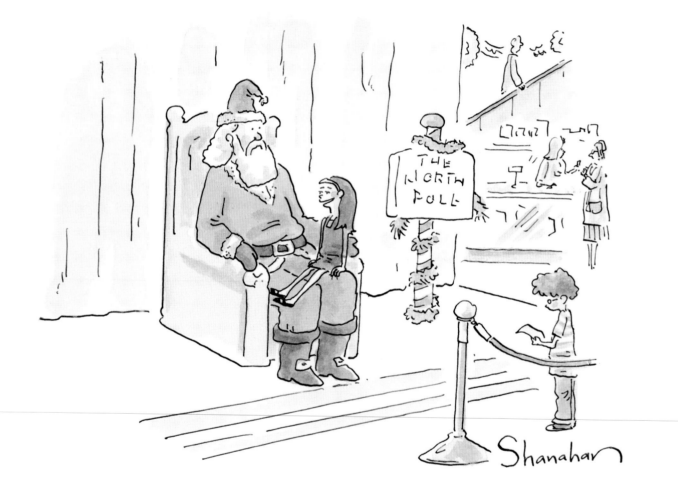

"Your thighs are like iron."

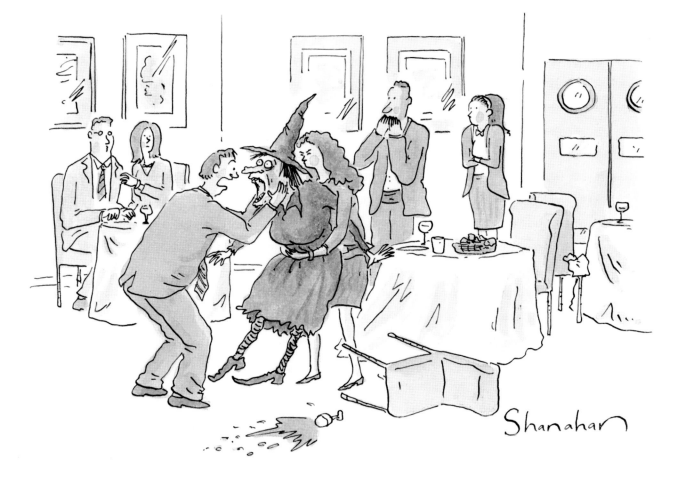

"Keep pushing—I can see the baby's head!"

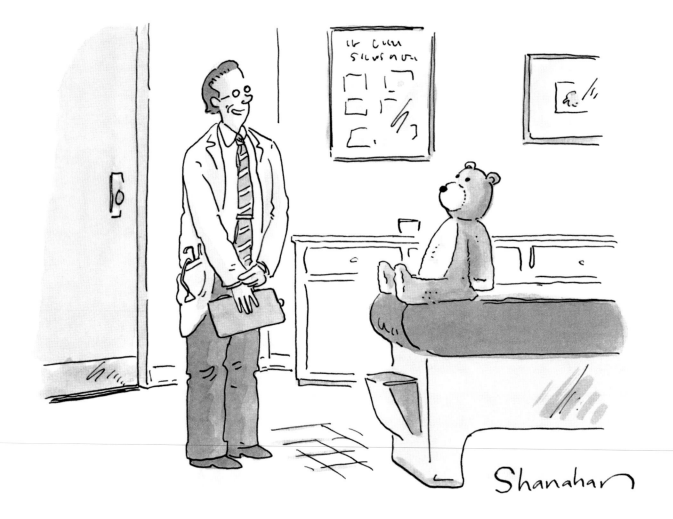

"*You have the most adorable lesions in your lungs.*"

Shanahan

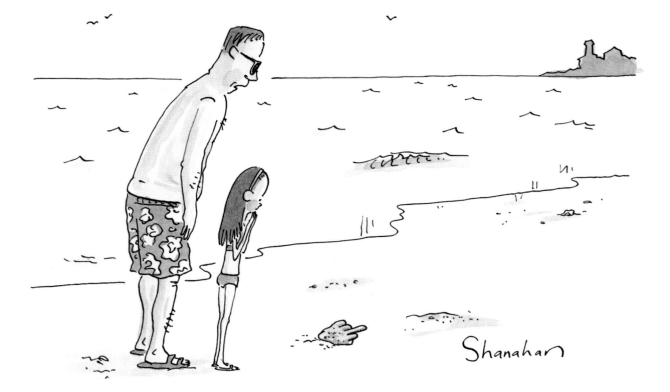

"Well, sweetheart, it's Mr. Sea Star's only defense mechanism."

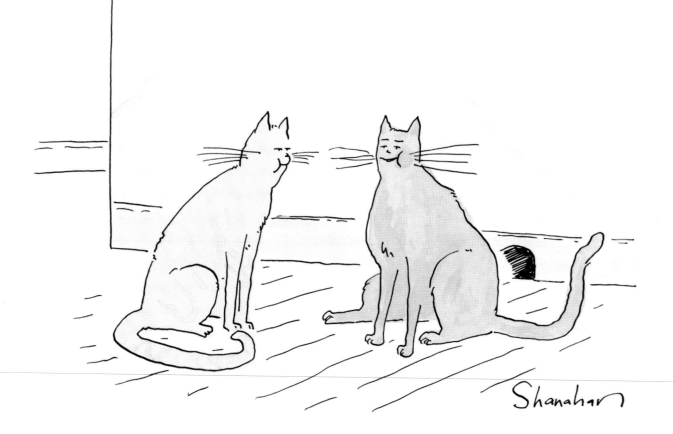

"Mmmm . . . I got a cheese-filled one."

Sam Gross

I was born _in wedlock and I was soon abandoned by_ _____ _my parents and was raised by_ jellyfish. At _parent-teacher meetings_ in high school _I felt embarrassed to be associated with them,_ Not long after that, _I grew up and came to realize all the sacrifices they made for me;_ _including giving up stinging people in the water for Lent._ Eventually, however, despite my best efforts, _they grew to resent me because of my_ _prior behavior toward them_ and then _they turned my sister against me who stung me_ _during Lent and I wasn't even in the water._ Perhaps not surprisingly, _I would have_ _preferred to be raised by wolves like my little friend Grrrr!_ The _fact_ of _the matter_ is that his parents were feared at school and so nobody _made fun of him in the schoolyard._ And so, I suppose without _this upbringing_ _I would have become a, Whoa! Is that a question mark?_ _My! my! my!_ In closing, I'd just like to say _I spent too much time filling this damn thing out._

Where do you get your ideas?
funnycartoons@autodafé.com

Which comes first, the picture or the caption?
The agony.

How'd you get started? _I have a button at the base of my spine._

I've got a great idea for a cartoon—wanna hear it?
No, but I think Diffee has a need to.

Have you mooned or *been* mooned more often in your life? _I was once mooned by a starlet if that is at all possible._
What would make a terrible pizza topping?
Anything alive.

What might one expect to find at a really low-budget amusement park?
The Tunnel of Onan

What did the shepherd say to the three-legged sheepdog? _A large erection will keep you from toppling over._

Complete the pie chart below in a way that tells us something about your life or how you think.

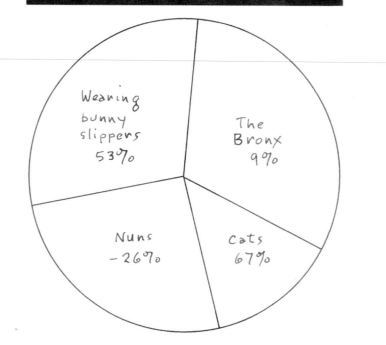

In the box below, draw something you couldn't live without.

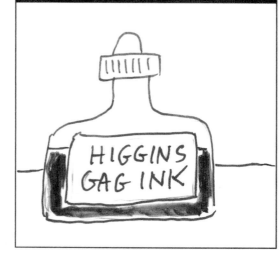

264

What do you hate drawing? Ten pins and horses. I've never done a cartoon of a horse bowling.

Being as accurate as possible, how many desert island cartoons do you think you've come up with and submitted to *The New Yorker*? All of my gags are desert island gags. Those that are bought are redrawn by the staff at the New Yorker so that they take place somewhere else.

What's the funniest thing that you witnessed, overheard, or came up with that you couldn't figure out how to use in a cartoon?

It involved a naked 83-year-old diabetic grandmother and I can't go into any more detail.

If you could ask Bob Mankoff, *The New Yorker* cartoon editor, one question, what would it be? Why?

Answer the following questions with a number from 1 to 10 (1 being not very much at all and 10 being quite a bit):

How much do you enjoy bowling? 4

How close have you ever come to getting a tattoo? 1

How often do you whistle or hum? 5

How much do you resemble Bea Arthur? 10

How likely is it that you will water-ski in the coming year? 1

How often do you curse? 26

With what frequency do you imbibe smoothies? 1

How much do you dislike licorice? 1

What's your favorite number between one and ten? ∞

How confident are you in your dancing ability? 2

How Jewish are you? 1

Naming Names

What name might you give to a mild-mannered, slightly overweight dental assistant in one of your cartoons? Fiona

Other than Lance, what name would you give to a twenty-eight-year-old metrosexual entertainment lawyer who cycles on weekends?
Fiona

What would be a good name for a new, commercially unviable breakfast cereal?
Sugarturds

Come up with a name for an unpleasant medical procedure.
Endopancreatic lobar probe

If you used a pen name, what would it be? Mont Blanc

Please do not draw anything in the space below. Seriously, I mean it this time.

You're figuring I'm contrary and I will draw something in this space but you are wrong.

Circle your preference.

beach	OR	mountains
poetry	OR	sports
day	OR	night
llamas	OR	alpacas
Montana	OR	Maine
hot	OR	mild
jazz	OR	country
soup	OR	salad
Luke Skywalker	OR	Han Solo
accordion	OR	bagpipes
pickup truck	OR	Volkswagen Beetle
gorilla suit	OR	chicken suit
time travel	OR	free health care
(swimming)	OR	jogging
spring	OR	fall
General Tso's chicken	OR	Caesar salad
hip-high fishing waders	OR	lifetime supply of ketchup
life without shoes	OR	life without computers
having a facial tattoo	OR	being a vegan
$10 gift certificate to Orange Julius	OR	$50 gift certificate to Chess King
your very own dump truck	OR	an iPod
one hundred dollars in quarters	OR	snowshoes
walkie-talkie, a pogo stick, a gallon of orange juice, an extension cord, and three new pairs of scissors	OR	a canoe
funny	OR	(not funny)

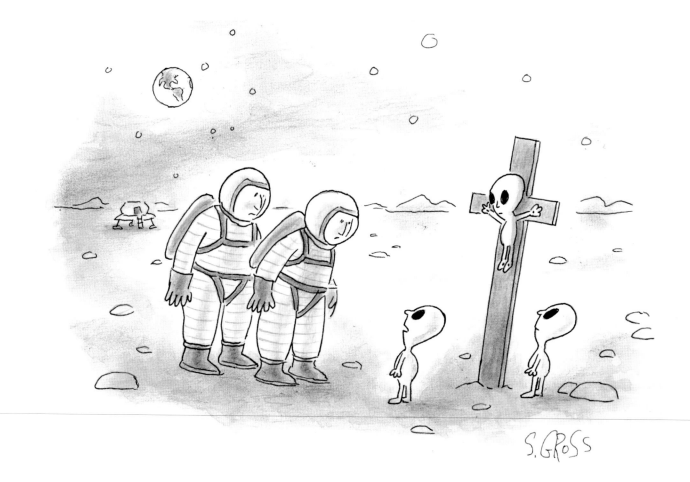

"We've already blamed it on the Jews."

"*If I had the abortion we wouldn't be eating so good.*"

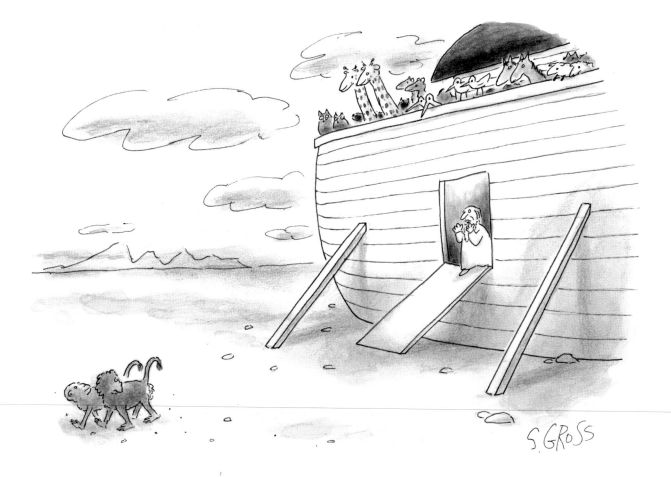

"Come back when that thing on your asses clears up."

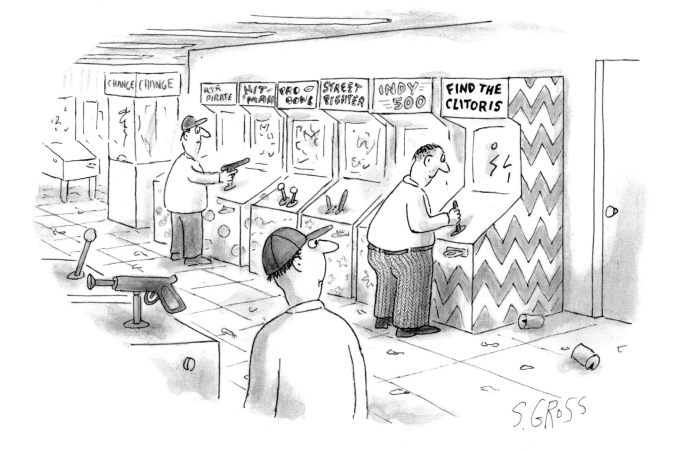

APPENDICES

APPENDIX 1

CARTOONISTS AT WORK

It should be said here, on behalf of all of us cartoonists: Just because what we do doesn't look like a real job doesn't mean it isn't work. We work at what we do. Seriously, we do. I say that because I know that it sometimes doesn't look like it from the outside.

WHAT A CARTOONIST IS ACTUALLY DOING.	WHAT IT MIGHT LOOK LIKE TO A SPOUSE OR LOVED ONE.
writing gags.	sitting there.
research.	going to a movie.
enabling deliberate unintentionality through the liberation of the unconscious.	snacking or napping.
unlocking the ludic possibilities inherent in familial cohabitation.	throwing dirty socks on the floor instead of in the hamper.
mentally arranging the visual elements of a proposed drawing to best achieve graphic impact and clarity.	looking through binoculars at the neighbor's daughter home from college.
drawing	forgetting something important relating to financial or domestic responsibilities.

APPENDIX 2

REJECTION REASONS

So, as I mentioned in the introduction, a lot of people keep asking me why I think these cartoons were rejected. Simply put, it's because, for one reason or another, they're not appropriate for *The New Yorker*. In this appendix I'm going to give you an incomplete and purely theoretical list of what some of those reasons might be.

The other thing people keep asking about the first book is, "How come you didn't include more of your own cartoons?" It was mostly my mom asking me that, but still, I'm going to attempt to take care of both of those birds with one appendix. I'll give you a rejection reason followed by one of my own cartoons as an example. And I'd like to make it clear that the following cartoons aren't necessarily good cartoons—they're just good examples of what *not* to do. That is, if you want your work to appear in a fancy-pants literary magazine.

TEN POSSIBLE REASONS WHY CARTOONS GET REJECTED BY *THE NEW YORKER*

REASON NUMBER ONE:
TOO LOWBROW

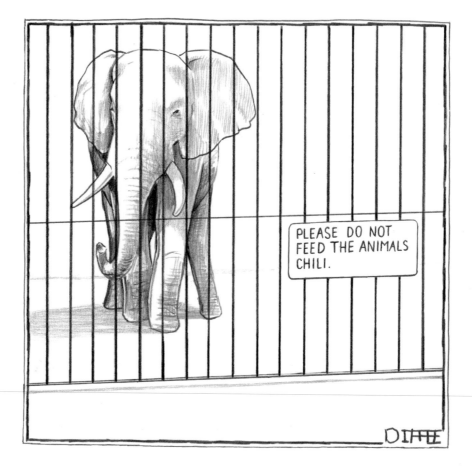

They shy away from anything of this sort. No poop jokes, no projectile vomiting, and certainly nothing coming in or out of noses. (I know . . . what else is there?) I for one have done scores of scatological jokes over the years and never sold one. But what are you gonna do? Stop doing 'em? The funny thing is, when you spend all day trying in vain to create little diamond-cut tidbits of sophisticated, highbrow humor, nothing makes you giggle at the drawing board like a good old-fashioned farting elephant gag. Alas.

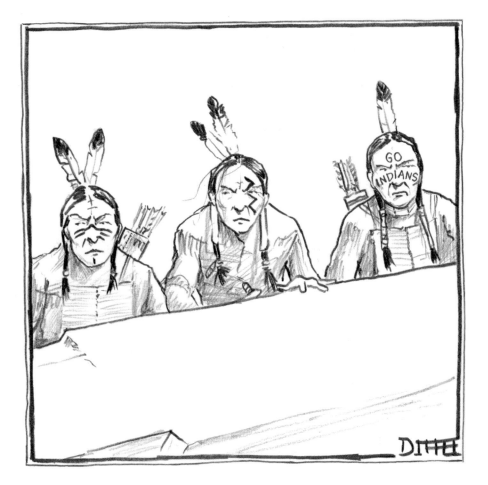

I don't know. To me this is less a cartoon about Native Americans and more a cartoon about people who paint their faces at ball games. And besides, you can't say the gentleman on the right isn't wholeheartedly pro-Indian. Crap, I'm gonna get letters.

REASON NUMBER THREE:
TOO DARK

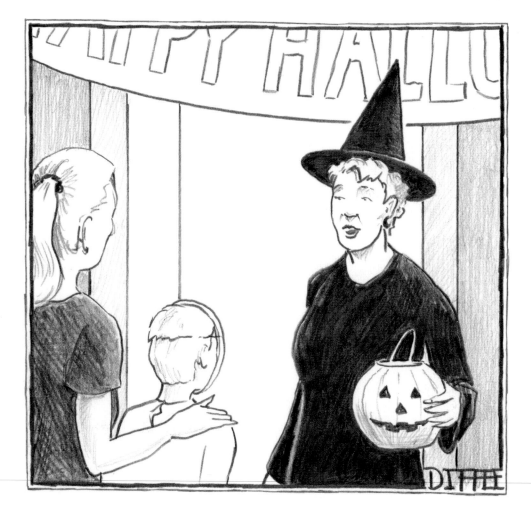

"Come on in. The kids are in the backyard bobbing for pink eye."

By "too dark" I mean cartoons that are too morbid, too creepy, too sick or twisted—cartoons that are a little too "real" about dying, disease, dismemberment, drug use, bad things happening to animals or children. Surprisingly, I can't think of anything funny to say about those things.

REASON NUMBER FOUR:
TOO WEIRD

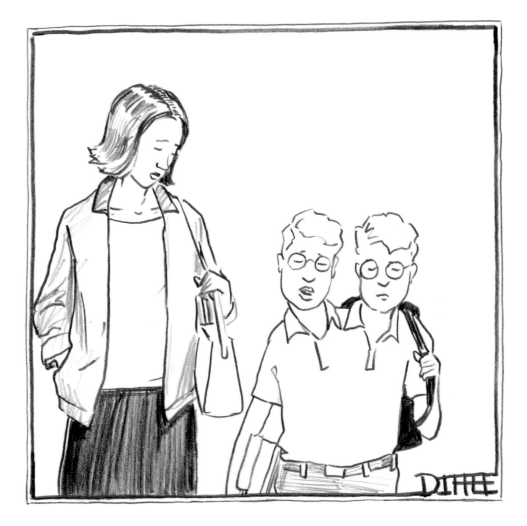

"Kids at school call us 'eight eyes.'"

I told you, it's weird.

Here's another:

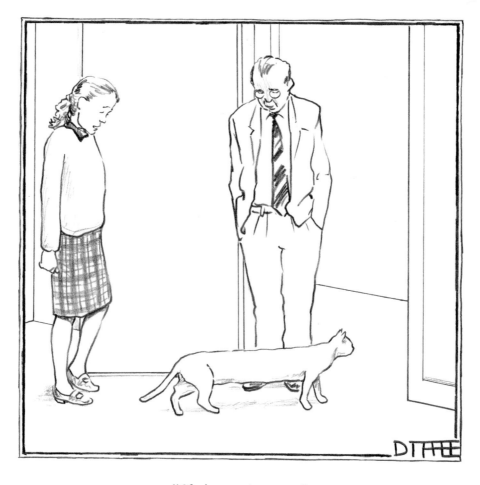

"She's a weiner cat."

For some reason a lot of my rejects fall into this category. It's the flip side of having complete creative freedom. Occasionally I'm gonna do stuff that's a little too "me." I can't really explain why, but to me these are funny. I am apparently alone in that opinion, and I'm surprisingly okay with that.

REASON NUMBER FIVE:
TOO POLITICAL

I actually don't have any examples of this one, mainly because *The New Yorker* just doesn't run things that are overtly or specifically political. Besides, there are great cartoonists doing the political thing very well in other places. Also, I don't really keep up with the news. I watched CNN once, but that was only because I couldn't get to the remote control without dislodging the catheter.

REASON NUMBER SIX:

TOO DIFFICULT TO "GET" (AND WHEN READERS DO GET IT, IT ISN'T FUNNY ENOUGH TO JUSTIFY THE EFFORT, PROMPTING THE THOUGHT, *IS THERE SOMETHING MORE HERE THAT I'M MISSING?*)

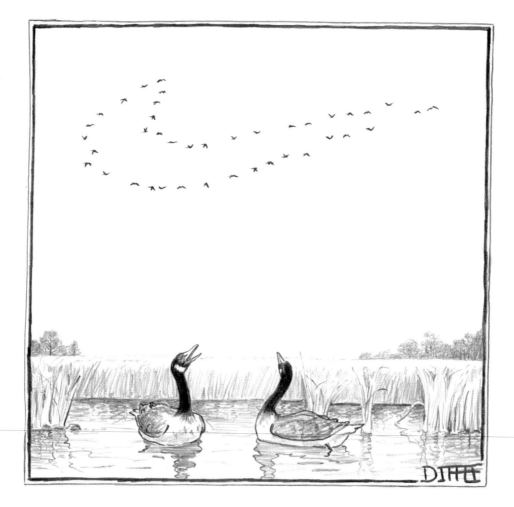

"Sellouts."

It's a Nike symbol . . . and therefore hilarious, and no, there isn't anything else that you're missing. It's just not that funny. A swing and a miss. Or, at best, a foul ball. Get it? Foul ball—as in fowl? Which leads us nicely into the next reason. . . .

REASON NUMBER SEVEN:

TOO DUMB

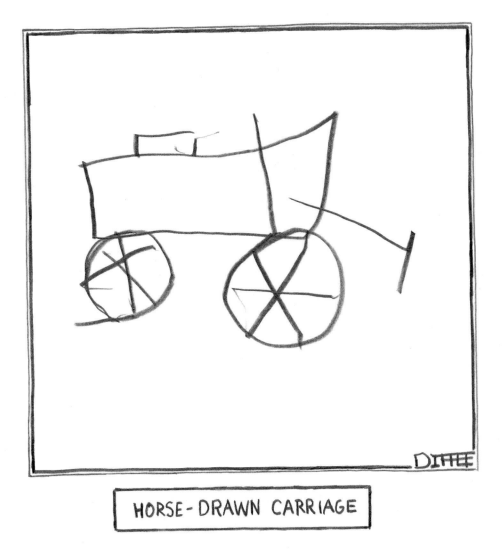

HORSE-DRAWN CARRIAGE

This is one of my favorites. I'm dumb.

REASON NUMBER EIGHT:
TOO BAD

NOTE: This is a bad cartoon. I'm not proud of it at all, but I hope I'll get some credit for having the courage to publish bad work so future generations might be bettered. Not many people have the guts to do that. Only me and Jewel.

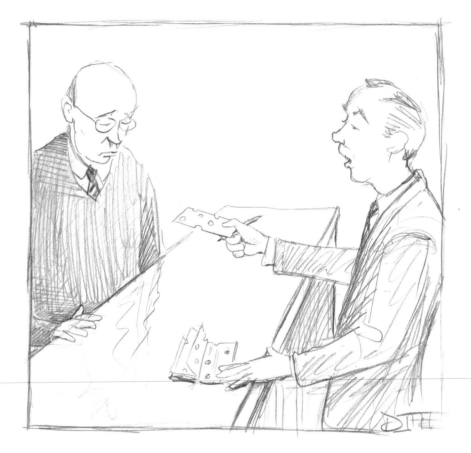

"It's from my Swiss account."

It's an awful cartoon. Just terrible. It's a pun, the domain of amateurs. Puns are to cartooning what lip syncing into a hairbrush is to show business. I can only say that when I did this, it must have been a really slow week in my head. Notice that I didn't even bother to do a finished drawing of this one. What you see here is the "rough" used to pitch the idea to the magazine.

REASON NUMBER NINE:
TOO DIRTY

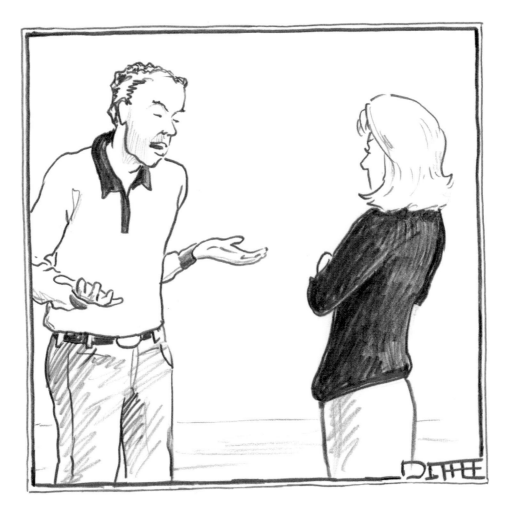

"You say sex pervert. I say horse enthusiast."

The New Yorker does plenty of sex-related cartoons, but there are some things the magazine won't touch—mostly things that are illegal. I guess there's a good reason why you've never seen *The New Yorker Book of Rape Cartoons.*

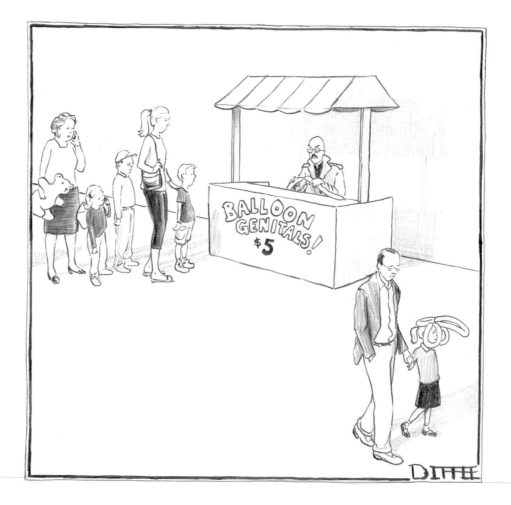

Sorry, Mom.

APPENDIX 3

BOB ANSWERS
THE TOUGH QUESTIONS

Paul Noth

I can and I don't.

He didn't so I won't.

Roz Chast

I just found this note on my desk that says, "Call Fred! Important!
2 p.m.!!" Do you know who this Fred is?

Roz, check out www.whoisfred.com.

J.C. Duffy

Was it something I said?

Not in so many words.

Marshall Hopkins

Is never good for you?

Neber has been berry berry good for me.

Alex Gregory

Why "Bob" and not "Rob"?

Hey, Alex, thanks for blowing my secret name.

Nick Downes

Who will be wearing what on Oscar night?

Personally, I'd like to see everyone in bright, orange Gitmo jumpsuits or boxer-thong combos.

Ariel Molvig

Why don't you wuv me?

Because love is blind, and then I'd have to ask everyone to submit braille cartoons.

Glen LeLievre

Boxers or briefs?

Actually a combo with a boxer front and a thong back to show off my buns.

Robert Leighton

Get it?

Not really but I can fake it.

Mick Stevens

Why was my name on a gravestone in one of your earlier cartoons? I've been running scared ever since.

Silly boy. Just change your name.

Julia Suits

Why dots?

Why nots?

David Sipress

Have you no sense of decency, sir? At long last, have you no sense of decency?

Not since I started wearing the boxer-thong combo.

Zachary Kanin

Where do you get your ideas?

Toledo.

Eric Lewis

Do you still love me?

How can I when you've treated me in such a cavalier and callous manner?

I will have no more truck with you.

Harry Bliss

Why don't we make love more than once a week?

Because your last name promises more than anyone could fulfill.

Mort Gerberg

Please, sir—may I have some more okays?

Mort, all the okays are going to China and India, so move.

Jason Patterson

Where do you like to get lunch in Midtown?

My favorite is the Mid-Town Luncheonette, which is actually located in Toledo.

C. Covert Darbyshire

Could you please stop hitting on my wife?

Agreed and you'll stop making those obscene phone calls to my potbellied Vietnamese pig.

Michael Shaw

Are you my real father?

No, your real father is that guy who is also the real father of Anna Nicole's baby.

Leo Cullum

Bob, may I ask you three questions?

Leo, I'm a busy man, so let's make that one question with three parts.

Carolita Johnson

Does it hurt you when I stick this pin in this little voodoo doll?

Yes, but it's a good hurt.

P.S. Mueller

Are the rumors true that you can bend foreign coins with your powerful mind?

More important, I can influence their exchange rates.

J.B. Handelsman

Why is *The New Yorker* prejudiced against me and/or my work?

We are not prejudiced against you, J.B. We are prejudiced against everyone.

Mike Twohy

Do you laugh this hard at everyone's cartoons?

Mike, I try to refrain from laughing at anyone's cartoons. It is a sign of ill breeding.

Sidney Harris

John O'Brien

What was wrong with that idea, eleventh from the bottom of that batch I sent on February 15, 2002?

The umlaut.

Jack Ziegler

Where did you get that haircut?

My hair was granted autonomy in 1986 and full independence with the fall of the Berlin Wall in 1989, so all questions such as this should be addressed to bobshair@gmail.com.

Robert Weber

Bob, are you sure this is something you really want to do?

No, but noblesse oblige.

Marisa Acocella Marchetto

Why are you always published?????

Because I'm fair but not stupid.

Pat Byrnes

If a train leaves New York at 9:00 a.m., and another train leaves Albany at 9:30 a.m., and their speeds are respectively 50 mph and 42 mph . . .

Could we move on to the verbal portion of the test?

Michael Crawford

Could you supersize that for me, sonny?

Yeah, in Toledo.

Gahan Wilson

What's the meaning of life, Bob?

I think I can best answer that with an analogy . . . color: spectrum as tone: scale.

P.C. Vey

When is the cartoonists' lounge going to be redecorated?

The new cartoonists' lounge will, when completed in the fourth quarter of 2009, fulfill every desire and exceed every expectation. It will be located in Toledo.

Christopher Weyant

Bob, why do good things happen to bad people?

Please see the analogy I gave Gahan.

Kim Warp

Have you ever laughed out loud at one of my cartoons? Smiled to yourself? Never mind.

Not only that, but I've passed gas as well.

Drew Dernavich

Why are you interested in coming to work for me, Mr. Mankoff?

Sometimes I think it's your hair, and other times I think it's your anaphylactic reactions to peanuts.

Danny Shanahan

Is it I, Lord?

Oh, you and your Shanahanigans.

Sam Gross

Why?

Because if a train leaves New York at 9:00 a.m., and another train leaves Albany at 9:30 a.m., one train has on it Paul Noth, Roz Chast, J.C. Duffy, Marshall Hopkins, Alex Gregory, Robert Leighton, Ariel Molvig, Glen LeLievre, Nick Downes, Mick Stevens, Julia Suits, David Sipress, Jason Patterson, Eric Lewis, Harry Bliss, Mort Gerberg, Zachary Kanin, C. Covert Darbyshire, and Michael Shaw. And the other has Leo Cullum, Carolita Johnson, P.S. Mueller, J.B. Handelsman, Mike Twohy, Sidney Harris, John O'Brien, Jack Ziegler, Robert Weber, Marisa Acocella Marchetto, Pat Byrnes, Michael Crawford, Gahan Wilson, P.C. Vey, Christopher Weyant, Kim Warp, Drew Dernavich, Danny Shanahan, and Sam Gross. Neither one of these trains is ever going to get to Toledo.

IN MEMORY

J.B. (Bud) Handelsman
February 5, 1922–June 20, 2007

ACKNOWLEDGMENTS

Thanks are in order. First of all to my cartooning colleagues for their admirable efforts and creativity, especially those who persevered this year in the face of personal challenges.

Thanks also to Bob Mankoff and David Remnick; Marshall Hopkins and Drew Dernavich for their PhotoShop help; David Kuhn and Billy Kingsland for their continued guidance and support; and Tricia Boczkowski and the rest of the team at Simon Spotlight Entertainment. Special thanks to Tanya Erlach.

Copyright Information